W9-BUA-486

DISCARD

Dynamic
COLOR
Painting
FOR THE BEGINNER

DIANE EDISON

Dynamic COLOR Painting

FOR THE BEGINNER

ABRAMS, New York

To Daphne Blackburn and my daughter Rebecca, whose unwavering support,
encouragement, and love made this book possible, and in memory of my mother
Davie and sister Mary, who are in my thoughts daily.

Cover design: Sarah Gifford

Library of Congress Cataloging-in-Publication Data
Edison, Diane.
 Dynamic color painting for the beginner / by Diane Edison.
 p. cm.
 Includes index.
 ISBN 978-0-8109-7090-8 (pbk.)
 1. Painting—Technique. I. Title.

 ND1471.E35 2008
 751.4—dc22
 2007044455

Text copyright © 2008 Diane Edison

First published in 2008 by Laurence King Publishing, Ltd.
Published in North America in 2008 by Abrams, an imprint of Harry N. Abrams, Inc.

Printed and bound in China
10 9 8 7 6 5 4 3 2 1

harry n. abrams, inc.
a subsidiary of La Martinière Groupe

Harry N. Abrams, Inc.
115 West 18th Street
New York, NY 10011
www.hnabooks.com

Contents

Preface

Idelle Weber
Gutter II (Land O'Lakes)
1979
Oil on linen
48 ½ x 71 ¼ in.
(123.19 x 180.98 cm)
Courtesy Idelle Weber and
Bill Massey

In *Land O'Lakes*, Weber treats us to a different interpretation of garbage. Using classic realism, chiaroscuro shading, and brilliant color, she leaves us to ponder the question of beauty in art. The claustrophobic crop brings the viewer almost too close for comfort.

The human desire to embellish, imprint, and record has survived from earliest times to the present day, while techniques of painting have constantly evolved as new materials were discovered and put to use. Prehistoric cave dwellers would decorate walls with paint made from dirt or charcoal, mixed with spit or animal fat, before they realized that pigments taken from iron oxide deposits in the earth were more reliabl As early as the ancient Egyptians, the technique of fresco painting, in which water-based color is painted on a prepared wet plaster surface, made huge wall commissions possible. The advent of wood panels arou 1100, followed by canvas stretched over panels or a frame, ushered in portable works of art. This new portability, along with the patronage o the arts by wealthy benefactors, helped to increase the role of the artis as a professional. And despite the limitations imposed by the preferenc of patronage—frequently for portraiture, scenes of great battles, and religious themes—the individual personality of the artist often shines through in early oil paintings. Patronage continues in the guise of museu galleries, and collectors, but today's artists are highly individual, often highlighting personal causes at the same time as honoring commissior

Artists today use a variety of surfaces to paint on—paper, metal, gla and whatever other surface will hold paint. Computer-generated imag have helped young artists to reconsider and stretch their subject matte An understanding of the rigor involved in learning to paint, however, strengthens such experimentation. When teaching an advanced paint: studio, I find that the very definition of what a painting can be is regula challenged in unexpected ways. Yet for a challenge to be successful, the basics must be in place—rather like a pianist learning to play the scale before going on to master improvisation.

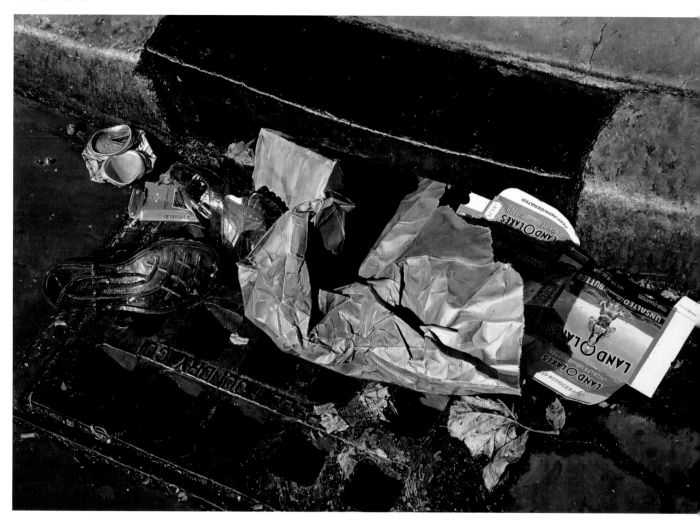

My philosophy of learning to paint is twofold: I want to illustrate what
 v as a natural bridge between seeing and painting color, while at
 ame time challenging beginning students with complex ideas
 unding painting. For many, drawing is considered the most direct
 um from the mind to the hand; it is also an artistic discipline in itself,
 scending its perceived service as primarily a preparatory instrument
 t. Beginning students, however, do not always make the connection
 drawing is an art form, which accounts for the fact that they seem to
 t how to draw when they begin painting. This lack of connection is
 ling, since it tends to interfere with the intuitive ease of the transition
 drawing to painting.

With this book, I propose a different approach from the traditional
 tice of starting painting courses with monochromatic color schemes,
 eby circumventing the problem of "drawing" with the paint rather
 spreading paint as a liquid; instead, *full-range color painting* is the
 erpiece of instruction. Full-range color is the use of a comprehensive
 palette that originates from direct observation of color in an
 ronment. By seeing and understanding color and color value, this
 of painting can become as direct as a drawing. This text will provide
 ting students with the tools and techniques to work in full-range color
 g oil or acrylic media, and in so doing will present them with a context
 ppreciating the value of color theory and design. The comprehension
 ese relationships in tandem with the physical application of the paint
 e crux of why I view this text as a bridge. I am attempting to advance
 ntuitive quality ordinarily associated with an easeful transition from
 ving to painting.

Over the years, I have consistently challenged beginning students
 ays they were not expecting. It is at this point in their educational
 ers that they are the most approachable and least cemented in the
 eit of what an artist is supposed to be, thus making this an ideal time
 nfluencing their attitudes toward painting and art in general. The
 e at hand is how to encourage beginning painters to think the way
 did in grade school—perhaps before some well-meaning instructor
 them that what they had created did not resemble what they
 nded it to look like, an experience that can mark the end of visual
 rpretation. Experimentation, risk, and a love of making a mess are
 dually discouraged in the pursuit of perfection in the style of working
 observation alone that tends to begin in middle school and peak
 gh school. I intend that this book should enable students to recover
 fearlessness and freedom so necessary to making art.

Even at this early stage of painting it is important that students are
 n instruction on integrating content and narrative throughout the
 ned assignments. The painting philosophy expressed in my text
 urages an appreciation of traditional materials and techniques
 le simultaneously presenting students with opportunities to branch
 and experiment—to "break the rules," so to speak. I believe it is just
 nportant to teach students to find a personal style and provide an
 ortunity for new ideas as it is to help them to master technique.

begin the book with a discussion of design and the visual elements
 esign in Chapter 1. These are the building blocks for composition
 students will need to learn in order to create and edit paintings. In
 pter 2, we go on to explore the other element for composition;color.
 dents will learn to understand color and how to create and use it while
 king their own color wheels using paint, the first opportunity in the
 k to learn about palette preparation and paint mixing. In the next three
 pters, three painting techniques are described in detail: wet on wet, or
 prima painting, wet on dry and scumbling, and, finally, the Venetian

Laurin Ramsey
Oil on canvas

Beginning student Laurin
Ramsey's landscape oil painting
is a panoramic view of the
changing cityscape of Athens,
Georgia. Her strong composition
and subtle color mixing provide
good examples of creating
natural light and atmospheric
perspective.

painting technique of glazing in layers. In Chapter 6 there is a chance t
bring all these painting techniques together in a study of subject matte
and content, including portraiture, landscape, and abstract painting.
The book ends with sections on self-critique and health and safety, anc
includes a glossary and list of further reading.

Throughout the book, step-by-step sequences demonstrate
techniques, while the text is illustrated with examples of finished work
a wide range of artists. Feature spreads pick out such subjects as palett
preparation, building a stretcher frame, stretching and priming the
canvas, choosing and using brushes, and also cleanup and preparation
for the next day's painting.

Acknowledgments

Thanks to Laurence King Publishing; to Lee Ripley, Publishing Director,
her active help and support with her offer of a contract—her faith in me
was my greatest encouragement; to Anne Townley, whose patience
helped me gather my knowledge of painting into a clear and concise
manuscript, while asking all of the right questions; and to Melissa Dan
whose questions and commentary have helped me to sharpen my writi
Thank also to Eric Himmel, Editor-in-Chief at Harry N. Abrams. I am als
grateful to the reviewers who provided useful feedback at various stage
of the manuscript. In particular I would like to thank Clare Marie
Goldsworthy and James Xavier Barbour. My thanks to the following: Ir
D. Costache for introducing me to Helen Ronan, who invited me to subr
a proposal; Dana Vannoy, who edited my proposal and was a constant
source and support for my writing; Robin Dana, my book photographer
for the wonderful suggestions, ideas, and collaboration; George Adams
the George Adams Gallery, who has represented me as an artist for fifte
years—his support and encouragement of my art and the writing of thi
text have been immeasurable; Carmon Colangelo, director, colleague,
adviser, and friend; Clarence Morgan and Arlene Burke Morgan, who ha
been my colleagues from afar and up close, for their support over the ye
Rylan Steele for additional photography; Thomas Manley, whose hard
work as my studio assistant will always be appreciated; Judson Duke,
my invaluable research assistant and builder of painting surfaces; Lesle
Dill, gallery mate and friend; Carol May, a true friend for over two decad
Ellen Levy and Joan Marter, with whom I served on the board of the
College Art Association; Joseph Wiley and Brandon Williams, for all thei
technical and IT support—they kept my upgrades coming. I am also ve
grateful to the strong support of my colleagues at the Lamar Dodd Scho
of Art, University of Georgia Athens: Radcliffe Bailey, James Barsness,
Scott Belview, Stefanie Jackson, Margaret Morrison, Joseph Norman,
Judy McWillie, Martijn Van Wagtendonk, and Troy Duane Wingard; and
to all of my beginning painting students for their wonderful art, some
included in this book, and for continuing to teach me how to teach.

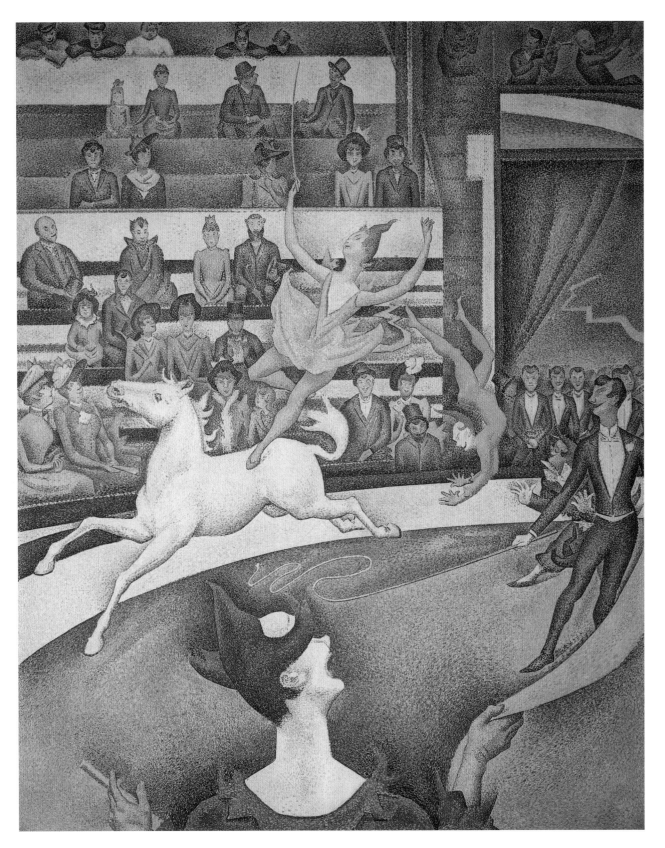

Georges Seurat
Le Cirque
1891
Oil on canvas
73 x 60 in. (185.5 x 152.5 cm)
Musée d'Orsay, Paris

Seurat, known for his style of painting called pointillism, creates a swirling movement with a series of performers in the center stage of a circus. This technique uses small dots of pure color that merge in the eye of the viewer, bringing luminosity and warmth to the scene.

Chapter 1:
Design Principles and
the Visual Elements

In this chapter we will explore the concept of design and its practical use in composing paintings. The importance of basic design knowledge cannot be overemphasized. The utility of design is often overlooked or disparaged for fear that too much concentration on design principles may impede creativity. I believe that, on the contrary, an understanding of design strengthens and empowers the new painter. As for the danger of impeding creativity, I will always counsel a new painter first to master the rules and then choose to break them later. Design is about planning and organizing. It is useful, when painting from observation, in providing both a blueprint and a template to organize the illusion of three-dimensional space on a two-dimensional plane (the flat space of the canvas or paper in front of you), and it is crucial to understanding visual phenomena. You need a strategy to make sense of what you are seeing, which will then help you to make decisions about what to include in your painting. Design is but one of many ways to edit your paintings.

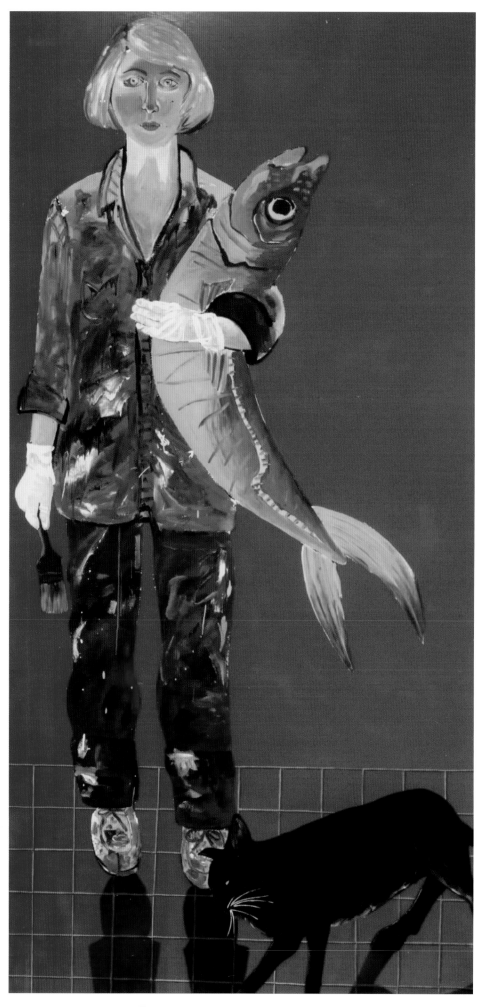

Joan Brown
Self-portrait with Fish and Ca
1970
Enamel on Masonite
96 x 48 in. (243.8 x 121.9 cm)
Courtesy of George Adams
Gallery, New York, and Galle
Paule Anglim, San Francisco

Joan Brown's self-portrait is a
example of dramatic color us
The painting is deceptively
simple yet elegant in line. Co
and value are used to great
effect in the use of bright red
both the foreground and the
background. The yellow of th
fish is made even more dram
by comparison. The chromat
neutral grays in the clothing
help create the illusion that
the figure is moving from fror
to back on the picture plane.
Because of the high contrast,
the blue-black coloring of the
cat creates a silhouette that
keeps it front and center. It is
placement of the strong colo:
that affects the composition,
which itself has a very
economical use of line. Altho
Brown's painting is figurative
the space is imaginary and
symbolic and, in the case of t
background and foreground,
creates a sense of figure/gro
ambiguity, where it is hard to
decide what is figure and wh
is the background. The use o
simultaneous contrast in the
placing of complementary co
of similar brightness—red ar
green and yellow and blue—
conveys a sense of movemer
It is also a strong example of
use of chromatic neutrals to
create gray (see p. 51).

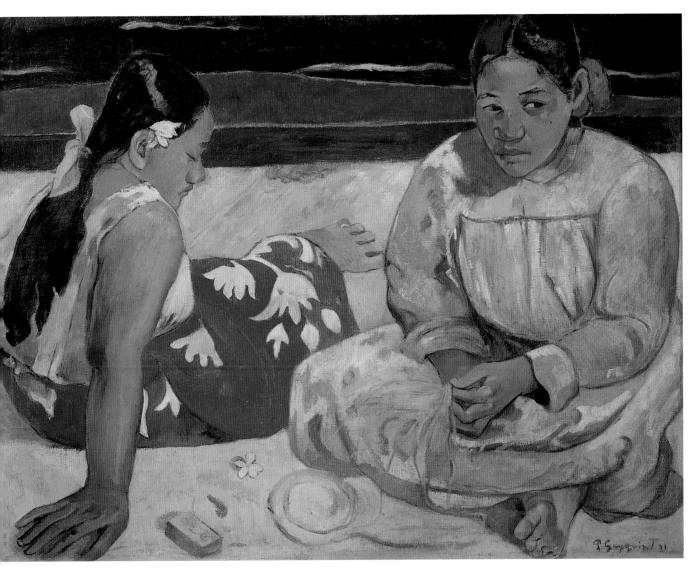

Paul Gauguin
Tahitian Women: On the Beach
1891
Oil on fine-weave canvas
27 x 35 in. (69 x 91 cm)
Musée d'Orsay, Paris

Gauguin's *Tahitian Women* shows the effect of scale and proportion within a composition. By placing the figures in the foreground and making them large, the background is automatically diminished and the illusion of distance is created. The space between the figures and the way the hand and one foot are cropped off the paper create interesting pockets of negative space (see p. 76). The sense of balance is achieved by equality of the visual weight of the figures and the negative space surrounding them.

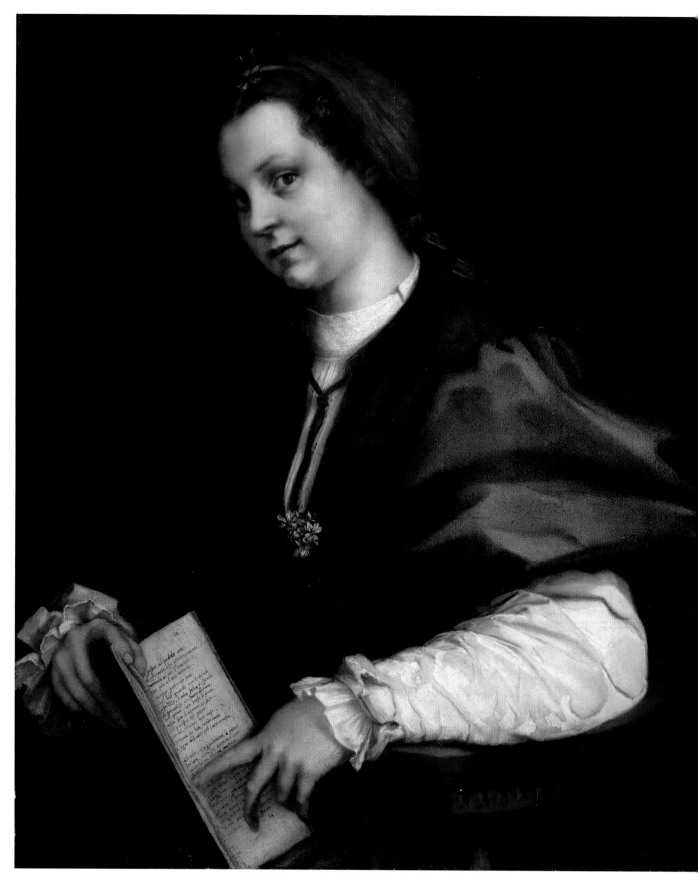

Andrea del Sarto
Portrait of a Woman with a Book of Petrarch's Poetry
c. 1526–28
Oil on panel
33 x 27 in. (84 x 69 cm)
Uffizi Gallery, Florence

In portraiture, one often speaks of the gaze, the relationship betw
the sitter and the viewer. Andrea del Sarto's subject is all awarer
with a knowing nod to the viewer. Compositionally, she is framed
a series of triangular shapes, starting with the blue of her cloak o
her left shoulder, followed by the length of the sleeve of her left a
Her emergence from darkness is a strong example of the chiarosc
painting technique following the tradition of Caravaggio (see p.

gn is also about problem solving, though in art and painting there is
ngle right answer. It may help to think of design in art as a bag of
al tricks composed of a series of elements and principles that can be
to create the illusion of space. How you use these visual tricks is up to
but you should be aware of these underlying processes. The elements
sign can be broadly described as dots and lines, shape and depth,
re, space, value, and color. How you go about designing or composing
image using these elements is usually governed by various principles,
ding harmony, balance, economy, scale and proportion, dominance
focal point, and rhythm and movement. We will explore these
ents and principles in this chapter, and each will be illustrated in the
mpanying contemporary, historical, and student images.
Most professional artists produce paintings in a very intuitive manner,
h tends to be reflective of their knowledge both of the role of design
creative tool and of art history. It is always worth studying works by
rical and contemporary artists. Once you understand how and why
created their images, you will be able to use the lessons you learn to
you plan and organize your own paintings.
eginning students need only refer to Kako Ueda's *Vanitas* (p. 18) to
an idea of the breadth and variety of the design elements and
ciples being used in creative contemporary art. Here, the design
ents of repetition and similarity coexist in the same painting.
etition, combined with color and scale, helps achieve an overall sense
lance. These collected patterns form the core of a painting that leads
viewer through the composition. Ueda's use of shaped cut paper and
t explores the definitions of what a painting can be.
When we begin to create a painting, we are faced with a flat surface
paper, the canvas, and so on). This is known as the picture plane.
nning painters will usually start with a painting surface that is either
angular or square, and are thereby dealing with an area that has four
t angles. Not unlike a window, the outside shape of your canvas is
t will frame your subject matter. The design challenge is how to create
nage that is equally interesting in all four corners and not just focused
e center of the canvas. This is where the design elements and
ciples can be brought into play.

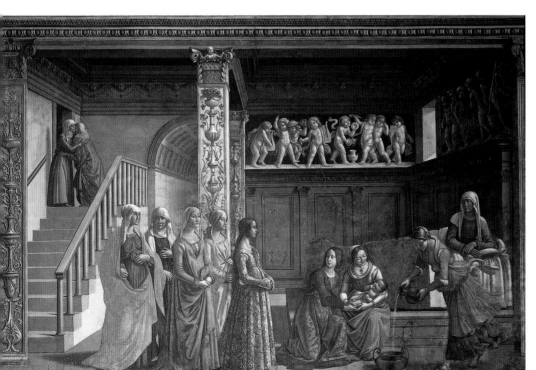

Domenico Ghirlandaio
The Birth of the Virgin Mary
1486–90
Fresco
Cappella Tornabuoni, Santa
Maria Novella, Florence

This fresco illustrates the use of
one-point perspective (see p. 22),
in which the lines and figures
converge on a single vanishing
point at the eye level of the
artist. If you used a ruler and
traced the lines, you would see
this quite clearly. The vanishing
point here is slightly above the
head of the standing woman in
the gold gown (fifth figure from
the right).

Design Elements

Dots and Lines

The dot can be described as the most basic mark. Lines can either stan
alone or be connected. A line can follow the general outline of a subjec
Lines can also have different qualities; they can be thick or thin, light o
dark, free-flowing or rigid. Richmond Teye Ackam positions lines and d
to create a cohesive image in his painting *Red and Black*, below.

Shape

We can create a shape by joining several lines together. The shape can
also be referred to as the **figure**—whether it is an object or a person—a
the space between the shapes and on which the shapes rest is called th
ground. The relationship between the figure and the ground, known a
the **figure/ground relationship**, is important in the composition of the
whole image. In Rogier van der Weyden's *Portrait of a Lady* (p. 19), the u
of a dark background mirroring the dark tones of the costume serves to
accentuate the paler, more ethereal qualities of the face, neck, and veil

There are occasions, however, when it is useful to blur the distinctio
between the figure and the ground, and this is known as **figure/groun
ambiguity**. Joan Brown's *Self-portrait with Fish and Cat* (p. 12),
demonstrates this, where both the background and foreground of the
image are painted in red, achieving an imaginary and symbolic space.

Richmond Teye Ackam
Red and Black
2003
Acrylic on vellum
11 in. (28 cm) diameter
Courtesy of the artist

In this work, the subtle basic
shape of dot, line, and form gives
way to a fully realized painting.
The size, shape, and color of the
individual forms help define the
focal point, or the area that the
viewer's eye is most drawn
toward: the yellow, which stands
out in contrast to the green. The
black arch in the background
comes in and out of our view,
an example of figure/ground
ambiguity. The ambiguity arises
out of the sense that the figure
and ground are at times visually
indistinguishable. The slightly
larger circles in front give the
illusion of deep and shallow space
(foreground and background).
The image appears deceptively
simple. As you see, abstract or
nonrepresentational art is by
no means exempted from the
requirement of design fluency.

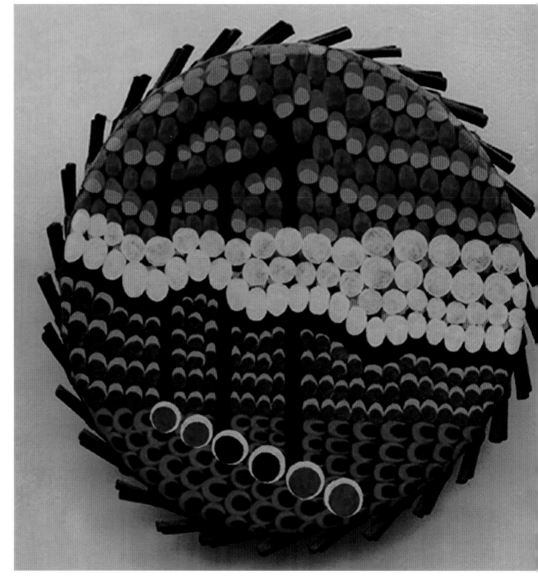

imilar to the concepts of the figure and the ground is the design
ent of **negative space** (see also p. 76). If you consider a mark on the
ire plane as a positive shape, then the area surrounding it is negative
e. The tendency of new artists to view the outside lines that form
cts or figures as the most important often gets in the way of
erstanding their relationship to the negative space. One way to
onstrate negative space is to attempt to draw the negative space first,
as the inside lines of a picket fence. What remains is the fence itself.
term negative space is not meant to be disparaging; it is a means of
ally separating the figure from the ground.

ike figure/ground relationship, negative space is important in terms of
position on the square or rectangular surface. A successful composition
oe one where the shapes of the negative space are also considered as
of the design. Beginning painter Kelly Smith's *Fruits and Vegetables*
ting (right) is an illustration of effective and inventive overall use of
itive space. Here the negative space is formed by the pale blue material
hich the fruit and vegetables are placed, and the shapes created as a
t are as interesting as those of the objects in the still life arrangement
f. Together, the fruits and vegetables and the pale blue of the negative
e create a dynamic composition.

mith's painting also shows the effective use of **cropping** to create a
ally interesting composition with a sense of continuation. Here the
s of the picture plane have been considered as a frame to the image,
ving a carefully chosen portion of the still life arrangement to be
ded within it, as is demonstrated by the cutting off, or cropping, of
e of the fruits and vegetables. Cropping the image through composition
o illustrated in van der Weyden's *Portrait of a Lady*.

:ure

ure in a painting can be both tactile, through the tactile nature of the
t, and visual, in the rendering of textures such as feathers or fur. It can
eated through the use of **repetition**. In design, this is a mark or shape
is repeated throughout the image. A checkerboard is a good example.
iture, this phenomenon is called **similarity**. An example is a field of
s in which each blade appears to be exactly the same, but in reality
are all different. As we have seen, Kako Ueda's *Vanitas* (overleaf) shows
repetition and similarity. The repeating of shapes and colors in this
ge also creates a **motif**.

motif occurs when visual elements are combined and this new
oination is repeated, creating a pattern, which becomes a visual
ne. A motif can be in the form of strict repetition, or it can merely
est similarity.

lmost the opposite of repetition is **variety**, where many dissimilar
es form the core of the design. More of a random quality is conveyed,
emonstrated in Norman Rockwell's *Shuffleton's Barbershop* (p. 27),
re all the pieces of furniture and objects in the room combine to create
cohesive whole. Most designs and artwork employ a combination of
tition and variety.

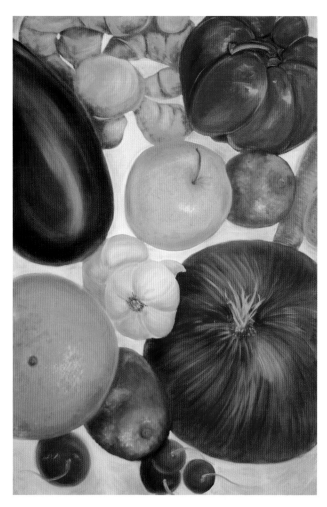

Kelly Smith
Oil on canvas

Beginning painting student Kelly Smith's fruit and vegetable painting is an inventive illustration of the overall use of negative space. For the sake of simplicity, view the pale blue material on which the fruit and vegetables are placed as negative space—negative only as a way to describe the difference between the objects and the space or air around them. Arranging your still life and allowing for interesting abstracted shapes with this space creates a dynamic viewpoint. This picture is a very open composition, with the edges cropped from all sides.

Space and Depth

Creating a sense of space and depth in a painting is all about creating a[n] illusion of a three-dimensional space on the two-dimensional plane of a piece of paper. Space can be **deep** or **shallow**. In deep space we look fa[r] into the distance, as in Richmond Teye Ackam's *Red and Black* (p. 16), b[ut] we can also look into shallow space, which seems much more limited a[nd] is also suggested in the foreground of Ackam's painting by the use of la[rge] dots to define a more cramped area.

Artists use a variety of different visual tricks. The most basic is to pl[ace] a larger object next to a smaller one. Of course, a sense of proportion co[mes] into play. If one of those objects is a house and another is an adult pers[on] then we might assume that both are a similar distance away from the viewer. But if one is a large cup and the other a small cup, then we mig[ht] assume that they are actually of a similar size and that the larger one i[s] nearer to us and the smaller one farther away.

Kako Ueda
Vanitas
2004–5
Hand-cut paper with watercolor
18 x 19 in. (45.7 x 48.3 cm)
Courtesy of George Adams
Gallery, New York

Ueda's *Vanitas* shows repetition and similarity coexisting in the same painting. An overall sense of balance is achieved by repetition, color, and scale. The repeating shapes and colors create a motif.

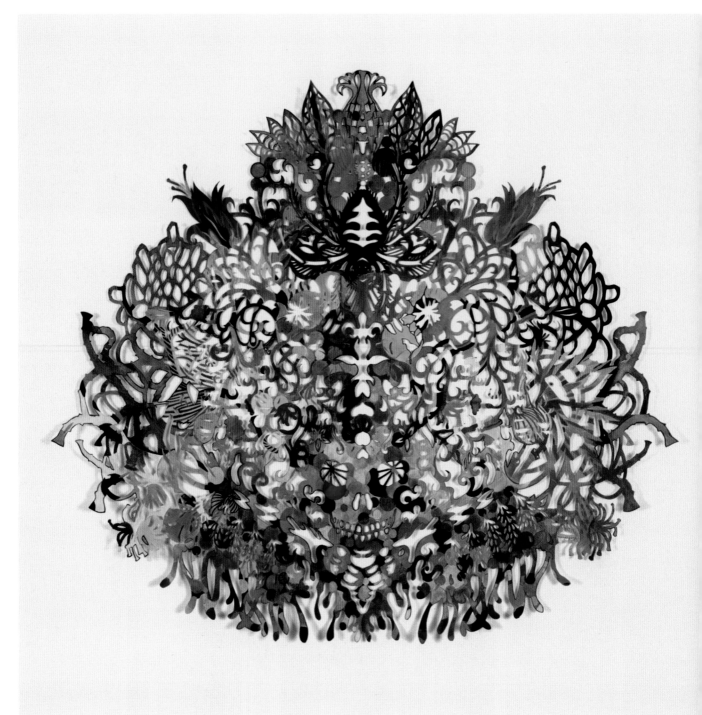

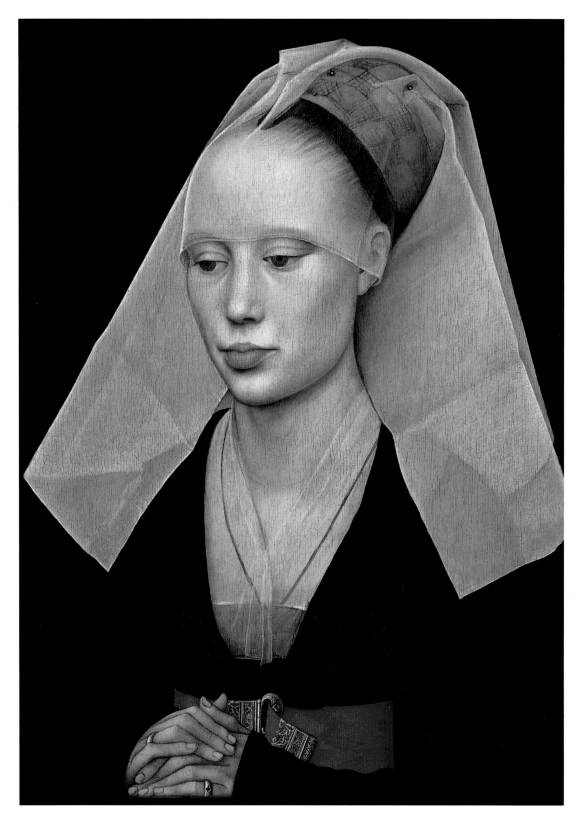

Rogier van der Weyden
Portrait of a Lady
c. 1455
Oil on oak panel
14 ½ x 10 ⅜ in. (37 x 27 cm)
National Gallery of Art,
Washington, D.C.
Andrew W. Mellon Collection

Portrait of a Lady has a distinctive interplay of figure/ground relationships. The dark background tones behind the figure echo the dark clothing, creating drama in the pale skin tones. The painting illustrates cropping of the image through composition. It also employs repetition, with a triangular shape recurring throughout, starting with the veil being cropped off at the edges, thereby allowing the background to repeat this shape. The red band tied high above the waist becomes a sort of focal point by way of its isolation: It simply stands out. And the triangular shape continues at the neck, and even in the subtle shape of the wrinkles in the veil.

Another trick is to overlap objects, where the objects that are overlap will appear farther away. In his image of *Tahitian Women* (p. 13), Gaug overlaps the two central figures so that the figure on the left appears to farther away from the front of the canvas.

Artists have traditionally used **linear perspective** as a way of depic distance in paintings and drawings. Linear perspective describes a vis point of view. A scene itself remains the same: What changes is the viewpoint from which we choose to see or depict it. Viewpoint change according to where we stand, our height, and how we hold our heads. (Think of the different ways in which a small child and a full-grown ad would see and describe the same scene.) Linear perspective consists o one-, two-, and three-point perspective. The perspective is determine by the original viewer of the scene—that is, the painter—and once the painting is painted, the perspective is fixed (wherever the viewer stan the viewpoint depicted in the painting stays the same).

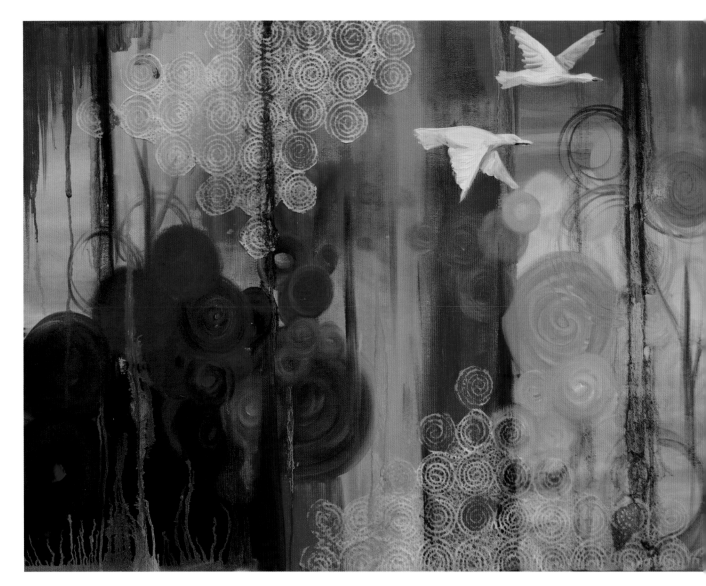

Jessica Schramm
Oil on canvas

Beginning student Jessica Schramm's paintir combines abstract shapes and imagery with realistic birds, thereby creating an imaginary world. She has combined wet on wet painting glazing, and scumbling to good effect. (See pp. 156–163 for more examples of abstrac painting.)

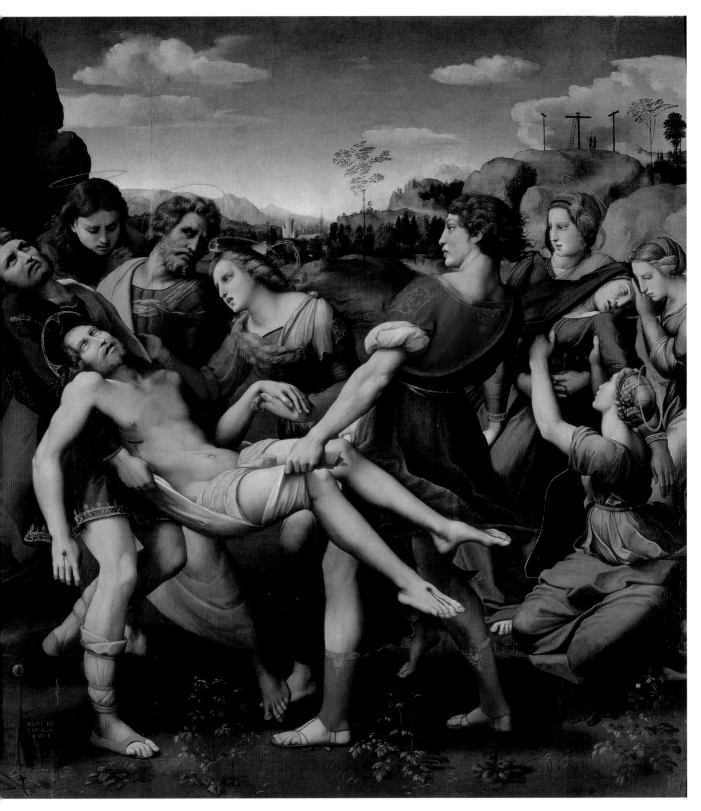

Raphael
The Entombment
1507
Oil on wood
72 ⅜ x 69 ⅛ in. (184 x 176 cm)
Borghese Gallery, Rome

Raphael's *The Entombment* is an example of one-point perspective. In this painting there is a single point where the lines and figures converge to a vanishing point, just over the shoulder of the middle woman helping to carry the Christ figure.

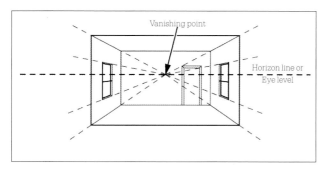

One-point perspective

In **one-point perspective** there is a single point at which the lines and figures converge to a vanishing point. This vanishing point change depending on the height of the person viewing a scene; everyone will s the horizon line differently. The vanishing points converge at the horizo line. Imagine staring down railroad tracks with the tracks directly in fro of you: If you are standing and then decide to sit down, the horizon line and vanishing point will change. In Ghirlandaio's *The Birth of the Virgir Mary* (p. 15), the vanishing point is just to the right of the head of the fig in the background, and in Raphael's *The Entombment* (p. 21), it is just c the shoulder of the middle lady.

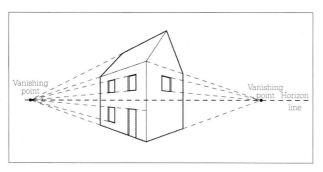

Two-point perspective

In **two-point perspective** the viewer (the artist) is standing to eith the left or the right, at an angle, and the lines will converge toward two vanishing points, both on same horizon line. Imagine a room in which y are standing over on one side. Two-point perspective often seems a mor natural point of view, because we tend to enter environments casually, without heading for the absolute center. I usually advise my students to compose as they naturally come upon a view. Andrea del Sarto's *Portrai a Woman with a Book of Petrarch's Poetry* (p. 14) is an example of two-pc perspective, in which the vanishing points are at elbow height and off each side of the painting.

Three-point perspective

Three-point perspective takes into consideration a view looking up or down. The horizon line is near the bottom or top or off the page itself. In François-Auguste Biard's *Four O'Clock at the Salon* (opposite), three-point perspective is used as part of the composition to add to the sense of an upward view. Both we, as viewers of the image, and the figures in the foreground of the painting are looking up toward a vanish point that is off the top of the picture, while the horizon line is off the bottom of the painting. The other two vanishing points are off the pictu to the left and right.

In nature, **atmospheric perspective** is created by such atmospher: effects as dust or clouds combined with distance, such as in a landscape painting. This creates a hazy, soft-edged effect, an effect that also chan the color strength and tone, with objects that are closer to the viewer appearing clearer and harder-edged. The overlapping of objects as they recede in space also heightens this phenomenon.

Value and Color

Value can be defined as the relative lightness or darkness of a visual sp Value in color is defined as the relative gradations between the darkest and lightest tones. Adding white **tints** a color lighter, whereas adding black creates a darker **shade**. There are combinations of color patterns that produce various optical results. Most artists use these intuitively. In *Pistia Kew* (p. 24), Idelle Weber contrasts blue with its complementar color orange to create a dramatic visual. Having an understanding of how color works will help you to design your painting much more quick

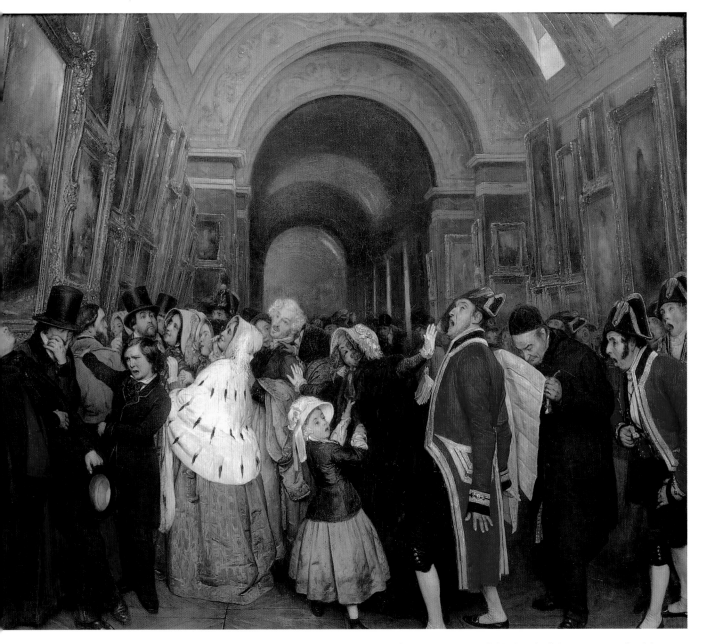

François-Auguste Biard
Four O'Clock at the Salon
1882
Oil on canvas
22 ⅜ x 26 ½ in. (57.5 x 67.5 cm)
Musée du Louvre, Paris

Four O'Clock at the Salon is an example of three-point perspective, with the viewer looking upward toward a vanishing point and the horizon located off the bottom of the painting.

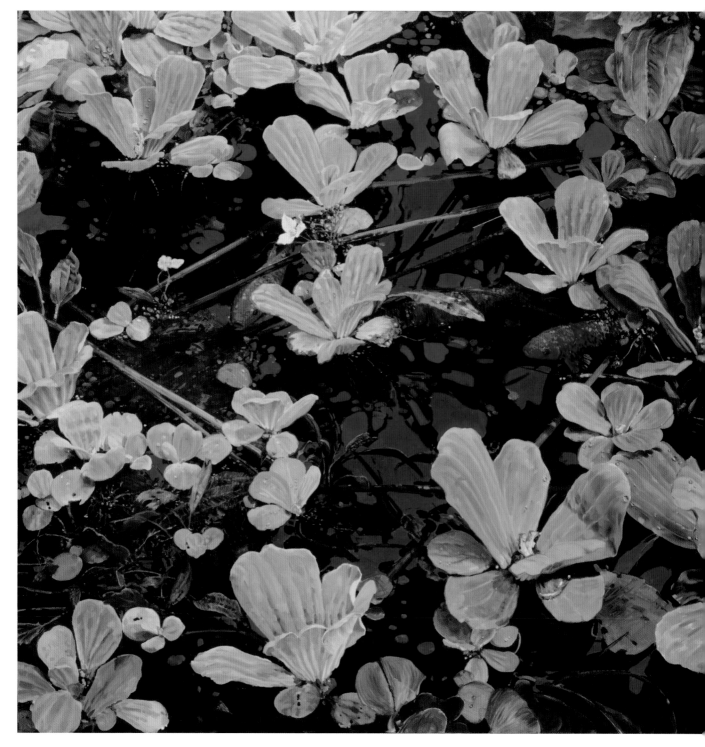

Idelle Weber
Pistia Kew
1989
Oil on linen
58 x 59 in. (147.3 x 149.9 cm)
The Nelson-Atkins Museum
of Art, Kansas City, MO
Courtesy Idelle Weber and
Bill Massey

In *Pistia Kew*, the sense of balance that Weber
achieves is a combination of figure/ground
ambiguity, motif, and dramatic color usage. Th
cropping of the image serves to create the sens
of continuous space with its open composition.

nciples of Design

mony

nony is about bringing all the design elements together in the right
ortions so as to create an image that is easy to view. Liz Wright's
Wave, below, demonstrates harmony of color where no one color is
ominant. Repetition can also be used to create harmony, as shown
right's repetitive use of abstract circular shapes, and Ueda's *Vanitas*
B), where the repetition of shape draws the image together.

nce

twork, we refer to the visual **balance** of the composition. For example,
all, dark, filled-in circle and a larger circle drawn with a thin line
ed next to one another will be perceived as having equal balance.
rs can also be balanced, as in van der Weyden's *Portrait of a Lady*
9), where the dark tones of the background and the sitter's dress are
nced by the lighter tones of her face and veil. Gauguin's *Tahitian*
1en (p. 13) demonstrates balance in the equality of the visual weight
e figures with the visual space surrounding them.

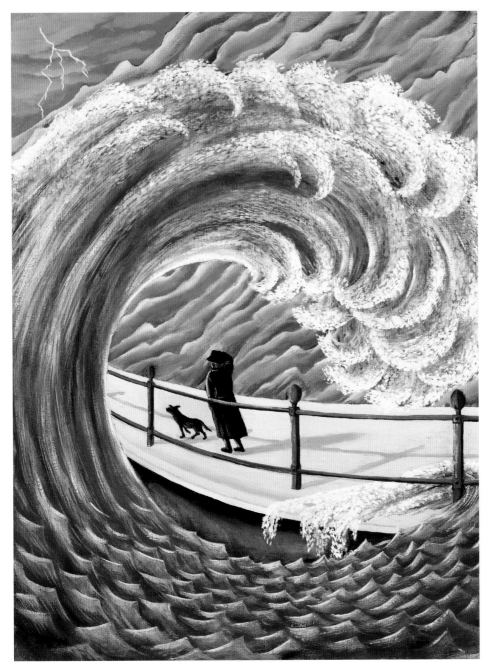

Liz Wright
Tidal Wave
1993
Oil on panel
16 x 12 in. (40.7 x 30.4 cm)
Private collection

Liz Wright's *Tidal Wave* is at
once beautiful and foreboding.
The concentric sweep of the
wave creates a frame within
a frame, and in so doing allows
the figure and dog to compete
visually with the power of
the wave. They are almost in
silhouette, creating a high-
contrast focal point.

Economy

Using economy in design involves being disciplined about using only w
is needed to create an image without clutter. Liz Wright uses the minim
of objects in *Tidal Wave* (p. 25), combined with a minimal use of color, to
create her composition.

Scale and Proportion

Scale and **proportion** relate to size, and thus to the creation of depth ir
an image. Size is relative in the sense that a small object placed next to
larger one will create the illusion that the smaller object is farther away.
With context, however, you will have a frame of reference to judge its siz
for example, if you photograph a small piece of jewelry next to someone
hand. Scale and proportion in a painting are usually demonstrated by
means of the design elements used to show space and depth.

Dominance and Focal Point

In design, the way in which the viewer perceives certain areas of a
composition is controlled by placement. Some parts of the design will sta
out and become the focus because they **dominate** visually. This can be
achieved through color. In Richmond Teye Ackam's *Red and Black* (p. 1
the **focal point** is the yellow, which stands out in contrast to the green.
He invites you into his painting by the concentric patterns on the outer
edge of its surface, which create a drumlike effect. This is again emphas
by the repetition of the circle. In *Shuffleton's Barbershop* (opposite),
Norman Rockwell uses dramatic lighting to create a focal point and dra
the eye into the picture and through into the room at the back where a
game of cards is taking place.

Jane Deakin
The Sacred Snake
1994
Oil on canvas
47 ¼ x 47 ¼ in. (120 x 120 cm)
Private collection

Jane Deakin's *The Sacred Snake*
uses color to literally snake the
imagery throughout her
composition. The chromatic
grays of the background serve to
bring forward the center space
that engulfs the snake, yet the
highly detailed body of the snake
still moves further out. These
decisions lead to an interesting
level of figure/ground ambiguity.

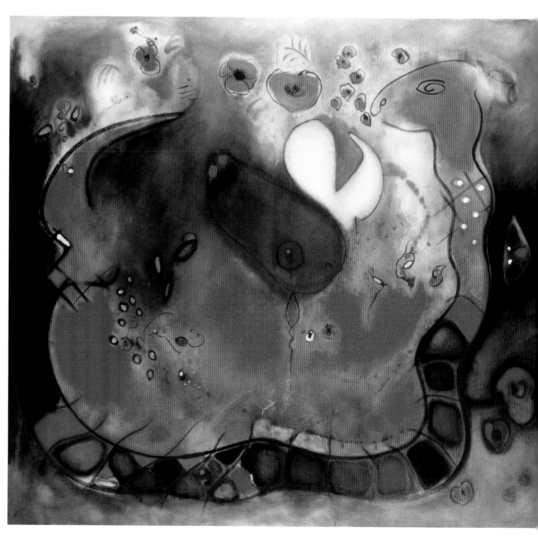

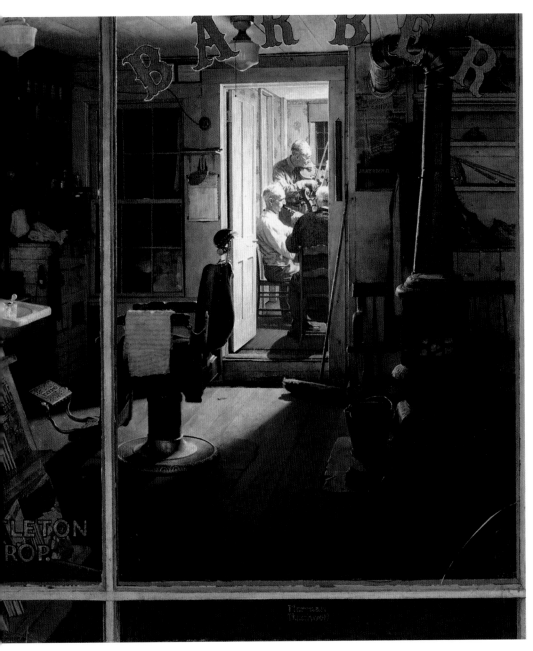

Norman Rockwell
Shuffleton's Barbershop
1950
Oil on canvas
46 ¼ x 43 in. (117.5 x 109.5 cm)
Berkshire Museum, Pittsfield,
MA. Printed by permission of
the Norman Rockwell Family
Agency. © 1950 The Norman
Rockwell Family Entities

Rockwell's composition pulls the
viewer from an outside stance
into the deep space of the card
game in the background. By
using dramatic light for the
background, Rockwell shows
the concept of focal point and
dominance. In this painting,
you really understand how the
outside edges of the rectangle
are taken into account to create
both deep and shallow space.
Through these visual devices,
Rockwell presents examples
of proportion, balance, variety,
harmony, and economy.

thm and Movement

r can be used to create visual **rhythm** in an image, as in Richmond
Ackam's *Red and Black* (p. 16), in which he uses different shades and
s of color to create a wave effect. **Simultaneous contrast** is another
of using color to create movement in an image. This phenomenon
rs when two complementary colors (colors opposite each other on
's color wheel—see p. 35), such as bright red opposite bright green
right blue opposite bright orange, are used to create an even brighter
tion. Comic book illustrations use this knowledge to dramatic ends. The
cing of these colors can create visual movement, as demonstrated in
Brown's *Self-portrait with Fish and Cat* at the beginning of this chapter.

Chapter 2:
Understanding Color
through Paint Mixing

In this chapter, we begin to examine color theory using the color wheel and a chromatic color chart, and we will create our own color wheels and charts using paint in order to explore color in a very practical way. This will introduce us to the process of color mixing and the application of paint to a prepared surface. Full-range color as a method of painting emphasizes a full-color palette right from the start of a piece of work. Learning to see color in all of its combinations, from the more obvious to the subtle, is the first step in painting from life. Later, when you begin your first painting from direct observation (see p. 70), you will

discover that your color choices soon become more nuanced and comprehensive as you become more skilled at representing the color in your subject matter.

Although it is possible to purchase a variety of color wheels and charts, constructing your own teaches you about color through trial and error. You will also learn how to prepare a palette, how to choose your preferred type of paint and medium, and how to mix your own paint colors. The color wheel and chart that you create here will help you in your observations and choices of color in the discussions throughout the rest of this book.

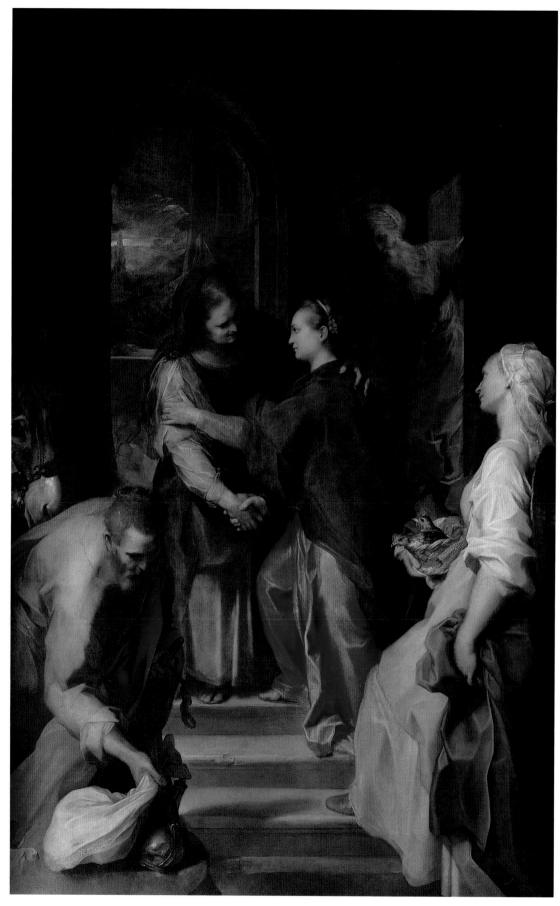

Federico Barocci
Visitation
1584–86
Oil on canvas
82 x 70 in. (208 x 180 cm)
Cappella Pozzomiglio, Santa
Maria in Vallicella, Rome

In the *Visitation*, warm primary colors form a
triangular shape in the foreground; darker, cooler
colors are used to render the background, allowing
it to recede from the foreground.

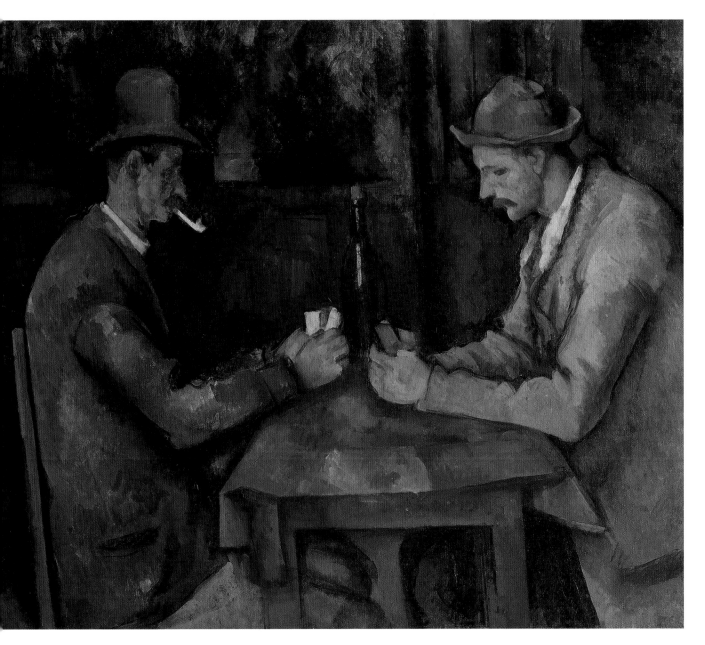

Paul Cézanne
Les Joueurs de Cartes
(The Card Players)
c. 1890–95
Oil on canvas
18 ¾ x 22 ½ in. (47.5 x 57 cm)
Musée d'Orsay, Paris

Cézanne's *The Card Players* illustrates the way in which warm and cool colors can be used to create a sense of composition. The warm colors appear to advance, while the cool colors seem to retreat into the background. This is an intimate study of a game being taken seriously; its warmth offsets the intensity of the subject matter.

Color Wheels and Chromatic Charts

Color wheels are systems designed to explain the behavior and propert[...] of color. In this book, we will use the color wheel system created by the Swiss artist and designer Johannes Itten (1888–1967); this is one of the most widely accepted of the color wheel systems and, in my experience[...] is the most intuitive (see p. 35). Using it, we will create one color wheel and one chromatic color chart.

Color wheels provide a way to compare and contrast color appeara[...] and to observe the effect of a given color on adjacent colors. Armed wit[...] this basic understanding, we can begin to view and examine color phenomena. Most beginning painters will have a tendency to think of color in limited ways: Apples are red, and lemons are yellow. But by doi[...] so, they are considering only local color—that is, color unaffected by li[...] and dark. It would be hard to imagine when that might occur. When I t[...] my students to paint all of the colors they see reflected in a pot, they fi[...] that the supposed gray or silver of the pot is actually comprised of all th[...] colors of the fruits in the still life, and there is no silver or gray as such.

In this chapter you will:
— prepare a palette for color mixing;
— choose either oil or acrylic paints and the appropriate mediums for each;
— mix your paints for making a color wheel;
— make a color wheel using paint with black and white tone and tint sections;
— make a chromatic color chart using paint;
— clean up and prepare for the next day's painting.

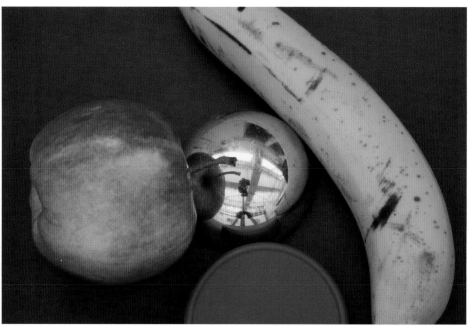

Images showing color reflected in a shiny object

If you were to paint a round, shiny object, such as a ball, with a bright red apple and a banana placed beside it, the ball would show colors reflected from the fruit (above).

If you changed the color of the surface that the fruit was placed on, you would get a different set of colors in the reflections (right).

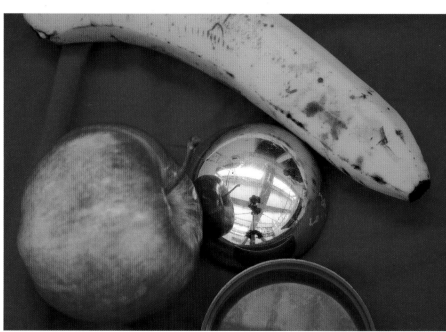

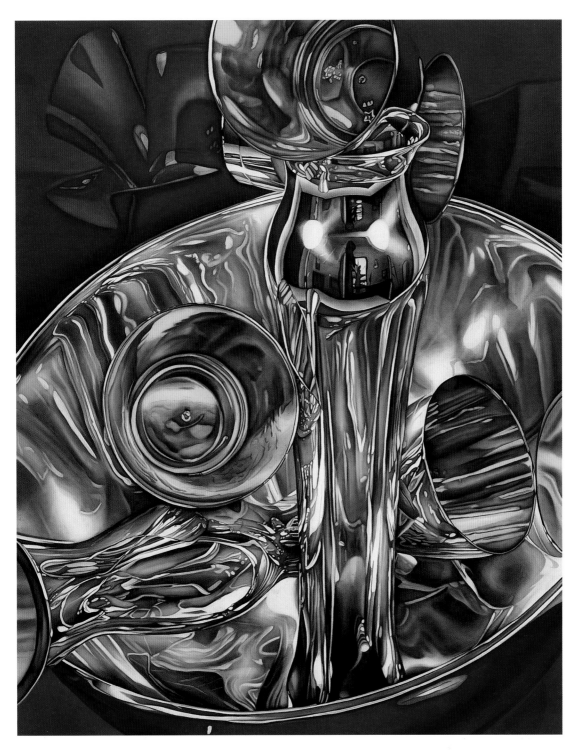

Jeanette Pasin Sloan
Balancing Act XIII
1999
Oil on linen
28 x 22 in. (71.1 x 55.9 cm)
Private collection

In this rich and varied painting by Jeanette Pasin Sloan, her choice of highly reflective surfaces, and therefore reflected color, results in imagery whose abstracted shapes create a sense of tension and the possibility of movement.

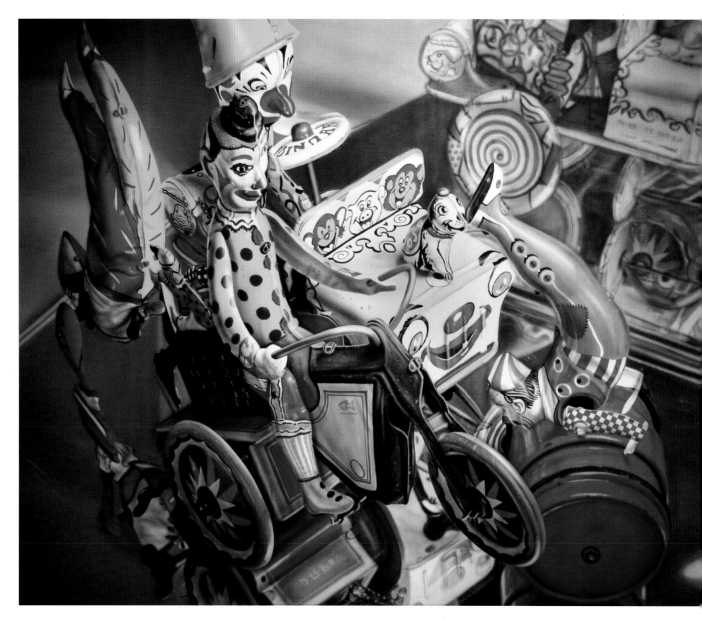

Cesar Santander
A Group of Performing Clowns
Date unknown
Acrylic on Masonite
24 x 30 in. (66.9 x 76.2 cm)
Gallery Henoch, New York

Cesar Santander combines strong color and rich value in his *A Group of Performing Clowns*. With heavy use of unmixed primary colors and chromatic grays, the muted colors of the walls and floor make the red, blue, and yellow colors seem brighter by comparison. It is the darker tones that create this contrast.

olor wheels also aid us in judging value, which is the relative lightness
rkness of a visual space. Value in color refers to the relative gradations
veen the darkest and the lightest tones, for example dark blue or pale
. The way we view color is relative and depends on adjacent colors.
r is not viewed in a vacuum. As we move through this book, you will
er understand the possibilities of color mixing.

he three primary colors that form the basis of the color wheel are
yellow, and blue. These three colors are taken straight from the tube,
use you cannot mix any other colors together to create them. When
mix pairs of the primary colors, three secondary colors are formed:
ge, green, and violet. When you mix each primary color and its adjacent
ndary color, you form the six intermediary colors. These colors are
orange, red-violet, yellow-green, yellow-orange, blue-green, and blue-
t. Together these twelve colors make up Itten's color wheel. Colors
osite each other on Itten's color wheel are known as complementary
s. At the end of this chapter, you will learn how to create a chromatic
t. This chart helps you to see how many complementary colors can
ixed to produce chromatic grays, rather than relying on the mixing
ack and white alone.

Once you have created your color wheels and chromatic charts, you
have a set of tools to refer to when you begin your first paintings. As
paint you will begin to see that generally the chromatic chart will be
most useful in terms of normal color usage. This is not to say that the
e primary colors are less prevalent; rather, variations of these three
s are harder to recognize at first.

Itten's color wheel
Johannes Itten's color wheel is
one of many color systems and is
widely used. The traditional color
wheel is usually round, but you
will see from the student examples
on the following pages that
different styles also work well.

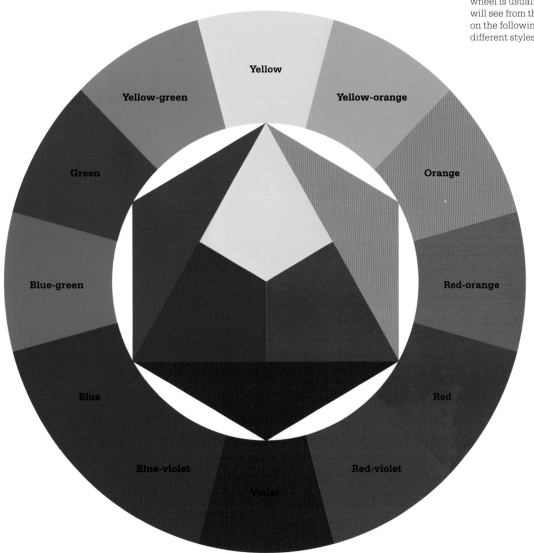

Yellow

Yellow-green · Yellow-orange

Green · Orange

Blue-green · Red-orange

Blue · Red

Blue-violet · Red-violet

Violet

Using Black and White

With a clear understanding of the ways in which they affect color, black and white can be quite useful. It is important to remember that there is also color in black and white objects—when you look at an object that think is black or white, try looking again more closely. Black, for example may be quite bluish in nature, while white may have more of a pinkish a yellowish tone. By adding white and black to the colors in Itten's chart you will learn how to work with tint and shade—tint being the addition of white and shade the addition of black. It is wise to be cautious to beg with, so as to not dull or muddy the colors.

Note that there are no bad color mixtures—just results that you mig not want to use at the moment. The term "muddy" generally refers to c that is unclear or has a grayish or brownish tone. Muddy color is simply a form of a chromatic neutral gray. (See pp. 50–53 for a discussion of chromatic grays.)

Color wheel painted by student Ashley Buzzy showing the results of tint and shade. The twelve colors of Itten's color wheel have been shaded (i.e., black added) in the inner circle, and tinted (i.e., white added) in the outer circle.

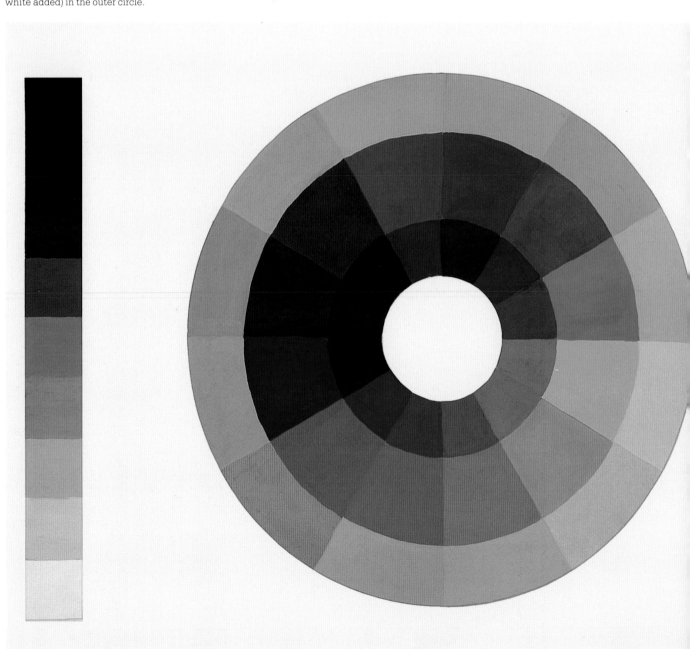

Understanding Color through Paint Mixing

Warm and Cool Colors

Generally speaking, the warm colors on the color wheel are yellow, yellow-orange, orange, orange-red, red, and red-violet. Used in a painting, such colors give the appearance of advancing forward, of coming out toward the viewer.

The cool colors are yellow-green, green, green-blue, blue, blue-violet, and violet. These colors appear to recede in a painting, away from the viewer.

Many different effects can be created by working with this temperature theory, combining warm and cool colors in subtle or less subtle ways. Refer to the color wheel to see the transition from the warm of yellow to the cool of violet, bearing in mind that there are also warm and cool shades within each color, such as warmer yellow and cooler yellow.

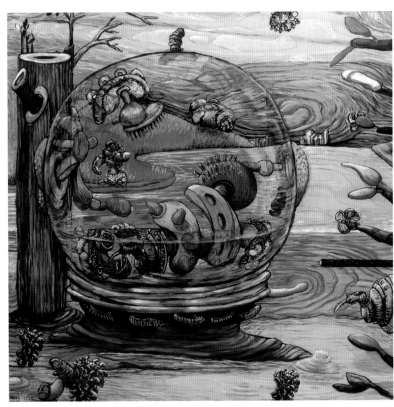

Sandy Winters
Devil's Haircut
2006
Oil and collage on wood
48 x 48 x 2 in. (122 x 122 x 5 cm)
Courtesy of George Adams Gallery, New York

In Sandy Winters' *Devil's Haircut*, we are treated to an imaginary world that is both contained and open. The outside environment of floating images reflected on the surface of the globe exaggerates the transparency and distortion that is created by the reflections from inside the globe.

Preparing a Paint Palette for Color Mixing

Materials:
— **11 x 16 in. (30 x 40 cm) glass [alternatives to glass: ceramic tray, paper palette pad, white butcher's wrapping paper]**
— **White paper**
— **Duct tape**
— **Firm piece of board or wood**

A palette is a flat surface on which to mix your colors. You will need to use a palette to mix your paint for all painting projects. The dimensions of your painting palette will generally be based on the size of the given area requiring paint coverage. For example, for a large landscape painting, you will need to mix larger amounts of color to fill the size of the canvas; for this, a large palette allows for more room. For the purpose of these charts, the size of your palette should be approximately 11 x 16 in. (30 x 40 cm). There is a variety of surfaces to choose from when selecting a palette: glass, a ceramic tray, a paper palette pad, or the inexpensive alternative of plain white butcher's wrapping paper. I prefer

glass, because of its smooth surface, which makes paint mixing relatively easy and cleanup fairly simple. I highly recommend the heavy-duty glass used for furniture tops, which is designed to be unbreakable with normal use.

Whichever surface you choose, you need to prepare it for use as a painting palette. Since the surface you are painting on will be white, you should have white as the color of your palette. If you are using glass there are two ways of achieving this: by painting the underside of the glass white, or by placing a sheet of white paper under it. You should then tape the glass down to a firm surface such as wood, being careful to tape over any sharp edges. Duct

tape is the best for this, given its flexibil. and ease of tearing; it also sticks well and generally does not lose its adhesive qualities if it comes into contact with wet paint.

Ceramic trays are both smooth and white, so serve well as palettes, the only drawback being the possibility of chipp the ceramic surface when using a paint scraper.

Paper palette pads, bound like draw pads with a cardboard backing, make good palettes since their waxy surface encourages the paint to stick, as does butcher's wrapping paper—a cheaper alternative that needs to be attached to a firm surface like cardboard.

4 Repeat this procedure on the opposite side, again placing a piece of duct tape on the front edge of the glass.

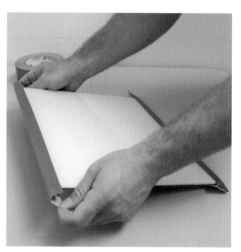

5 Fold the duct tape under all three layers.

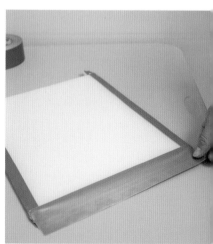

6 Lay duct tape on the edge of the front surface of the third side of the glass.

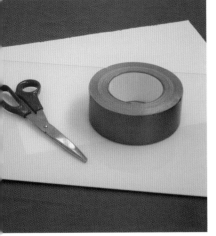

To prepare a glass palette, you will need scissors, duct tape, a white sheet of paper, and a firm piece of board or wood.

2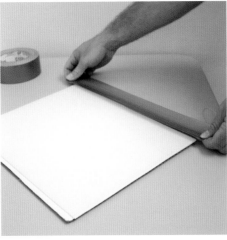

Place the white sheet of paper under the sheet of glass and attach to the board. Lay a strip of duct tape on the edge of the front surface of the glass.

3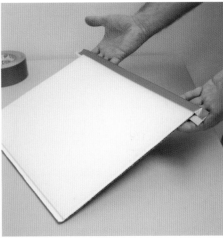

Take the duct tape and very carefully fold it under all three layers.

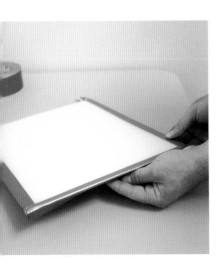

Fold this third piece of tape under all three layers.

8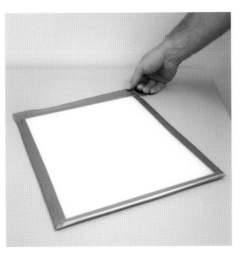

Follow the procedures above to complete the fourth and final side.

9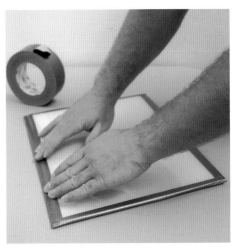

In this final step. make sure all sides are smooth and secured to all three layers.

Paint Preferences: Oil Paint or Acrylic?

With its long and rich history, oil paint is often perceived as preferable to or better than water-based media such as acrylic. Yet acrylic offers the painter choices and techniques that are not possible with traditional oil paint. In the end, the choice comes down to the desired style for your painting and the way in which you prefer to apply the paint. Where oil paint requires several measures to prepare the painting surface, acrylic paint can adhere to most surfaces with little or no preparation. Be sure to choose oil paint or acrylic paint: Never mix acrylics and oils together or use the same brushes for both types of paint.

Acrylic Paint

Acrylic paint is a water-based painting medium noted for its quick drying time. It uses an acrylic polymer emulsion as a binder. It creates a clear, strong, and flexible paint surface. It is waterproof once dry and not as toxic as oil paint, although it can never be considered totally nontoxic (see pp. 168–69). Acrylic paints adhere to most surfaces and the brushes clean up with water and soap (although once dry, the paint will not come off the brush completely). This ease of cleanup makes it attractive to many painters. Owing to its quick drying time, users can rapidly paint over sections and start again, and this, I believe, is the main drawback of acrylic for the beginning student—being able to abandon sections of a painting can quickly create a situation where painters do not learn from their mistakes.

Oil Paint

Oil paint is made with pigments that are ground and mixed in oil. Linseed oil has historically been used for this purpose, and is still used today along with other oils such as poppy seed, safflower, and walnut. Oil paint is slow-drying, dries with a hard film, and maintains its brightness of color. The lack of change after drying, together with the possibility of both transparency (allowing light to pass through a layer of paint so that other layers may be revealed) and opacity (resistance to light so that images cannot be seen through the layers of paint) in one painting, makes this medium highly desirable. Oil paint is my paint of preference, thanks to its smooth application and its slower drying time, which means that I do not have to worry about my palette drying out too fast while painting. However, many oil paint pigments are toxic, as are the solvents necessary to paint with and clean them. Therefore, there is always a slight risk attached to the use of oil paint, whether from ingestion, inhalation, or skin contact (see pp. 168–69).

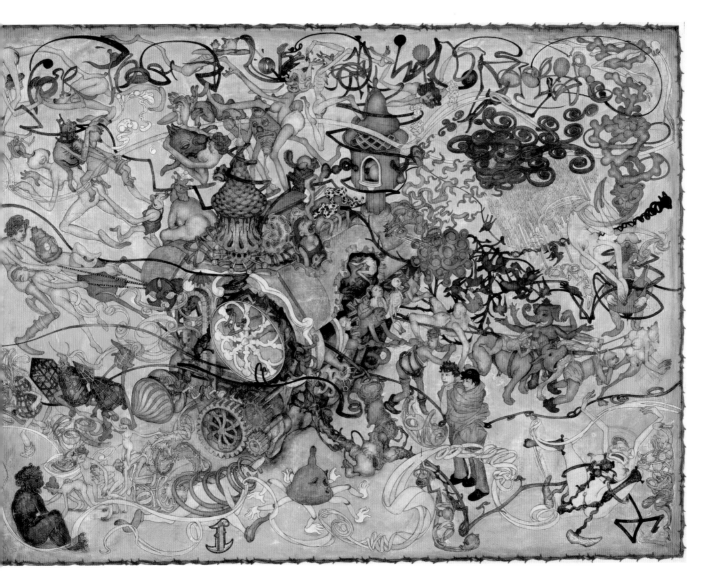

James Barsness
Engine
2005
Acrylic and ink on paper,
mounted on canvas
51 ¾ x 69 in. (129.5 x 175.5 cm)
Private collection. Courtesy
of George Adams Gallery,
New York

The figures within this imaginary world by
James Barsness are captured in a tableau of
entanglement, relentless movement, and color.
The colors consist mainly of warm hues, which
keep the narrative to the fore. The seductiveness
of this painting lies in the tension between its
sense of playfulness and the underlying intensity
of the spectacle. While the curvilinear shapes
guide you through the painting, its myriad details
are only absorbed after multiple viewings.

Painting Mediums

The function of painting mediums is to aid the spread of paint on a surface. They are mixed with the paint and used to control it and affect its behavior. Depending on their individual properties, mediums can change the gloss, the drying time, the level of transparency, and the consistency of the final film (layer of color) of the painting. Acrylic mediums come prepackaged, while oil painting mediums need to be mixed up from various ingredients by the artist.

Acrylic Painting Gel Mediums

Gloss medium: Adding this medium creates a shiny surface and can create a transparent effect if you allow one layer of color to dry, coat the medium over it, then repeat this process with another color.

Matte medium: This helps in the spread and flow of the paint on the painting surface and leaves a neutral, flat appearance.

Masking fluid: This clear fluid is painted over specific, dried areas of a painting in progress to protect them from colors being applied in another area. When the new section of the painting is dry, the masking fluid can be removed to reveal an untouched area. This method is often used for highly detailed work.

Retarder: This is added to acrylic paint to slow down the drying time.

Oil Painting Mediums

Oil painting mediums help the flow of the paint by lessening the drag of the brush, and they also speed up the drying time. I recommend using a medium consisting of one part cold-pressed linseed oil, one part linseed oil, one part stand oil, and one part gum turpentine. You can use odorless turpentine, which has similar properties, as an alternative to gum turpentine, but for the purist, gum turpentine is a must; I have used both to good result.

Liquin: "Liquin" is the trade name for a Winsor Newton product that I will use here, but other companies have similar products—Galkyd, for example, which is made by Gamblin Artists Oil Colors. The addition of Liquin helps to create a smooth, glossy surface and to thicken oil paint. Mix a single drop into each of the individual mixed colors of paint on your palette just before applying to the painting surface. Liquin is also a paint drier, so keep in mind that you should not use too much, as you do not want your colors to dry out over the course of a painting session. This is true for both the beginner and the more experienced painter. If your paints dry out too soon on the palette, you will need to mix a new set and try to match the original colors.

a Abad
ernity Ago

crylic, printed paper, and
collaged on handmade

7 ½ in. (135 x 70 cm)
4 Pacita Abad Art

ernity Ago takes the basic
of the circle and combines
a dizzying array of colors
atterns, producing a rich
try. The variety of mediums
urfaces that Pacita Abad
compounds this feeling of
ment and detail.

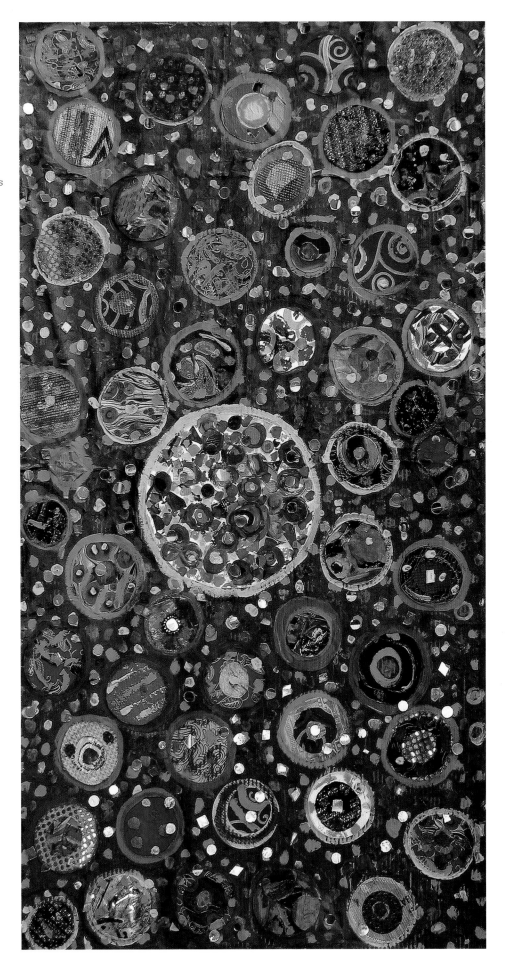

Tools and equipment

— Gesso hardboard panels (we will use the
 more permanent board so that we have
 a handy and sturdy reference tool), or
 firm cardboard or any other flat surface
— Chalk pastel pencil or chalk
— Circle compass, 10-in. (25-cm) diameter
 capacity (the compass will be used only
 if your wheel requires perfect circles;
 other designs may be used instead)
— Filbert brush
— Palette
— Palette knife
— Cotton rags
— Brush-cleaning containers
— Palette cups
— Plastic plant mister filled with water
 (for use with acrylic paints only)

Paint colors

— Cadmium yellow light
— Permanent red
— Ultramarine blue deep
— Titanium white
— Black

Making Your Color Wheel

Finally, we begin working with paint, as we prepare a painting palett
to create a color wheel.

The colors listed to the left make up a palette of the three primary
colors that can be mixed together to form all the other colors on the co
wheel, plus black and white. The color wheel you will create is based
Itten's color wheel. You will add a shade using black and a tint using w
This will enable you to understand the effects of black and white on co

You will find that different paint manufacturers will use different
names for each color, and so you may need to search through the pain
supplied by several manufacturers to find the colors you want.

Instructions

Begin with an 11 x 14-in. (28 x 35-cm) gesso board, which can be purcha
with gesso already painted on the board. Using a light-colored chalk p
pencil and a compass, draw a circle and divide it into twelve equal par
(Alternatively, you can choose to make a different design, but you will
need to start with twelve equal parts. See the examples on pp. 46–47.)
The shape of these sections may follow any design you choose, though
is best to draw each section with the same shape. You may choose to u
as large a circle as the dimensions of the board allow or one that is sma
(Remember to save some space in your design, both inside and out, so
that you can use the black paint to shade your twelve colors and the w
to tint them.) Using a filbert brush (see p. 86), your aim is to paint each
section on your wheel with these colors in this order, moving counter-
clockwise: yellow, yellow-green, green, blue-green, blue, purple-blue,
purple, red-purple, red, red-orange, orange, and orange-yellow.

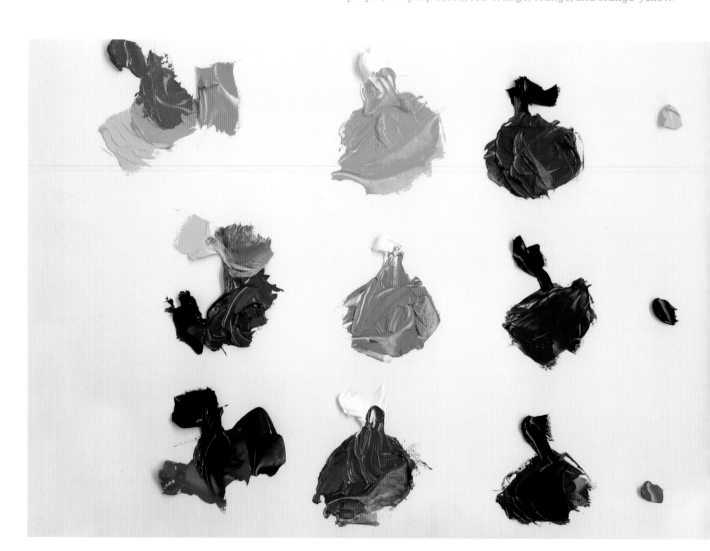

sing your choice of either oil or acrylic paints (see p. 40), mix your
s on your palette (see pp. 38–39 for palette preparation). You will
to mix enough paint for both the color wheel and the tint—these
ls will only be successful if you mix enough paint to have the same
ires each time.

art by squeezing out approximately a 3-in. (7.5-cm) wide and 1-in.
m) deep amount of paint from the red, yellow, and blue tubes. Place
colors about 2 in. (5 cm) apart from each other on the palette. These
ie three primary colors and should come directly from the tube: You
ot mix any other colors to make these three. Using your palette knife,
ogether the yellow with the blue (see pp. 48–49). The result will be
i. The tone of the green will depend on how much of each color has
applied. Yellow is the lighter color: More of it will lighten the green.
ersely, more of the blue will make it darker. For the purpose of these
.s, a deep green leaf color will work the best. Using the same steps,
ed and yellow to make orange. The best orange color to aim for would
mewhere between an orange and a pumpkin. Finally, mix red and
.to get violet. Violet is the trickiest to mix and may take more time.
ou have now created your secondary colors. You may find that you are
ble to make these mixtures at first try, but you should continue to mix
ent proportions until you have the colors you need.

ow, using the secondary colors of orange, violet, and green, you will
e the intermediary colors, which are created by combining a primary
a secondary color, using the same steps as described above.

often have my color students take notes about the paint colors and
ortions they have used on the color swatches they make, which
.es what I call a color diary. Repeated attempts to achieve the desired
should not be cause for concern: They are not mistakes, but rather
tice exercises. The finished result makes up your twelve-step chart
.mary, secondary, and intermediary colors.

Opposite below
The colors mixed here were created using red,
yellow, and blue.
The left examples on each row show a mixture
of two colors before white and black is added. Top
row far left shows red and yellow mixed to create
orange; second row shows blue and yellow mixed
to create green; final row shows blue and red
mixed together to create violet.The middle
examples in each row were tinted with white paint,
and the right-hand examples were shaded with
black paint.

Below
Table showing how the three secondary colors
(green, violet, orange) mixed with the three
primary colors (yellow, blue, red) combine to form
intermediary colors.

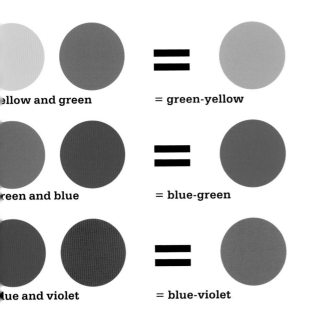

ellow and green **= green-yellow**

reen and blue **= blue-green**

lue and violet **= blue-violet**

4. violet and red **= red-violet**

5. red and orange **= red-orange**

6. orange and yellow **= yellow-orange**

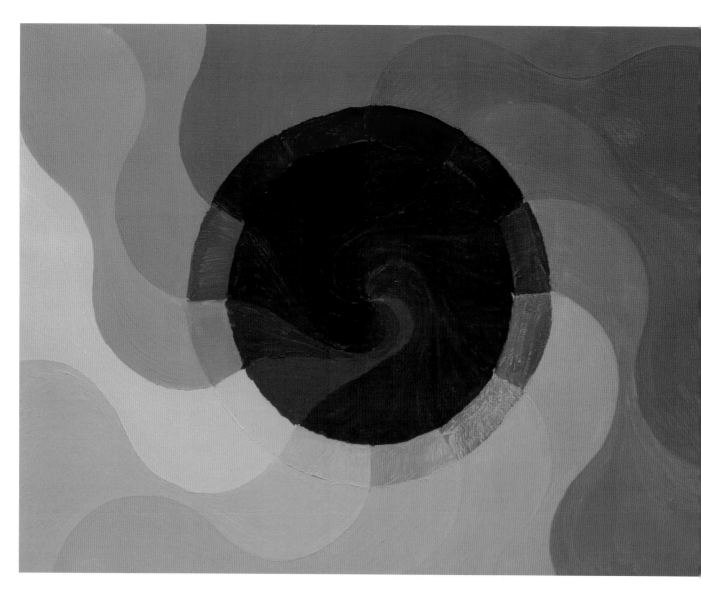

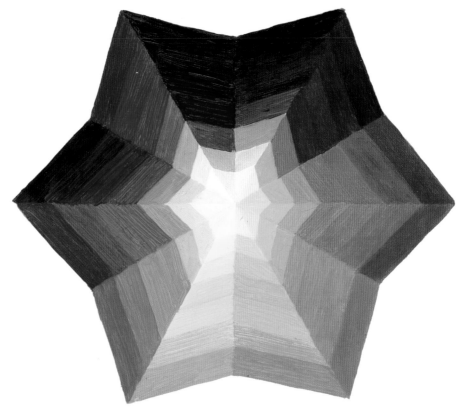

Understanding Color through Paint Mixing

s the examples show, you may be as creative as you like in your
t. Whatever shapes you choose to use, they should be clear to you. As
nake your charts, you should ensure that the color is carefully mixed
at the chart can be used as a tool as well as a visually pleasing wheel.
hen you have completed your color wheel, you should clean up your
te and your brushes, in preparation for your next painting session
op. 56–57).

hing Brushes During a Painting Session

hes may be cleaned over the period of a painting session as needed.
s not to be confused with the final cleanup with soap and water
op. 56–57). Work with at least three separate brush-cleaning jars.
etter to clean brushes of similar paint tones in the same jar during a
ing session. With oil paint, swishing the brush in the brush-cleaning
orks well enough. Acrylic paint must never be allowed to dry on the
n, so you must clean it off with water as you go along. It is good idea
ve several brushes to work with, as the bristles get saturated over the
e of a painting session and tend to dilute the paint more toward the end.

Opposite above
Student David Zoellick's color wheel is an
inventive take on the circle, where the swirling
darker shades merge into the center of the wheel.

Opposite below
Star-shaped color wheel created by student
Kimberley Perry. This design clearly shows the
effects of the white tint on the inside star and
the black shade on the outer edges.

Below
This color chart by student Krista Franks is a very
nontraditional take on the color wheel, but no less
effective as a result. She has her twelve colors
in the center line slightly larger than the others,
with the effects of the white tint going from the
center to the bottom, and the effects of the black
shade from the center to the top.

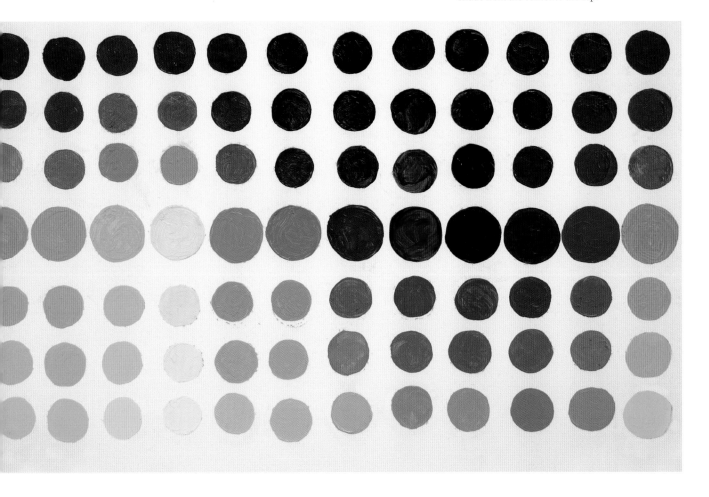

Color Mixing: Oils and Acrylics

Materials:
— **Tubes of paint**
— **Palette**
— **Palette knife**
— **Painting mediums for oil**
— **Painting gel gloss medium for acrylic**

Arrange your paints and painting mediums. Your painting mediums should be placed in containers similar to shampoo bottles—plastic containers with tops. This protects the medium from getting dirty and muddying the colors. You can also use anything left over later.

Squeeze out enough paint for the day's

task from your paint tubes. Lay out you[r] palette with your colors on the left-han[d] side if you are right-handed and the reverse if you are left-handed. You will find it easier to mix your colors if you d[o] not try to mix them straight from the t[u]... Place these colors about 2 in. (5 cm) apa[rt] from each other on the palette.

1 Squeeze out some yellow oil paint from the tube to the palette.

2 Squeeze out a similar amount of red oil paint from the tube to the palette.

3 Using your palette knife, move a sm[all] amount of yellow paint over to the c[other] side of the palette.

7 Using a sideways motion with the flat bottom of the palette knife, as if you were decorating a birthday cake, begin to mix the yellow and red together.

8 Once all the streaks are gone and a solid color remains, see whether this is the color you want. If you need to add more color, repeat the procedure.

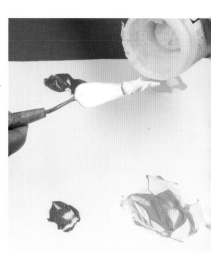

9 If using acrylic paint, add some acry[lic] gel gloss medium to the newly mixe[d] orange paint.

Controlling the Drying Time of Acrylic Paints

Acrylic paint dries rather rapidly as the water evaporates from the paint, and so may present more challenges than oils. As with oil paints, there is first a drying time, when the paint feels dry to the touch, and then a curing time, during which it dries fully. Hot, moist environments will slow down the drying time of both acrylic and oil, although the effect is more marked with acrylic. A hot and dry or windy environment will speed up the drying time.

For acrylic paints, there are products on the market you can apply while the paint is still wet to slow the drying time considerably, such as retarders. Spraying water periodically over your palette using a plant mister will also slow down the drying time. A note of caution: Too much water will dilute the chroma (brilliance of color) or the hide (covering ability) of the paint, causing acrylic paint to perform more like transparent watercolor.

During the mixing, stop and wipe your palette knife. This will help you to control the color. As you are mixing, keep track of the changing color.

5 Scrape up a little of the red paint that you wish to mix in.

6 Place the red color on top of the yellow.

Mix the acrylic gel medium into the orange paint.

11 If using oil paint, add a drop of Liquin to the orange to speed up the drying time and give it a glossy look.

12 Mix the Liquin into the mixed orange paint.

Making Your Chromatic Chart

Tools and equipment
— Gesso hardboard panels or firm
 cardboard or any other flat surface
 (we will use the more permanent board
 as a handy and sturdy reference tool)
— Chalk pastel pencil or chalk
— Filbert brush
— Palette knife
— Cotton rags
— Brush-cleaning containers
— Palette cups
— Plastic plant mister (for use with acrylic
 paints only)

Paint colors
— Cadmium yellow light
— Permanent red
— Ultramarine blue deep

The colors listed above comprise the three
primary colors that can be mixed together
to form all the other colors on the chromatic
color chart. Painting mediums will not be
necessary for the color chart.

In the earlier discussion, you learned how to use white for tinting and b
for shading (see p. 44). When students begin to think of how to create t
color gray to add value (relative lightness or darkness), what immediat
comes to mind is some combination of black and white. Yet it is import
to remember that color is to be found everywhere within our environm
It may not be that bright and unadulterated color you find in color whe
but it is a form of color nonetheless. When students rely solely on black
white for their gray tone when creating value, they end up with a mor
chromatic gray, when in fact gray contains color, just as we saw that b
and white do earlier. Using monochromatic gray would be no different
example, from painting an apple using red and adding white to make
lighter and black to make it darker: The painting would appear indisti
chalky, and rather dull; the color would not look natural.

To create grays that contain color, we mix together the complemen
(the colors directly opposite each other on the color wheel). The gray t
achieved in this way are called chromatic neutrals. Now that we have
finished the first step of creating a color wheel, we can use the twelve
colors to make a chromatic chart. Think of the chromatic chart as a se
of grays created with color from the color wheel.

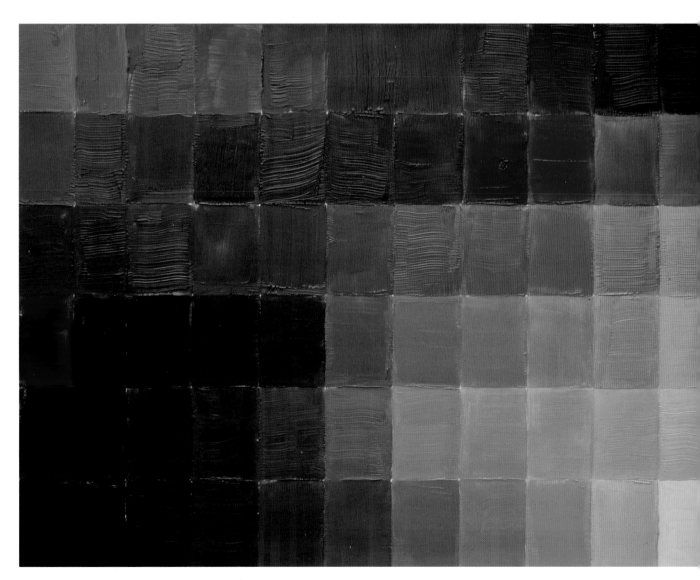

How to Make a Chromatic Gray

In these first three steps you will see how to make a chromatic gray using red and green—complementary colors on the color wheel. Place green paint onto the red.

2 Mix the green paint into the red with your palette knife.

3 Here is the result: a chromatic gray formed by mixing red and green.

How to Make a Monochromatic Gray

A monochromatic gray is formed by the addition of black and white (instead of mixing complementary colors, as in the three steps above). Add black paint to your red.

2 Next, add white paint to the black and red mixture, and mix up with the palette knife.

3 As you can see, this monochromatic gray mixture you have created (bottom) is very different from the chromatic gray color (top).

site
s chart by Zeke Paull, the paint strokes are evident, yet the chart is still very effective. one decides to place paint on the surface nes a personal choice after exposure to a y of painting techniques.

Instructions

You can use many different designs for chromatic charts, but in order to paint the design below, take a chalk pastel pencil and start by drawing grid with six columns and twelve rows. Then, using either oil or acrylic paints, follow the instructions for mixing your paints on pp. 48–49 (for reasons that will become clear, please make plenty of each of the colors mixed to obtain your color wheel, see pp. 44–45). Paint the following co in the following order across the top row of the grid, starting at the left:

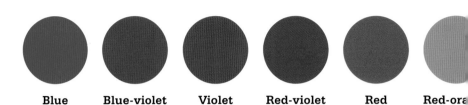

Blue **Blue-violet** **Violet** **Red-violet** **Red** **Red-ora**

Next paint the following colors in the following order across the bottom row of your grid, starting at the left:

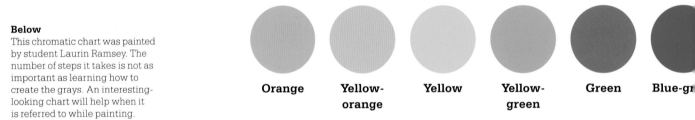

Orange **Yellow-orange** **Yellow** **Yellow-green** **Green** **Blue-gr**

Below
This chromatic chart was painted by student Laurin Ramsey. The number of steps it takes is not as important as learning how to create the grays. An interesting-looking chart will help when it is referred to while painting.

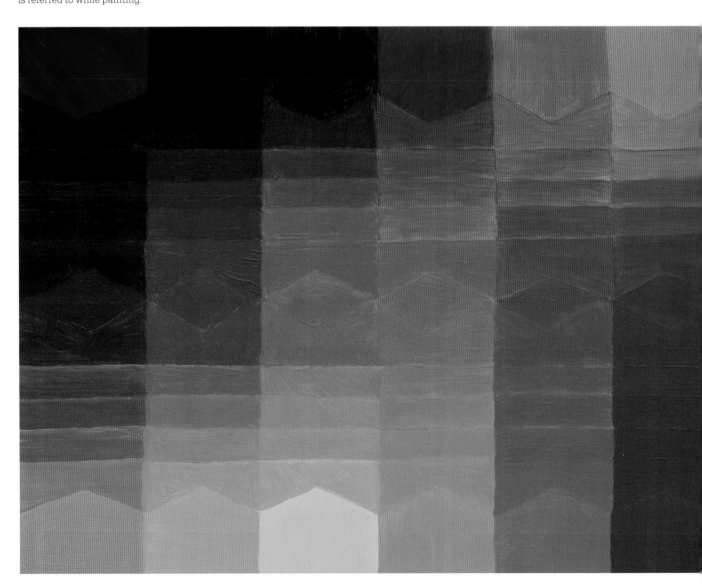

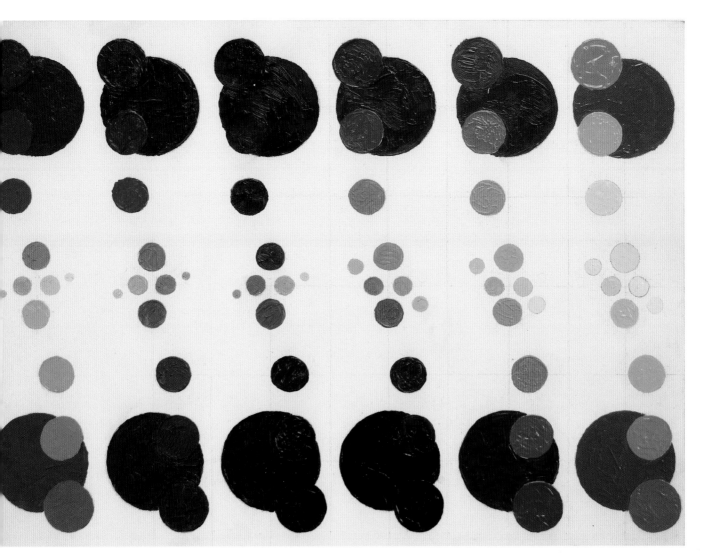

You will then complete this chart by mixing the two colors that face
[e]ach other across a column into the intervening cells. Let us take, for
[exa]mple, the fifth column from the left, where you have red at the top and
[gree]n on the bottom. Move some red down into the second row of that
[colu]mn, then mix in green taken from the bottom. Do the same for the
[lowe]r end—move some green up from the lowest row into the cell above
[and] mix in some red. Continue to add red to the green shades at the
[bott]om moving up, and likewise, green to the red color down from the top,
[work]ing together into the center of the column. Gradually, you will end up
[with] a chromatic neutral color in the middle. As you aim for the most
[neut]ral tone, notice the color bias (the emphasis of one color over another
[dep]ending on the amounts of color added while mixing). The resulting
[color]s will not be those of black and white but, rather, chromatic gray hues.
[In] six steps, as in this example of a chromatic chart, you end up with
[fair]ly colorful gray. When done in only three steps, the gray would be
[extr]emely colorful, whereas in ten steps or more, you end up with colors
[that] have much less chroma (brilliance of color). Of course, you do not need
[to u]se a grid of squares. You can choose any format you like, as you can see
[in] the other examples shown.

[W]hen you have completed your chromatic chart, you should clean up
[your] palette and your brushes, ready for your next painting session
[(see] pp. 56–57).

Above
The results of student Alexander
Shute's assignment were
unplanned but very instructive.
By allowing some of his colors
to sit on top of others, he has
discovered one of the hardest
things for new students to
understand: that color is relative.
As you can see with the top
yellow—when it is placed on the
green-yellow it appears very
bright, yet on the white board it
takes on a different tone.

General Painting Supplies

When buying your painting supplies, it is important to have the best quality within your budget. Student-grade art supplies are cheaper, but should be augmented with professional-grade wherever possible. It is worth buying professional-grade versions of your three primary colors; you can always then mix these with various grades of secondary colors. Although Internet shopping is invariably the cheapest option and provides the greatest variety, I encourage my students to shop locally and try to support the merchants in town when possible. In terms of hardware—hammers, staplers, and drills—there is no valid reason to go cheap here. Go to a hardware store and ask questions. You must not skimp on safety.

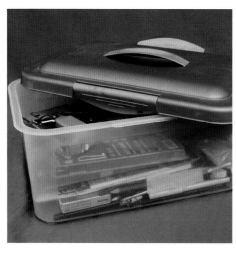

Tackle box: An essential storage and carrying case, tackle boxes are inexpensive, usually plastic with a handle, and can be purchased with either one or two compartments.

Paint tube squeezer: This handy tool will literally push out every last drop of paint from a tube. A less effective but cheaper alternative would be a metal or wooden dowel.

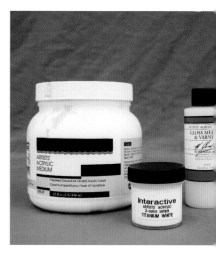

Gesso and acrylic mediums: Gesso—used to p[...] most painting surfaces—is least expensive wh[...] purchased in large containers as shown here. Acrylic mediums can be found in every art sho[...]

Glass palette: A properly prepared glass palette provides one of the best surfaces on which to mix paint. The duct tape serves the dual purpose of covering the sharp edges of the glass and taping to it a sheet of white paper and a firm surface (see pp. 38–39).

Circle compass: If used carefully, the compass will give you a perfect circle and is essential for creating a color wheel.

Plant mister: For those choosing to work in acr[...] or other water-based media, the mister will ke[...] your palette moist. It also helps to shrink a loos[...] canvas to a more taut stretch.

...inting mediums: As in so many art products, ...ill find the larger containers will be much ...per in the long run than the tiny jars that tend ...pushed in art stores.

Pastel sticks and pencils: Using a light-colored pastel pencil (above) or stick (top) for preliminary sketching is preferable to lead pencil as it mixes easily with the oil of acrylic paint. You will need a dark enough color to be legible.

Palette knife: This invaluable tool should be chosen carefully. This example shows the blade in a stair-step fashion that keeps your hands out of the paint. The handle is generally made of wood (plastic-handled versions are cheaper but not recommended).

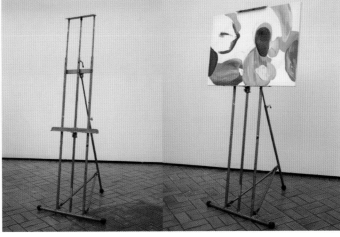

...ared gesso hardboard panels: These work ...or small paintings and color wheels; they are ...rimed and require nothing more than perhaps ...t sanding to give them extra tooth.

Easel: This metal adjustable easel has the advantage over wood in terms of durability and weight. It will take a large-size painting and adjusts from both ends. As you can see from the right-hand example (painting by Zeke Paull), the easel allows for the height of the individual artist—you need not bend or reach if you adjust it properly.

Cleanup and Preparation for the Next Day's Painting

Materials:
—Tubes of paint
—Painting mediums
—Plastic containers with tops
—Palette knife
—Palette
—Liquin

There are many ways to save paint that you have mixed on your palette for the next day's work. The palette cup can be used to collect and save paint. Another inexpensive alternative is to leave the paint on the palette and cover it: Before covering it, use a paint scraper to remove all the paint that has dried out and perhaps mix together any patches of paint that are very small, as paint tends to dry more quickly in smaller amounts. You will find that the random leftover colors end up being used for something. After you have separated your colors, you can put baby-food jars over each patch, or you can put plastic wrap over the whole palette.

Alternatively, if you wish to clean up the palette completely, it is much easier to do so while the paint is still wet, when you can simply rub it off with a cotton rag. Once the paint becomes tacky or dried out, a paint scraper is required.

To clean your brushes, use a paintbrush-cleaning container filled with odorless turpentine for oils or plain water for acrylic to remove excess paint before washing each brush in warm soapy water. You can make such a container from a glass jar by placing a piece of metal or plastic screen (similar to what you find on a screen door) near the bottom, about two fingers up. This protects the brush from going into the mix of old paint and solvent.

Palette cups have airtight tops to preserve paint.

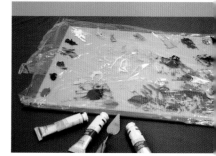

A palette scraper is invaluable for cleaing glas

Overturned jars are another simple, cheap method of protecting your premixed paints on the palette.

Clear plastic wrap has the advantage of cover all the paints at once, with minimal expense.

After soaking brushes (see opposite), wash them thoroughly with soap and warm water.

Although it may not look as though you need t extra soapy water rinse with acrylic paint, squ the brushes to remove any stubborn remainde

:are of Brushes

ever leave your brushes in the cleaning r with the brush facing down. This will 2nd and ruin your brushes. If for some 2ason you need to soak them, make sure they are elevated, not resting against 1e bottom, with just the bristles in 1e solution.

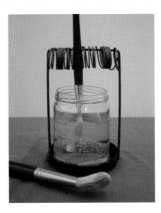

Example of a damaged brush allowed to sit in jar of turpentine, alongside the proper way to suspend a brush in a cleaning solution.

you have cleaned your brushes with less turpentine, you must wash them with soap under warm running water. will take off the oil paint and solvents, h break down the brushes over time. lic brushes should also be washed out soap under warm running water. another way to clean your brushes is to oaby oil, which is nontoxic and can be to wash both your hands and your brushes. Generally I put the baby oil on the brush and rub my finger through, using a cotton cloth to clean off the excess. Afterward, you should use warm, soapy water to get the oil out, as described above, and then wipe it on a clean cotton rag.

After washing your brushes, it is a good idea to wrap them part in newsprint to help them keep their shape. If you can be this disciplined, your brushes will last for years.

The next time you prepare to start painting, take all of the old turpentine and old paint sludge that has settled to the bottom of your glass jars and pour off the clearish mixture into a new jar to be reused. By reusing your turpentine, you will save money. With acrylic paints, simply use new water.

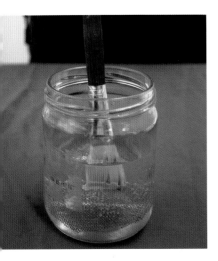

n acrylic paint from a brush using clean water soap.

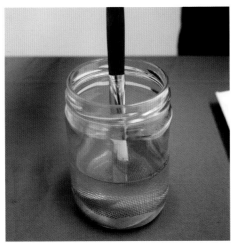

Clean oil paint from a brush by placing it into a container of turpentine. The mesh inside here (and in the previous image) is to prevent your brush from mixing with old paint and solvents that may gather at the bottom of the jar.

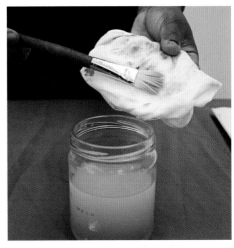

Dry all your brushes with a clean cotton cloth.

Chapter 3:
First Painting:
Wet on Wet

In this book, we will look at three basic methods of painting: wet on wet (alla prima painting), wet on dry and scumbling, and Venetian painting in layers. This is not an exhaustive list of painting techniques, but rather something with which the new painter can begin. It is not unusual for all three methods to be combined in one painting.

For our first painting, we will use the wet on wet, or alla prima, method. This is a rapid style of painting in which the paints are first mixed on the palette and further colors are then created on the painting surface by mixing the wet colors together. With this technique, there is only one layer of paint. It uses full-range color and is often completed in one session, working with wet paint blending into wet paint. A whole painting, or a section of a longer project, can be completed from start to finish in a single day.

First, however, we need a painting surface. Unlike the preprepared gesso board we used in the color wheel projects, we will now prepare and prime our own surface for painting.

Amer Kobaslija
Con Te Partiro
(Time to Say Goodbye)
2006
Oil on panel, diptych
74 ¼ x 85 ⅞ in. (188.6 x 218.4 cm)
George Adams Gallery,
New York

Kobaslija's painting of his studio is a glimpse i[n]
the working life of an artist. He provides us wit[h]
a personal point-of-view that is over his should[er]
and into the room. The life-size scale adds to th[e]
feeling of intimacy.

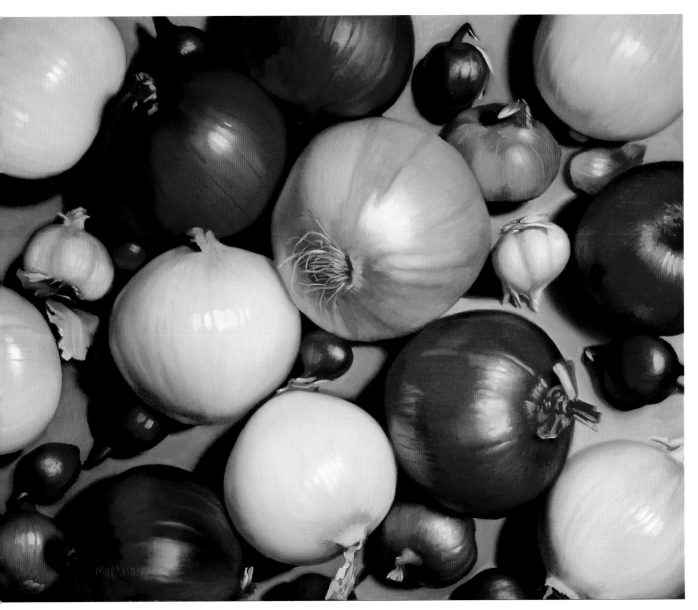

Margaret Morrison
Onions
2005
Oil on canvas
24 x 30 in. (60.9 x 76.2 cm)
Courtesy of the artist and the
Woodward Gallery, New York

Margaret Morrison's "portraits" of or "odes" to onions take the subject matter out of a limited set of perceptions. This still life is rich in color and depends on the dramatic use of the chiaroscuro technique (see pp. 78–79) to create a sense of volume and immediacy. It is this kind of still life that we are going to try in this chapter.

Painting Support and Canvas Preparation

In this section you will:
— **assemble your premade
 stretcher bars;**
— **stretch your canvas;**
— **prime your canvas with gesso.**

**Alternatively, you can use preprepared
canvas or wooden panels.**

Artists can, and do, paint on a variety of surfaces, limited only by wha
paint will adhere to. The beginning painter has at his or her disposal t
firm yet flexible stretched canvas—a woven material stretched over a
wooden frame until it is taut enough to paint on. Professional artists m
use prepared wooden panels, metal, glass, and any flat surface that m
the needs of their imagery. Historically, wood panels were some of the
first firm, transportable surfaces used for painting. Over the years, I ha
painted on both canvas and wooden panels to good effect. The choice
a painting surface is a decision based on experience and preference. E
of application is usually at the top of the list. For example, a surface wi
tooth (that is, a surface with a slightly rough texture) creates what we
call a drag on the brush, which simply means that the brush has to mc
over a slightly uneven surface. The downside of too much tooth is that
requires the painter to load up the brush with paint more often. There
right or wrong surface, just one that works for the individual. In this bc
our aim will be to create a smooth surface, and we will concentrate on
wooden stretchers with canvas and wood panels.

For ease and speed, we will start with premade stretcher bars and
proceed to prepare them with the gesso ground; priming a canvas wit
gesso creates a uniform surface for acrylic or oil paint. If, on the other
hand, you would rather make your own stretcher bars, see pp. 68–69 f
a demonstration of stretcher building using lumber and cutting tools.

Kelly Smith
Mixed media on Masonite

Kelly Smith's abstract painting
combines a variety of mixed
media to create both tactile
and illusory texture. The red
swirling lines moving upward
are created using a shiny red
fabric. The yellow and orange
round-shaped tops are slightly
warmer in tone than the red,
which has a bit of purple in its
mixture, thereby making it
cooler. As a rule, warm colors
move forward, so the yellow tops
seem closer to the viewer. It is
this combination that makes for
an exciting composition.

Wood Panel Preparation

Materials:
— Wood panels
— Sandpaper
— Gesso
— Lumber for framing
— Wood glue
— C-clamps

nting on wood has a long tradition
l is every bit as common as canvas
etched on a frame. In some cases,
ists prefer to stretch the canvas to
ooden panel, as this gives a firm
face to paint on. If you follow this
thod, you need to prime the surface
h gesso in a similar fashion to
way in which you apply it to the
etched canvas (see pp. 66–67).
I prefer to put the gesso directly
sanded wood, rather than applying
vas on top, to provide a smooth,
n surface. Wooden panels are
erally about 1 in. (2.5 cm) thick,
l it is a good idea to attach a frame
he back of the board to prevent the
od from warping. You can easily
ke a frame using wood glue and
lamps.
When applying the gesso, I use
ee to five coats. Careful sanding in
ween each coat makes the wood
re uniform and adds tooth so that
gesso adheres better.
The choice of surfaces is down to
sonal preference. Wood panels
be purchased inexpensively at
dware stores or can also often be
nd discarded at construction sites.
ther inexpensive alternative is
pered Masonite ("hardboard" in
UK). The tempering of Masonite
olves a process that infuses oil into
board to make it water-resistant.
ve found that tempered Masonite,
h its dark brown coloring and
pery smooth surface, is much more

Primed and nonprimed boards:
It is not an absolute rule that
you must paint on primed wood,
but for ease of application
without the paint seeping into
the surface, priming is superior.
Some artists consider the boxlike
quality to be reminiscent of
religious three-dimensional icons.

You can see the frame in this
back view of a wooden panel.
The purpose of this frame is to
support the ½-in. (1.27-cm)
panel so that it does not warp.

tedious to prime than other wood.
If choosing Masonite, it is a good idea
to attach wooden support beams
to the back to prevent too much
flexibility (see p. 69 for stretcher
support beams).

Stretching the Canvas on a Stretcher Frame

Materials:
— Unprimed linen canvas or
 unprimed cotton duck canvas
— Measuring tape
— Scissors
— Lightweight staple gun
— Mirror

Now that the stretcher is prepared, we will proceed to stretch the canvas. The finest canvas is unprimed linen canvas. The uneven weave of this canvas is considered by most artists to produce a far superior surface quality than the more even, machine-woven regularity of cotton duck canvas. Unfortunately, the cost is prohibitive, but more economical alternatives can be found; I recommend unprimed heavyweight cotton duck, which is relatively inexpensive and almost indistinguishable from the linen variety. Another practical advantage of unprimed cotton duck is that stretching pliers are not required.

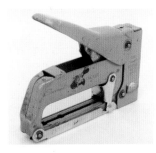

Staple gun: Make sure that you can squeeze with one hand. If you require two hands, you cannot hold the canvas to control the stretch.

Cotton duck canvas: Popular with students thanks to its low cost, compared with fine linen. Over the years, it has also become quite acceptable in professional painting situations.

Fine linen canvas: Good quality but costly. It still requires preparation with gesso and sanding, but can be purchased already primed and will require the use of the canvas pliers due to the rigidity caused by the primer (see p. 67).

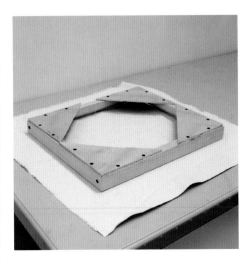

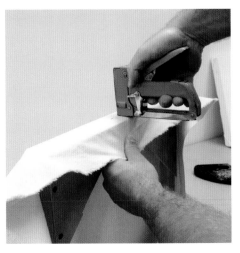

1 **Measuring the canvas**
Your canvas can be purchased cut to size or by the roll, which is much cheaper over the long run. The most important part in stretching is making sure you have enough canvas to cover the surface of the frame with some extra overhang for gripping. To achieve this, it is advisable to leave at least 5 in. (13 cm) overhang of material on every side of the stretcher. So if, for example, your stretcher size is 24 x 36 in. (60 x 90 cm), your piece of canvas would need to measure at least 29 x 41 in. (73 x 103 cm).

Once you have cut the canvas to size, lay the stretcher frame on the floor or a table. You will need to lay the canvas over the stretcher bars to make sure it is centered, with an even amount of the canvas hanging over each side. Take hold of the stretcher bars and the top edge of the canvas and stand them up.

2 **Starting to staple**
Pull the canvas over the stretcher bars toward you, with the painting surface facing away from you. Using a staple gun, place one or two staples directly in the middle of the top side of the stretcher. It does not matter which side you start on. Then go directly to the opposite side from where you started on the stretcher and repeat the same procedure, pulling it a little tighter before you place the staple. Rotate the stretcher and repeat the process on the remaining two sides. Always pull the opposite side a little tighter.

3 **Pulling the canvas taut**
If you have pulled the canvas equ tight on all four sides, you will r have a slight diamond shape forming on the fro of the canvas. Turn the canvas upright so that can both pull and stretch the canvas with your hands. Working in a clockwise fashion around four sides of the stretchers, place one or two sta on each the side of the canvas, next to the orig staple, and keep pulling and stretching as you

As you stretch the canvas, the diamond sh will begin to lose its distinctive edges, becomi more oval as the canvas is pulled taut. As you continue the stretching process along each sid the stretcher, this shape will completely disap

eparing a Painting Support

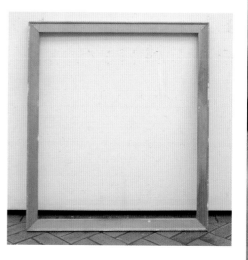

description of this preparation may
n like dreary busywork, yet I find that
time provides space for reflection and
gination. I do most of my important
ning while preparing a painting surface.
Stretcher bars may be purchased from
rtists' supply store. They are wooden
designed to be wedged tongue-and-

groove into one another and will guarantee
a tight fit. By wedging these bars together,
you form either a square or a rectangle,
depending on the dimensions chosen. A
wooden mallet or hammer will be needed
to force the four sides together. After you
bring all four sides together, you will need to
make sure the corners are at right angles.

You can do this by using a T-square or by
leaning the stretcher bars against a corner
of a room and seeing if all four sides are
flush. This is important, because lopsided
or uneven corners can cause warping of the
wood once the canvas is stretched onto it.

Folding and stapling the corners

It is now time to finish off the corners. This is a matter
of folding over and stapling the edge, which is best done
imilar way to making up the corners of a bed. Whichever folding
rn you choose, your canvas will look better if the same method is
for all four corners. The best way to achieve a uniform look is to
in a clockwise direction until each corner is finished. This folding
of the edges takes care of excess canvas.

5 ### Finished stretched canvas
The finished stretched canvas viewed
from behind. The larger the canvas, the
more important it is that extra material
be tacked out of the way.

Priming the Canvas

Materials:
— Gesso (1-gallon tub)
— Small roller or 4-in. (10-cm) house-painting brush
— Small block of wood or sandpaper block
— #1 sandpaper 100 grit dry

It is now time to prime the canvas by applying the gesso. When using oil-based paint, priming is absolutely necessary in order to protect the canvas from the corrosive effects of the oil paint and solvents. Priming is also necessary for acrylic painting, although it is not as crucial an issue as for oil. Acrylic paint will not harm unprepared canvas, but a lack of priming can result in the paint's seeping through and staining the canvas rather than remaining on the surface. Although many experienced artists find this staining quality attractive and have learned to work with it for their own creative needs, for our purposes we want the painting surface to be impermeable and so w[] use a primed surface.

I recommend that the gesso sho[] be applied with the stretcher flat on [] table or the floor. Any extra gesso w[] drip downward to the floor rather t[] sliding across the surface, as it wou[] do if canvas were primed in an upri[] position, leaving lumps and drips.

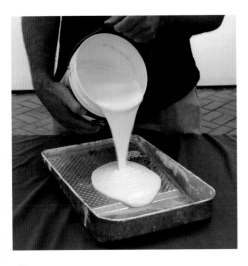

1 Before use, the gesso should be mixed or shaken in the can until smooth. This will aid in creating a flat surface texture on the canvas. If you can afford it, buying the gallon tub will save money in the long run. Keep the lid on securely so that it does not dry out. Here, the gesso is being poured into a tray in preparation for using the roller.

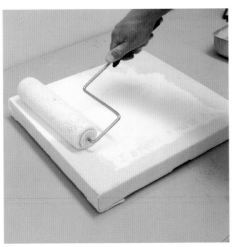

2 The advantage of using a paint roller (as opposed to a brush) is the speed and ease of application. The roller goes over very quickly, and the initial raised areas caused by the paint oozing at the edges of the roller quickly smooth out over the canvas.

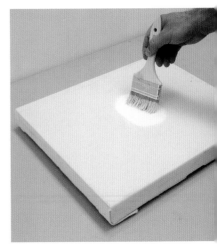

3 When using the brush, it is best to st[] in the center of the canvas, applying gesso in a circular fashion and worki[] it into the surface of the canvas.

When the gesso circle covers the center of the canvas, draw gesso line[] diagonally across to each corner wit[] width of the gesso brush, so that the[] is an X through the circle. After that[] continue to apply the gesso in a circ[] motion until you reach the sides. Th[] logic behind this is that the wet gess[] in the circle and the X will dry evenl[] preventing the canvas from warping.

ing Preprepared, Stretched, d Primed Canvas

tchers can also be purchased with the canvas already stretched and ned (painted with gesso). However, it is still important to paint an itional two coats of gesso on the front and sides of the panel. This is ause factory gesso is generally sprayed on and tends to sit on the ace. Adding another layer or two will push the gesso further into the ace of the canvas, adding a stronger layer of protection. Alternatively, you can purchase primed linen or cotton duck and use to stretch over stretcher bars. In this case, you will not need to prime canvas, but you will require a pair of stretcher pliers to pull the erial over the frame of the stretcher bars. This is because the factory ning makes the material inflexible and subject to cracking when tched. Such cracking usually occurs right along the edges.

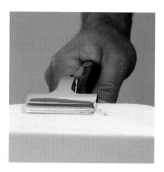

Stretcher pliers: These are necessary when using canvas that has been factory primed with gesso. Primed canvas is much less flexible than the unprimed variety, and you need a tighter grip to pull the canvas over the support.

This photograph illustrates what happens if you use canvas that has been precoated with gesso. Stretcher pliers are required because of the stiff, nonpliable nature of this kind of canvas, which makes stretching by hand to create a tight drumlike surface nearly impossible.

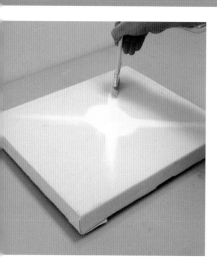

When you are finished with the front you will need to paint the sides of the canvas with gesso. This will allow the canvas to shrink more evenly as it dries. It is this shrinking, combined with the manual stretch, that gives the material its taut quality. You are aiming for a drumlike effect: something that is firm yet has flexibility.

5

Because the gesso that we are using is water-based, we have to take into consideration the drying time. The roller has the advantage of speed, allowing a first coat of gesso to be applied on multiple canvases one right after the other. This can also be done with the brush, but because the gesso dries quickly it could dry on to the brush in the process.

Regardless of how you apply the gesso, the canvas requires two to three coats. In between these coats the brush or roller should be washed and allowed to dry. If you start to gesso the canvas with a wet brush or roller, you will dilute the gesso.

6

You should sand each coat of gesso so that the final layers are uniformly smooth; sanding also provides the necessary tooth for subsequent coats to stick. A small block of wood or a sandpaper block will save your hands and allow for even sanding throughout. Allow each coat to dry thoroughly, overnight if possible.

Rigid Stretcher Construction

Tools and materials:
— 3 strips of ¾ x 4-in. (1.9 x 10-cm) stud, 8 ft. (2.44 m) in length
— Hand saw
— Measuring tape
—2 strips of ½-in. (1.27-cm) round wood dowel, 8 ft (2.44 m) in length
— Wood glue
— Small brads (finishing nails)
— ¼-in. (0.6-cm) depth plywood
— Corner clamp
— Hand drill
— Screws
— Phillips-head bit
— Countersink bit
— Quick-grip clamp

Tools and materials for building, stretching, and priming a canvas. From the bottom left: measuring tape, wood clamp, stapler, beveled wood with corner supports resting on them, metal angle clamps, screws, power drill, container of gesso, gesso brush, unprimed cotton duck canvas.

Beveling strips for the stretcher frame

Beveled wood means wood cut with a sloping edge. Using beveled wood for a stretcher frame prevents the canvas from lying completely flat on the stretcher and forming an ugly indentation. The easiest way to bevel the strips without a power tool is to add a piece of wood dowel. Take two of your three ¾ x 4-in. (1.9 x 10-cm) wood strips, and glue each ½-in. (1.27-cm) round wood dowel along the narrowest side of both strips, nailing them down firmly with small brads or finishing nails.

Cutting the strips to size

You will then cut these two beveled strips in half widthways to make up four strips for all four sides of the frame. Measure the strips according to the desired canvas size—the largest possible square canvas size when using these lengths of wood is approximately 48 x 48 in. (1.22 x 1.22 m). Mark the wood for the miter cuts, i.e., cu at a 45-degree angle, so that the strips w fit together at the corners of the frame. Using the hand saw, cut along these ma to make four strips with a 45-degree ang at each end.

Assembling the stretcher bars

Place two stretcher bars in the corner cla to make a 90-degree angle. Note: If you not making a perfectly square canvas, make sure that you place one long side a one short side into the corner clamp.

Drill a screw into the stretcher bars a the mitered cuts (to prevent splitting th wood, you may wish to drill pilot holes

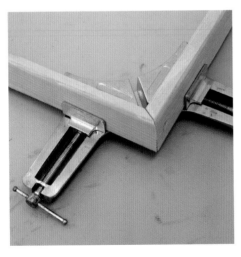

1 Fix your stretcher bars in a corner clamp, holding them steady for the screws.

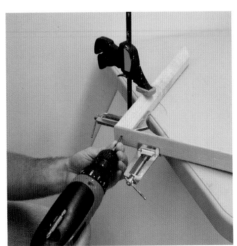

2 Drill screws into both sides of each of the mitered corners. (Making pilot holes before drilling the screws helps to prevent the wood from splitting.)

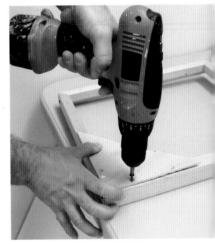

3 Make triangular supports and drill t on to the back of each corner of the stretcher.

Hand Drill: Health and Safety

- Make sure your hand drill is the proper size for your grip
- Keep your hands well away from the drill bit
- Only use a wood drill bit for drilling into wood
- A battery-operated drill gives you a wider range of movement than an electric drill
- If you choose to use an electric drill, do keep track of the cord, and make sure it is plugged into a three-pronged socket; if using an extension cord, make sure it is a heavy-duty one
- Keep the drill bit clean and free of wood chips so that there is complete visibility

ore screwing the mitered corners :ether). I recommend using drywall ews, which are around 1 to 1 ½ in. (2.5 to cm) in length, because their galvanized oves hold a little better than regular od screws. Repeat this process until you e all four 90-degree corners screwed ether. Since a miter cut is the weakest n of joinery, the screws only hold the tcher bars together until the corner ports are added.

:ting the corner supports
v for the corner supports. Using ¼-in. -cm) depth plywood, measure and w out two perfect squares. Make sure : the sides of your squares are less than the size of the shortest sides of your tcher bars.

Using a hand saw, cut out the squares in the plywood. Draw a diagonal line between two opposite corners of one of the squares. Cut the square along this line to make two triangles. Repeat this on the second square, so that you end up with four triangles.

Assembling the corner supports
Once all four sides of the stretcher bars have been assembled, flip the stretcher over so that the beveled side is down. Place the plywood corner supports on all four corners, and screw them down to the stretcher.

Support beams
Support beams are two perpendicular strips of wood that support the inside of the stretcher. To make these, you can use the third ¾-in (1.9-cm) wood strip left over from making your stretcher. In order to measure them to the exact size of the inside of the stretcher, place the end of the wood strip flush with the inside of the stretcher and mark where it goes under the opposite side. Use a hand saw to cut two lengths, this time at 90-degree angles.

Place one beam inside the stretcher and mark it on the outside for the countersink holes. Drill screws through the side of the stretcher into the support beam.

To add the second support beam running perpendicular to the first, you will first need to cut a notch into this second beam so that the first can rest easily in it.

Now follow the instructions on pp. 64–65 to stretch your canvas over the bars, and pp. 66–67 to apply gesso.

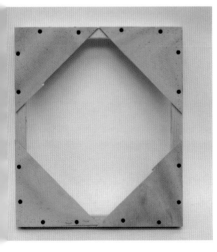
Back view of the finished stretcher, showing all four corner supports in place.

5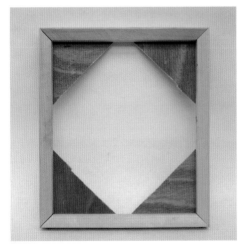
Front view of the finished stretcher, on which you are now ready to stretch your canvas.

6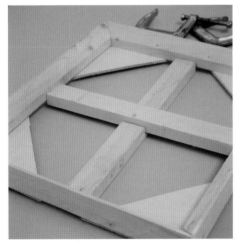
Back view of a frame with added support beams.

In this section you will:
— **select your subject matter;**
— **use a viewfinder to order the composition;**
— **make a sketch using a pastel pencil;**
— **consider the composition by using a focal point or by using natural or indoor lighting;**
— **learn to recognize the use of chiaroscuro shading and reflected color.**

Beginning Your Painting

Materials
— Rectangular canvas or wood panel, primed, roughly 11 x 14 in. (28 x 35 cm)
— Viewfinder
— Light-colored pastel pencil

Now that you have your first painting support primed with gesso, you a␣
ready to begin the painting. For your first painting, I suggest you try a s␣
life of fruits and vegetables. Fruits and vegetables offer bright primary a␣
secondary colors, which will enable you to pick out the colors easily in t␣
composition. We will begin by arranging the still life and then making a
preliminary sketch.

Margaret Morrison
Tomatoes
2005
Oil on canvas
24 x 30 in. (60.9 x 76.2 cm)
Courtesy of the artist and the
Woodward Gallery, New York

Margaret Morrison's illustration of tomatoes in␣
their variety is deceptively simple in compositi␣
yet extremely elegant in design. By using diffe␣
variations of one still life object, she creates a
colorful checkerboard effect.

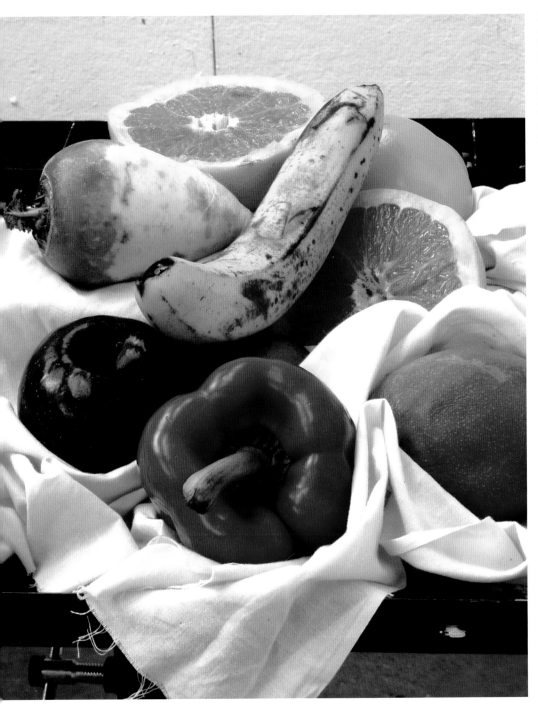

Photograph of still life
An assemblage of different shapes,
sizes, and textures of fruit is here
arranged on a neutral-colored cloth.
This will be the subject matter for
the still life painting shown on the
following pages. An arrangement
like this allows for the overlap of
the fruit and vegetables and
some space between, thus creating
positive/negative space integration.

ection of Subject Matter

ts and vegetables have very distinctive colors and shapes, which will
 you identify patterns and values in your first sketch. Try to have a
ction that includes both shiny and dull surfaces, both large and small
ns, some tactile texture, and, most importantly, fruits and vegetables
 are very colorful. Place these on a flat surface, which could be a
tral color or a piece of printed material. Striped material, for example,
 be reflected in the objects, adding another compositional ploy. Refer
k to the color and design principles in Chapter 1 when arranging your
 life (see pp. 25–27) and think of design as an organizational chart
ding your composition.

Composition: Using a Viewfinder

After arranging your still life, a handy tool in composition is the viewfinder. As in photography, a viewfinder helps in editing a composition by putting a border around the chosen subject matter. This border represents the outside edges of the painting surface. A viewfinder can be constructed out of paper or cardboard. By cutting out the center of a piece of paper in roughly the same dimensions as your painting surface, you will have a handheld viewfinder. I find that when a still life includes multiple items, holding up the viewfinder crops out extraneous visual information by allowing me to zoom in on a section of the composition that catches my attention.

1 Fold a white piece of paper or card in half.

2 Cut out a shape in the crease. The size of this shape should be half the dimensions of your painting surface.

3 You now have a very basic viewfinder. Be sure to give yourself enough outside "frame" so that you are able to hold it with a steady grip, and use cardboard if you want to prevent it from flapping about.

Using the frame of a photograph as a viewfinder, student Eleanor Simmons created a useful tool with which to compose her fruit and vegetable still life. You can see how she has held her viewfinder to frame her work, and her painting reflects these decisions.

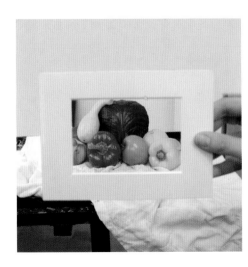

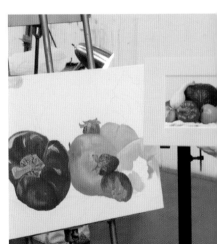

...ing a Preparatory Sketch

...e your preparatory sketch, arranging your composition and observing ...value patterns (see below). As you begin this sketch, use the still life as ...de, but feel free to change the placement of the objects based on ...oositional effects. For example, if an apple is in the foreground of the ...ting and a banana is behind it, have the apple overlap rather than ...placing it next to the banana: Overlapping objects illustrate spatial ...ionships. Cropping some of the fruits and vegetables off the painting ...ce will make the painting feel fuller and more open. You may want to ...d the trap of a composition with nothing at the top, the objects in the ...ile, and the surface on which they are sitting at the bottom. Make your ...ces based on how the colors of the fruits and vegetables work best.

...3egin by carefully drawing your still life using a light-colored pastel ...cil. The advantage of using pastel pencils to draw these lines is that ...will dissolve into the paint as you apply it. If you use graphite pencil, ...will find that it almost always leaves a grayish tone that requires more ...t applications to cover it up. As an example, if you are painting with ...color yellow, which has the least hide (covering ability), you will need ...ppiy many layers of paint to cover the gray tone of the pencil beneath.

...n the activity of drawing, the outside line of an object is the contour ...but in this preparatory sketch try to imagine the line you are drawing ...string being pulled around and over the items in your still life. As you ...v these items, show how different objects may overlap each other. ...will show the spatial relationship, help you to illustrate the volume ...form, and create the illusion of a three-dimensional collection of ...cts on a flat surface.

...Another technique you can use to create a three-dimensional drawing ...draw the value patterns. Value patterns describe the shape of patches ...lor on the surfaces of the subject matter. Generally, when we observe ..., we are not inclined to notice that every tone and shadow forms a ...oe. For the purpose of creating a painting, this is exactly what you ...ild look for. Lines are formed where different patches of color meet and ...vidual color shapes become clear. It is the lines formed where these ...r shapes meet that you should include in your preparatory sketch. ...ou draw the shapes you will see that these patches of color follow the ...our of the object, and so including them in your sketch will help you to ...te the illusion of three dimensions. Observing these patterns will also ...you to choose the composition of your painting by choosing an area ...teresting shapes. You will also be looking at color combinations and ...be able to choose an area with interesting colors.

Above
Student Brittany Gabey's preparatory sketch for her fruit and vegetable painting was composed using a viewfinder to help edit and make decisions about her subject matter. She used the method of cropping to bring the viewer even closer to the middle of the painting.

Right
Student Jasmin Kern's preparatory sketch is another example of the creative use of a viewfinder to organize pictorial space. Her sketch has a sense of a bigger picture continuing beyond the frame of the canvas, and its abstract arrangement makes it a very personal viewpoint.

Drawing in this way, following the shape of the colors as well as the outline of the object, is much like a puzzle requiring visual trust. I descr the term "visual trust" as accepting what you see, without question. B this I mean that sometimes the first thing you see without question is likely to be correct. This is not scientific, but I have observed it in stude and in myself over the years. We tend to spend time unconsciously nar things in front of us, in a sort of intellectual interference. We tend to disregard what we actually see and instead self-correct—but not alwa rightly. So much of observation relies on trusting what you see, not wh you think you see or expect to see. We know a pencil is straight and we unconsciously expect it to stay that way no matter the circumstances. just look at a pencil reflected in a shiny sphere and you will get the poi So, as you continue drawing you will find that painting from observati demands a willingness to believe the unbelievable. What this actually means is that you are seeing a different point of view, one that you can easily imagine. Try the upside-down drawing experiment: If you place photograph upside down and draw the image as you see it, you will fir that your accuracy is greater than if the photograph were the right way

This preparatory painting sketch can look similar to a paint-by-num kit. Most of these shapes individually can appear to be very abstract or nonrepresentational. In describing value patterns, the term motif is als used, usually to describe shapes that are created by the repetition of forms within a design.

When you start to apply your paint colors on the painting surface, you will gradually find that your composition begins to lose this initial pixelated look, becoming clearer as you delineate the objects and the space around the objects and/or the surface on which they lie. Do not worry, this sketch is not an exacting blueprint: You can and will chang these patterns as you progress.

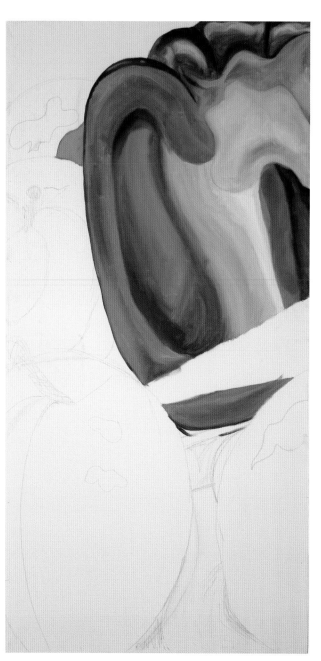

This preparatory sketch and the beginning of a painting by student Miriam Rowe is an example of what is meant by figure/ground ambiguity. The ground is considered the negative space in terms of understanding this phenomenon. Clearly, there is no true negative space, but rather the difference between the objects and the surface on which the objects are sitting.

m Rowe
canvas

s the finished fruit and
able painting by Miriam
, as sketched opposite.
sues of negative space
w muted by her use of
oscuro shading and cast
ows in particular.
al relationships in
sentational painting rely
ape, form, and overlap.
s what separates the
s from the surface on
they are placed.

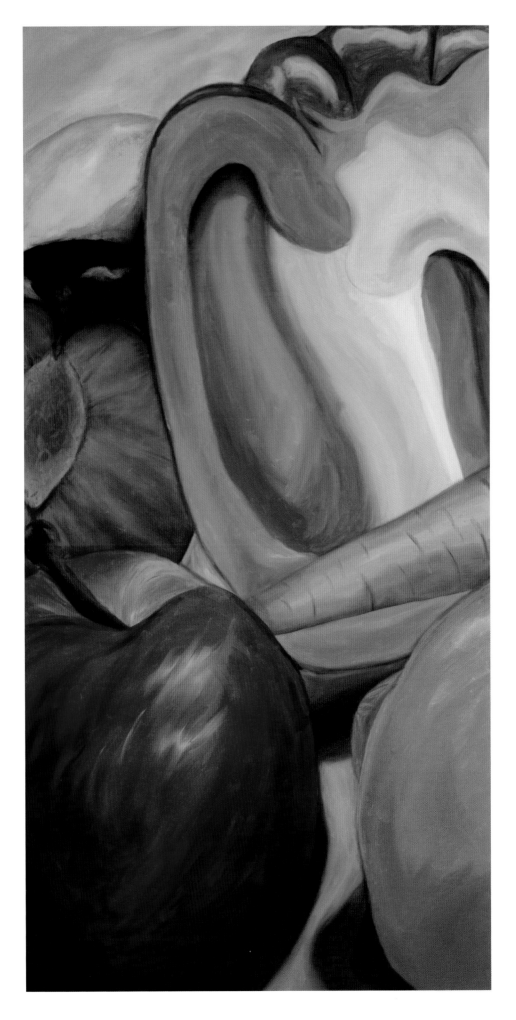

Negative Space

As you continue drawing, pay close attention to the shape of the canvas, with emphasis given to the four corners. It is important that the four corners be activated visually, either with objects or with interesting negative space shapes. Negative space is the space created around an object or arrangement of objects, creating a visual shape or pattern. This is a neutral term to describe a particular phenomenon: For example, if you draw the inside shapes of a metal fence, you end up with the solid fence itself as well.

There will be a tendency to direct most of your energy and attention to the center of the canvas, but a well-composed drawing is an open composition, a term I use to describe an arrangement that visually extends beyond the literal borders of the painting support. It alludes to continuation. The four corners of your painting support represent a frame that surrounds your imagery. Imagine the view outside from behind a window and observe how the outline of the window encloses what you see.

This fruit and vegetable painting by student Ch[...]
McMurray is a clear example of how consider[...]
negative space as much as positive space can[...]
produce great results. The negative space and[...]
shadows help to bring the fruit and vegetable[...]
full focus. The colors on the fruit and vegetable[...]
also made more brilliant by the cool and subd[...]
color of the surface on which they are placed.

osing a Focal Point for Composition

ng arranged your still life, you have one of many compositional
ces to make during this drawing stage. You may find that only one
l area of the still life interests you. As we have seen, pattern or color
binations can determine this area. This is not a problem; you simply
ge the scale of the drawing and enlarge a section, making it the focal
t of your composition. Objects that are drawn larger are naturally
e detailed and will draw the viewer in. As you draw, you can continue
arrange the objects to isolate areas of interest or, finally, if the painting
ce is canvas, you can physically crop the painting after completion.
ping or cutting the canvas is a way of focusing on a particular part
e painting.

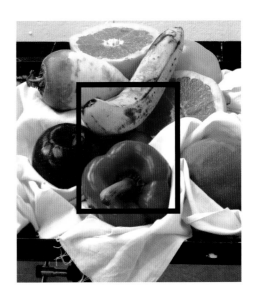

Close-up (left) of the area in the still life
arrangement that was chosen using the
viewfinder. See the crop on the whole photograph
(top). Then note how Brittany Gabey has matched
her preparatory sketch to this detail (above).

Using Light: Chiaroscuro Shading

Chiaroscuro is a traditional painting or drawing method that employs the full-range value of lights and darks, resulting in a stronger overall sense of volume and an illusion of deep and shallow space. Notable historical examples can be found from the Renaissance. This technique places the emphasis on the dramatic play of light and dark across forms.

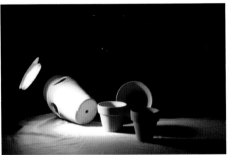

This collection of pots shows clearly all five stages of the chiaroscuro shading. See if you can identify the lightest light, the shadow, the core of the shadow, the reflected light, and the cast shadow.

The arrow shows the direction of the light source. When other objects are added to the still life, note the difference in the light as it strikes the varying textures and colors of these objects.

The light in this picture is coming from the right, and is at a steeper angle than in the previous image. This is most evident when you look at the apples, as the stalks are now producing shadows of their own.

Their multifaceted forms make pine cones interesting objects on which to observe light and shadow. Here, the light is coming in from middle left.

See how an egg creates a cleaner cast shadow than the pine cone. The light is coming from slightly higher up on the left here.

When the egg is moved to the basket, its cast shadow is considerably darker due to the surrounding pine cones reducing the reflected light.

There are five stages to consider when using chiaroscuro shading:

1. the lightest light (source);
2. the shadow;
3. the core, or darkest part, of the shadow;
4. the reflected light (light that bounces off nearby objects or the surface they are sitting on);
5. the cast shadow (which in itself has at least four different tones as well).

This way of shading and blending, coupled with careful attention to value patterns, the most basic building block in realistic and figurative painting.

Using a perfectly round ball as an example, start by mixing and laying down the color that best represents the lightest area. The color for the shadow will be a darker shade of the first color. After you have placed this color down, blend the edges to create a soft transition. Continue in this fashion with the core of the shadow which is the darkest part of the shadow. Then lay down the reflected color, which is based on color from nearby objects or the surface that the ball sits on. The cast shadow follows the shape of the ball somewhat and is usually much darker than the object itself. The shape is also dependent on how close the light source is to the ball. As you mix the colors above remember to consider how the many colors and tones of the ball are all affected by reflected color.

James Valerio
Still Life with Melons
1997–99
Oil on canvas
96 x 84 in. (243.8 x 213.4 cm)
Courtesy of George Adams
Gallery, New York

Valerio's still life is literally and figuratively a production. The curtains serve as a backdrop and a continuation of the lush display of fruit. The whole scene is lit from above with artificial light.

Baptiste Chardin
g Grace
0
, canvas
5 ¼ in. (49.5 x 38.5 cm)
e du Louvre, Paris

The natural light source in this scene is pointing upward from the lower left-hand corner of the canvas. This creates a directional light upward, which joins the subject matter and the environment.

Reflected Color

Reflected color is color reflected from one object to another, in the process changing the color of the second object. This is especially noticeable in landscape painting, where a sunset, for example, will produce a very different color effect from the morning sun.

Claude Monet
Rouen Cathedral in Morning Sun
1894
Oil on canvas
41 ¾ x 29 in. (106.1 x 73.9 cm)
Museum of Fine Arts, Boston

It was not unusual for Monet to paint subject matter at different times of the day, and this painting and the one to its right are prime examples of how the color and light of the day reflect on the subject matter. As this is reflected light, it is atmospheric, creating a kind of haze produced by particles in the air as well.

Claude Monet
Rouen Cathedral at Sunset
1892
Oil on canvas
39 ⅓ x 25 ⅝ in. (100 x 65 cm)
Musée Marmottan, Paris

In this painting of Rouen Cathedral, one of many of Monet's sunset variations, the cool color of the sunset reflecting on the stone creates a blue-gray tonality, whereas the warmth of the morning light with a hint of the evening color creates the lighter tones.

Craig McPherson
Empty Stage (Fly Rail)
2001–4
Oil on linen
72 x 48 in. (182.8 x 122 cm)
© Craig McPherson, courtesy
of Forum Gallery, New York

In Craig McPherson's *Empty Stage (Fly Rail)*, the use of reflected colors and cast shadows produces a sense of deep and shallow space using simple abstract shapes. The almost monochromatic color schemes emphasize this dichotomy of light and dark.

Materials
— **Paints**
— **Paint mediums**
— **Palette knives**
— **Palette**
— **Paint tube squeezer
 (or rolling pin or similar object)**
— **Plastic plant mister
 (acrylic paints only)**

— **Use the paint mediums and
 ingredients listed on p. 42 in
 Chapter 2.**

Paint colors (acrylic or oil) for a beginning full-range palette. Those marked with an asterisk (*) are recommended for a limited palette. It is advisable to purchase professional-grade paints whenever possible—they perform better than the student grade, and therefore you will know which mistakes in color mixing are the result of an incorrect color choice rather than an inferior product.

Preparing Your Palette

Now that you have arranged your still life and completed the prelimin sketch, you are ready to prepare the palette. Lay out your paints so tha you have easy access to them: If they are readily available, you will us them. I suggest that you start with the palette of colors shown below i either the full-range or the limited palette.

When applying paint from the tube to the palette it is helpful to stu the subject matter in front of you at the same time. You should also ma sure you have both the color wheel and the chromatic color chart to ha You will find it helpful to refer to these as you search for a color match— and they will remind you of what you are capable of in terms of color mi

The method you will use for this first painting will be the alla prima wet on wet, or direct painting technique, in which the whole painting sections of the painting are completed in one sitting, working wet pai into wet paint. With this method you will also be able to employ a style glazing that I call "blending as you go," laying one wet paint color ato another with enough firmness to mix the two together on the painting surface. As the paints remain wet, you are not confined to mixing just colors together, and so the colors you mix on your palette to start need be the only colors that you use. You can continue to mix these with oth colors as you complete the painting. However, it is best to start by mix about thirty colors on your palette before you begin, as described belo

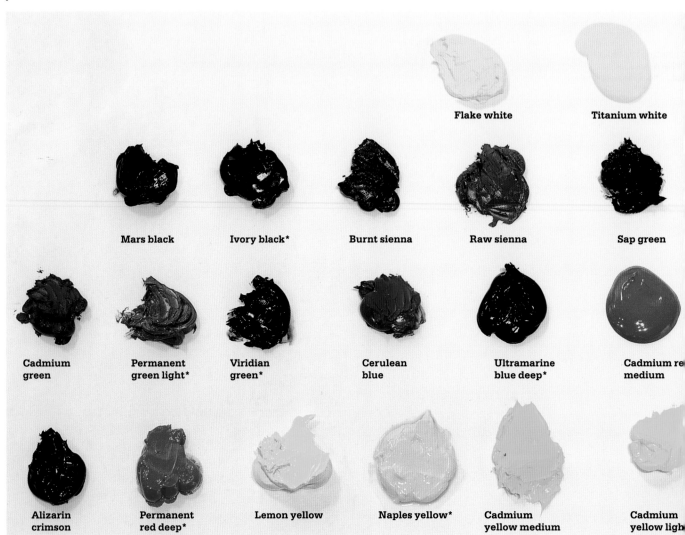

Flake white Titanium white

Mars black Ivory black* Burnt sienna Raw sienna Sap green

Cadmium Permanent Viridian Cerulean Ultramarine Cadmium re
green green light* green* blue blue deep* medium

Alizarin Permanent Lemon yellow Naples yellow* Cadmium Cadmium
crimson red deep* yellow medium yellow ligh

lace your painting mediums in containers near your palette. (Acrylic
t will also require a plastic plant mister.)

Vith your choice of either oil or acrylic paints (see p. 40), lay out all
ur yellows in a row along the edge of the palette. Follow the same
ern with all of your oranges, reds, blues, and greens. Your palette
ld be lined with your colors. Lay out small amounts of white for the
w section, the blue section, the red section, and the green section.
amount of paint you need will be determined by the size of your
as. The amount you squeeze from the tube will pretty much turn
o be an estimate.

tart by observing the most visually obvious reflected colors in your
ife and mix these colors first on your palette using your palette knife
pp. 48–49). As you look at your still life, you will begin to see that,
nically speaking, every color is a form of reflected color, not an object
olation.

hen look closely for other colors that remain to be mixed. While each
ct has its own color, each will affect, and be affected by, the color of
by objects. The first thing you discover is that the fruits and vegetables
ain much more variety in color than you might have seen at first
ce. For example, that lemon may contain much more of the red from
pple directly next to it.

Kari Ann Gertz
Oil on canvas

This painting by student Kari
Ann Gertz is a strong example
of reflected color and highlights.
The red and white stripes
provide counterpoints to the
round shapes of the marbles.

ain Kern
canvas

s painting by student
in Kern, marbles are
led to be perfect examples
ected light on spheres.
as used the Venetian
ique of painting in layers
glazes, which is discussed
next chapter.

If you have trouble distinguishing a color, create a peephole viewfin
This is a variation on the viewfinder (see p. 72). To make a peephole
viewfinder, take a sheet of white paper and using scissors or a noteboo
hole-punch, make a small ½-in. (1.27-cm) hole in the center. Look throug
it while placing it close to the area in question, using it to isolate that co
area. Color accuracy is important, but so is experimentation and
interpretation.

Using about ten of the full-palette colors, mix three or more colors.
You will have roughly thirty different colors. When the palette colors ar
thoroughly mixed, add a small amount of your oil painting medium to
each patch of color. For acrylic paint, you can use acrylic medium gloss
(for a shiny surface) or acrylic medium matte (for a flat surface).

Mix all the paints to an equal consistency—this will ensure a unifor
drying time in each layer. When painting wet on wet, I mix my paint to
the consistency of smooth yogurt.

Just before you start applying the paint, place a drop of Liquin (oil
paint only) in each mixed color. Try not to add too much Liquin, which
cause the paint surface to become brittle after drying.

Use acrylic medium and acrylic retarder to slow down the drying tim
of your acrylic colors.

Peephole Viewfinder

The construction of a peephole viewfinder
is quite simple. Fold a piece of paper in half
and tear out as small a piece as you can.
The peephole viewfinder is used to isolate
color when colors are so close in tone it is
hard to recognize what color is needed for
the mixing. The viewfinder is also a way
of understanding the relative nature of
color; to simply say something is red
ignores the context in which it is found. In
the following examples, the colors red, blue,
and yellow are being isolated with the
peephole viewfinder. As you can see, the
red surrounded by the white of the paper
appears to be of a different shade than the
overall red of the background. This is
precisely what is happening. Try this
yourself as an experiment. The blue color,
when isolated, is quite different than the
blue object itself in the other examples.
The same is true of the yellow, which
appears to be quite dark surrounded by
the white of the paper.

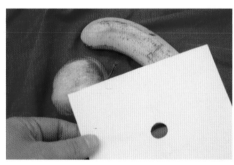

Peephole viewfinder
isolating a red area.

Peephole viewfinder
isolating a blue color.

Peephole viewfinder
isolating a yellow color.

Using Black and White

As mentioned in Chapter 2 (see p. 36), there is certainly a place for black and white when mixing color, but try not to rely exclusively on the shortcut of using white to lighten and black to darken. This will lead to monochromatic coloring. Remember that by adding white to a color, you lighten it—but you will also create a chalky color that has less chroma (brilliance of color) than before. Consider choosing a pale yellow that has a lot of white in it to lighten a color. If the color becomes too highly tinted (lightened), add some more of the original color to make it less chalky.

Black will not only make things darker, it will make the color duller; a very dark blue or brown is preferable in most cases. The best way to darken a color without dulling it is to use a combination of chromatic grays as well as black and white, as you learned in Chapter 2 (see pp. 50–53). You have the complete color wheel to guide you, along with your chromatic charts.

When observing your subject, it is important to understand that white objects are just as prone to reflected color and the effects of light as any other. The white you see in front of you does in fact have color and tone when observed in the environment. It is a mistake to assume that the white straight from the paint tube will be enough to depict this. The same is true of black, in that there is always some color bias. A shiny black object, for example, reflects all of the surrounding colors. Study the colors carefully as you lay out your paints.

José Bedia
...*Lo que hace falta*
(Things I Could Use)
2000
Acrylic on canvas
72 x 132 in. (182.8 x 338.3 cm)
Courtesy of George Adams
Gallery, New York

Bedia's *Things I Could Use* is a compelling image in which the monochromatic colors are rich and dramatic, combining chromatic neutrals and black and white to create the looming movement of the ship as it plows front and slightly off center toward the viewer.

Choosing Brushes

In painting as in any other field, one should have a working knowledge of the tools required. Our most basic tool is the brush. There is a wide variety of brushes available that can be used for both oil and acrylic painting, and the differences between the two are subtle. It is best to keep one set of brushes solely for oil painting and one for acrylic, and to avoid mixing the two.

A basic brush consists of three main sections:

— **the handle**, which may be constructed out of wood or plastic;
— **the ferrule**, which is generally metal, and holds the hairs in place;
— **the tip**, which consists of the brush hairs.

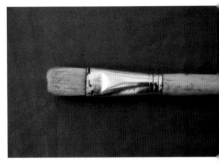

Round:
This brush has long hairs tapered to a point. The ferrule is round.

Flat:
This brush is flat with long hairs.

Filbert:
This brush is flat, oval-shaped, and fairly thick.

Bright:
This brush is flat with short hairs.

Dip the brush into the paint you have mixed on your palette, taking care to load up only the tip and no further than halfway down. You do not want to push paint into the ferrule of the brush. If you do, the paint will not come off easily and it will clog the hairs, which will eventually stiffen and ruin a brush.

Fan:
This brush is fan-shaped. It can be flat or thick and fluffy, and comes in a variety of hairs. It is generally used for shading.

start I recommend using as large a brush you can comfortably handle. Try to hold r brush at the far end with your arm ended, allowing as full a range of motion oossible, so that you stay loose. Holding rush like a pencil will enable only the rt range of motion of your wrist, and you end up trying to "draw with the paint." wing with the paint is something that eginning painter will often try to do, er than pushing the paint around as a iid on the canvas. To practice doing the er will help you learn the properties of nt. This loose stance also makes it easier ee your painting and the still life as well. The handle of the brush is tapered, with fullest part at the top. The length of the dle will determine how far you can step iy from your painting.

Traditionally the main brushes used by fessional artists were made of sable or tle hairs. Today, there is a great variety airs available on the market. Sable, a ural animal hair, is very soft and pliable, ing a smooth surface finish. Bristle ies from hogs (though these brushes / now be made from nylon) and, being er than sable, is a good choice for the nique of scumbling.

Many artists prefer to draw their iminary sketch on the painting surface ig a stiff-bristled brush, because the iness of bristle lends itself quite well to wing with the paint, giving a line that oser to one that can be drawn with a

pencil point than can be achieved with a soft brush. The advanced painter develops a preference for different brushes through trial and error. Most of my paintings are created with a sable brush, and I use the bristle variety only for scumbling or for drawing with paint.

Over the years, imitation sable and bristle brushes, which are much less costly, have become available and offer the beginning student a chance to learn without spending a lot of money. I have sampled some of the new synthetics and have found that they hold and spread the paint quite well. However, although it is possible to buy good-quality synthetic brushes, I would recommend that you also

acquire some top-of-the-range sable and bristle brushes. As a beginner, it is better to use as high-quality a tool as you can: You do not need to suffer from the self-doubt that arises from a poor-quality painting caused by using poor-quality tools.

I find that the filbert brush is one of the best all-around brushes for painting. The flat brush design, with its rounded edges, makes the placement of paint more manageable, and it does not leave a raised edge on either side of the brush mark. This brush can also be purchased in a "fatter" version.

When brushes are newly purchased, check for loose hairs and remove them before using.

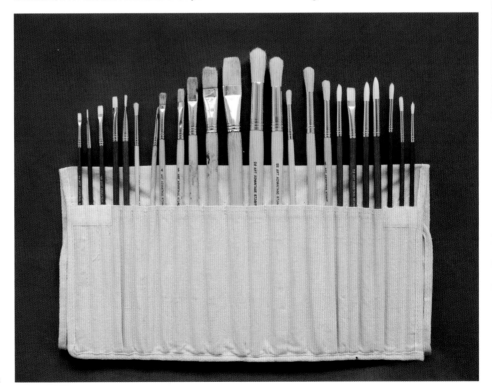

Brush apron

Painting Using the Wet on Wet Method

As we have noted, a painting using the wet on wet method is often completed in a day. However, it is not assumed that you, as a beginner, will finish your first painting in one sitting. In fact, even with wet on wet you can easily take a week to complete your painting by working on individual areas in turn. Drying time for paint is never completely predictable, but on the whole, the lighter colors tend to take more time to dry than the darker ones if you are not using a painting medium—and since painting medium contain driers, they can change the equation.

In general, when painting wet on wet, you should plan which areas you can more or less complete in a given session, because if you resume painting a whole day later, the areas you have already painted will have begun to dry to the touch or become tacky, meaning that you cannot work wet on wet on those sections. As areas begin to dry more fully you can employ some scumbling of paint (see next chapter).

For this, your first painting, therefore, you should aim to complete either the whole painting in one session or work on specific individual areas each day.

Your preparatory sketch allowed you to observe the color patterns, and the mixing of your palette was built upon this observation. Now, while painting, you will continue to observe the color, and the way in which you handle the paint in the wet on wet method will allow you to continue refining and mixing those colors.

The decision of where on the painting surface actually to start is affected by an artist's years of experience and preference. For the beginner, I suggest you start painting in the areas in which you are able to recognize the color combinations the best. This may be a dark area or a light area. (I still work in this fashion.)

Start by looking for and painting the patterns, just as you did in your preparatory sketch. Painting the value patterns will help you represent space and volume. However, do not worry about staying in the original lines of your sketch; you can always refine your painting later. (In wet on wet painting, applying colors right next to each other will always give you an opportunity to correct.) Here we are concentrating more upon representing color.

It is helpful when mixing your colors to think of color as transparent opposed to solid in all of your color observation. Try to imagine the color process in photography or the colored gels used to change the color of lights in movie-making—adding another color on top of the one you have already laid down will change the first color. Use a very bright and colorful palette for the first layers of painting with wet on wet technique. This will build a strong foundation for adding colors while the paint is still wet, as these bright colors will still be visible through any more subdued colors on top. When you place wet paint onto wet paint, the trick is to apply just enough pressure to mix the two colors together without disturbing the layers too much. The wet on dry technique (discussed in the following chapter) allows much greater control over the transparencies of the color than wet on wet.

Hieronymus Bosch
The Ship of Fools
1490–1500
Oil on wood
22 ⅞ x 12 ⅞ in. (58 x 32.5 cm)
Musée du Louvre, Paris

The Ship of Fools is an allegory for a group of listless individuals going everywhere and nowhere. Bosch's use of one-point perspective adds to the visual sense of stagnation and the obvious inattentive behavior of the shipmates.

Using Contrast

Greater contrast between the lights and darks in the earlier stages of the painting will make it easier to observe the actual shapes. As you continue with the painting, the contrast may be less intense as you begin to blend the edges of one color onto another in your painting.

A very bright area in your painting will seem much lighter if you have darker tones next to it. Contrast in painting is relative from the darkest to the lightest colors. Reflected color is the color that bounces off one object to the next. By the time you finish painting the reflected colors, what remains is a small amount of the imagined color of something. For instance, an object that is metallic and shiny is not gray but a combination of the other colorful objects casting reflections. A lemon will be yellow in the metal object but changed in color by the metal surface itself. See box on Using Light: Chiaroscuro Shading (pp. 78–79) or p. 80 for a discussion of reflected color in objects.

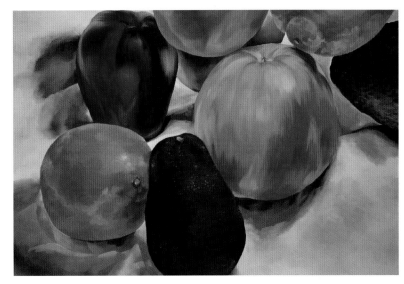

Elizabeth Baek
Oil on canvas

Student Elizabeth Baek's fruit and vegetable painting uses color contrast to dramatic effect. Ordinarily, the warm colors tend to come forward visually, while the cold colors recede into the background. This phenomenon is dependent on the tone of the colors being used. Here, the dark cool green of the avocado more than holds its own thanks to its placement —the orange behind it creates a contrast and focal point. This is repeated with the other avocado in the background.

Remember, the chromatic color charts show colors that you will be using
most of your paintings. Even objects that are simply primary colors are
ⁿted by lights and darks and will require light and dark tones.
As you lay down your colors, observe how each color reacts with the
next to it, both in the still life and on your canvas. For example, if you
at an apple next to an orange in your still life, you will see that both
apple and the orange will be reflected onto the surface of the other.
refore, some of the colors you will need to mix for the apple can also be
i to paint the reflections in the orange. While the paint is still wet, you
easily be able to adjust these colors, but they will be variations on the
color you mixed on your palette. You can do this by blending as you go,
ng the paints directly on your canvas, because you will always have a
edge of paint onto which you can mix and add fresh paint. This soft
ding has a more three-dimensional effect than a hard, "cut out" edge.

Wet on Wet Technique

Load up the brush with paint and lightly apply it to the painting support with just enough pressure to push it onto the surface. When applying your next color, overlap the first and allow the edges to blend. For example, if you apply red and overlap it with yellow, the overlapped area becomes orange. As much as possible, hold the brush closer to the end. Your painting strokes will work best when you are attempting to follow the shape you are painting. The stroke will vary depending on these shapes. Sometimes it will be a short stroke, usually for a small object. The control that you have learned from drawing will serve you well.
As with any technique, it will require practice to control the brush.

1 A pink-orange color is being laid around the collar of the figure.

2 While this is still wet, a darker version of this color is placed right next to the first one, slightly overlapping.

3 The two colors are blended while still wet.

4 A cerulean blue color is placed next to and slightly overlapping the orange and pink color, placed earlier..

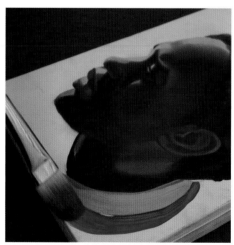

5 The blue color is completed around the collar.

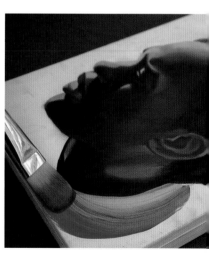

6 The colors are blended together, with firm but light pressure of the brush.

s you continue to apply the paints to the canvas and lose the white of riginal canvas, the colors will appear different from when they were unded by white. This is because all color is relative and dependent on lors adjacent to it. For this reason, it is recommended that you paint e all over the painting surface, rather than completely finishing one in, thereby moving toward completion with all the areas together. this "rendering as you go." The juxtaposition of colors optically es new colors according to their placement. (An example would be up dots of the color blue and dots of the color red in close proximity bserve how they optically become the color purple.) To a lesser e, large patches of adjacent colors will also have an optical effect on each color is perceived. This means that you need to take this into nt when you are mixing your colors. Again, you can make adjustments xing the colors on the canvas. Remember to continue to observe still life as you paint. New painters will often spend so much time entrating on the application of paint that they forget to *look at what are painting*. Try not to think about sections of the painting as idual units, but rather see the whole picture.

s you paint, you can use the technique of chiaroscuro shading (see pp.)). This means that you look for the lightest light, the shadow, the core irkest part) of the shadow, the reflected light, and the cast shadow, ing each in turn and looking at how the colors from each area affect other. In chiaroscuro shading, the steps are as large or as small as bject and the shape being painted.

Brittany Gabey has nearly finished her painting (below) based on the still life arrangement of fruit and vegetables (below left) that we saw at the beginning of this chapter.

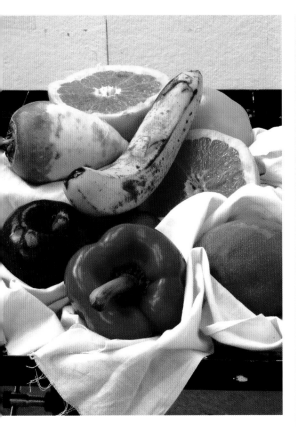

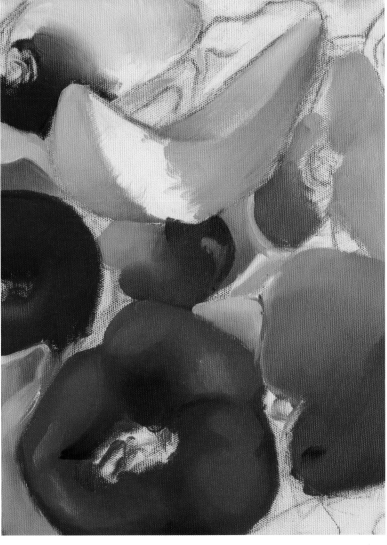

When to Stop

We have already discussed where to start a painting, so the next big question is how to finish it. How to know when it is finished is the mos common question. It is not a question that is necessarily solved by tim and experience. For these early paintings, there are some things you c look for in deciding whether you have completed your painting:

— Given that the style of this painting is representational, or "realistic is your subject matter mostly recognizable? I say "mostly" since a decision to do some cropping may render some objects not clearly identifiable. As I often instruct my students, I am more interested ir sense of color, volume, and composition in a painting.
— Is the space in the painting understandable in terms of where objec from front to back and the negative space surrounding them?
— Do the reflected colors follow the shape of the objects onto which th are reflected?
— Do you have unpainted areas left on the painting surface?
— Are the colors blended carefully without streaks?
— Finally: Do you like it?

It is better to have your painting slightly unfinished than to overwc Every painting builds on the last one, so be patient.

There are also practical considerations in knowing when to stop. In on wet painting, you usually attempt to complete the whole painting section of a painting in one session, working with wet paint blending wet paint as much as possible. (One note of warning: excessive mixing both the palette and the canvas without careful observation can lead muddy colors.) When using oils, once the paint becomes tacky to the t on the painting surface, it is best to stop on that section.

At the end of each day you should clean up your palette and wash brushes (see pp. 56–57).

Brittany Gabey
Oil on canvas

The finished fruit and veget painting created by student Brittany Gabey. She uses co in her color choices to create tension and a colorful still li The reflected color from the and vegetables is more than evident in the color of the ca shadows that they sit on. He interpretations are indicativ the kind of freedom you can in thinking about the contex color placement.

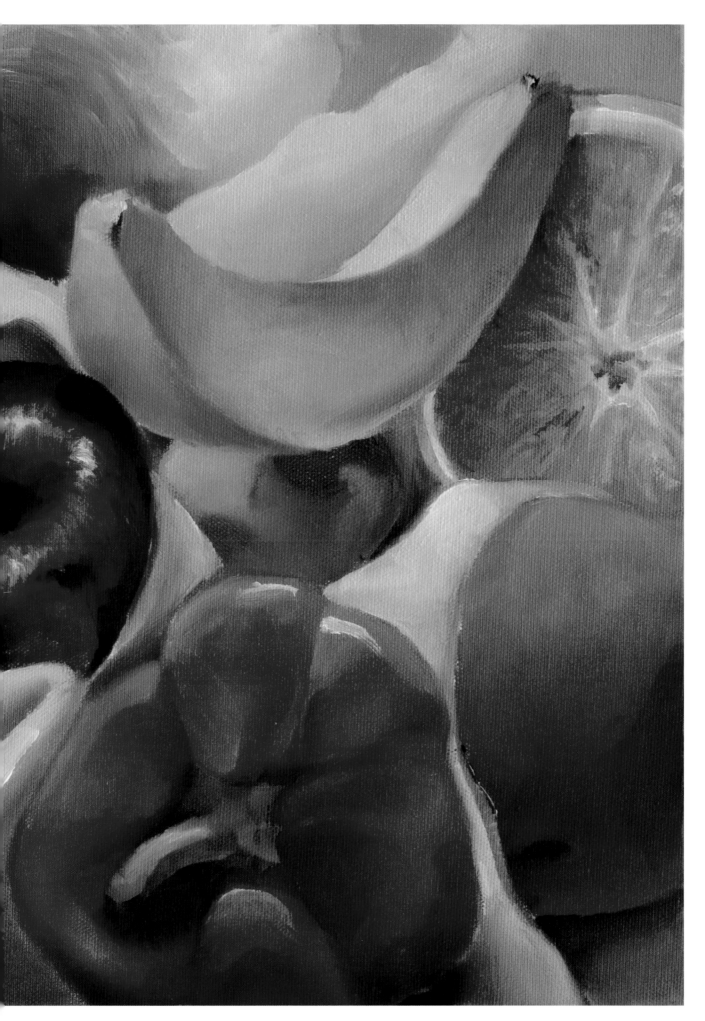

Chapter 4:
Second Painting:
Wet on Dry
and Scumbling

In this chapter, you will create your second painting using the technique of scumbling, which allows you to apply very light layers of paint over fairly dry older layers. A stiff bristle or old dried-out sable brush will give the best results for this technique. After mixing your colors, you take a very small amount of paint on the tip of the brush and spread it on the canvas, leaving trace amounts of color over the previously painted areas. This is a form of glazing that can be done quickly, without the worry of disturbing older coats of paint. Wet on dry simply means you are adding wet paint to a section of your painting that is dry at least to the touch. Scumbling is a technique that will help you accomplish this.

Michelangelo Merisi da Caravaggio
Bacchus
1595–96
Oil on canvas
37 x 33 in. (94 x 83.9 cm)
Uffizi Gallery, Florence

Caravaggio sets the figure of Bacchus (the Ro
god of wine) within a still life environment of
and fruit. This lush bounty combined with lau
leaves portrays a satisfied and relaxed figure.

io Coello
la Forma
90
canvas
10 in. x 16 ft. 4 in. (3 x 5 m)
ty, The Escorial

la Forma is a strong
le of Renaissance linear
ctive, where the viewer
the painting from a
gular entrance with two-
ree-point perspective.
ceding figures add to the
of deep space, and the
om the windows onto the
in the foreground gives
ene a focal point.

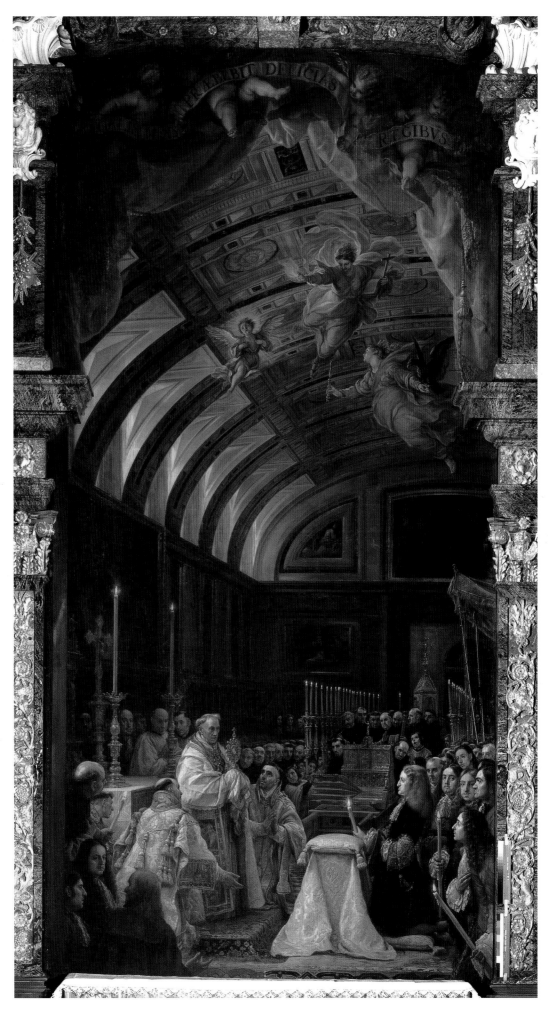

In this section you will:
— **arrange your still life;**
— **set up your lighting;**
— **use a pastel (chalk) colored pencil to draw your subject matter;**
— **prepare your palette while observing your still life and preliminary sketch, keeping your color charts handy;**
— **start your painting using the wet on dry and wet on wet techniques;**
— **clean up and prepare for the next day's painting.**

Our first painting, using fruits and vegetables, allowed you to experie[nce] the brilliant play of reflective surfaces and their overall effect on color. At the same time, you were able to enjoy and discover color in a relaxe[d] manner. By contrast, the next painting will involve a more nuanced a[nd] somber image—earthenware pots that have non reflective surfaces, contrasted with colored glass marbles. The earthenware pots will als[o] allow you to accentuate chiaroscuro shading (see pp. 78–79). The dry, finish of an earthenware pot sharply brings into focus the play of shad[ows] as they move across the form of the pots. Variety in the sizes and shap[es] of the pots will make it eiser to compose your still life.

In our first painting, the primary technique was wet on wet painti[ng]. In this next painting, we will combine wet on wet and wet on dry, wh[ich] is laying down fresh paint over and next to dried paint, working into t[he] unfinished or blank areas, gradually matching the new colors with th[e] old, and employing a technique known as scumbling. Many painting[s are] completed over a period of time, and so in most cases when work nee[ds] to be executed on a day-by-day basis, the working of new paint onto o[ld] becomes the habitual method.

Gustave Caillebotte
The Floor Scrapers
1875
Oil on canvas
39 x 57 in. (100 x 145 cm)
Musée d'Orsay, Paris

The Floor Scrapers is an homage to physical l[abor] painted with passion and observation. The fig[ure] in the upper left next to the light source is bal[anced] by the two figures that are in shadow. The wo[rkers] seem to be creating the composition by their [place] within the composition.

Francisco de Zurbaran
Supper at Emmaus
1639
Oil on canvas
7 ft. 5 ⅝ in. x 5 ft. ⅜ in.
(2.28 x 1.54 m)
Museo National de San Carlos,
Mexico City

Supper at Emmaus is an excellent example of the
chiaroscuro technique of strong lights and darks.
This is especially true in the rendering of the fabric
and the three figures highlighted from a dark
background.

Selecting and Arranging Your Still Life

Using your viewfinder (see p. 72), start arranging several pots in groups some upright and some overturned. Some should face the viewer, while others should be turned slightly away, showing their elliptical shape. The elliptical shape of a circle in perspective is a very commonly found shape which is sometimes very difficult both to see and to draw. I have found the exercise of learning to draw this shape is something of a confidence builder. Arrange the pots using bright, direct lighting. Try to use a light source coming from one direction, such as a spotlight, to make it simple. If most of the ambient light in the room is toned down, the still life will become more dramatic, showing strong lights and darks and a variety of dramatic cast shadows that will allow you to use chiaroscuro shading to great effect. The way in which cast shadows are arranged can create wonderful patterns in the overall composition.

Because the fired-clay pots are dry and nonreflective, include some shiny colorful objects in your still life for reflections and color contrast. Colored glass, such as marbles, will serve this purpose well. Since glass is transparent, you can place it in front of and around some of the pots. Color reflected onto the pots will help you distinguish the surface characteristics. Light will also diffuse through the glass and spread color in the cast shadow.

Your painting, if you choose, can take on quite an abstract point of view; the more interesting compositions are often those that are more abstract in nature. Just as with the fruits and vegetables, you will find that, by zooming into a section of the still life, what you focus on may have an abstract appearance.

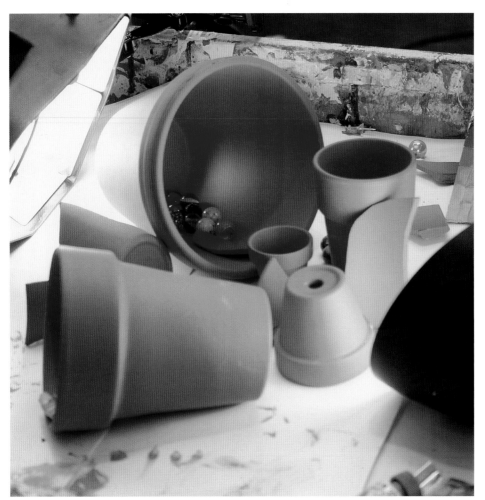

Photograph for still life
The composition for a still life painting begins at the moment the subject matter is chosen, the next step being the physical arrangement of the various objects. The lighting is the final touch prior to preparatory sketches, in order to decide which viewpoint works best. Take note of the proximity of the light source from the right-hand side in this example, and the dramatic shadows and tones that are produced as a result.

Robert Durham
Into the Wee Hours
2001
Oil on panel
13 x 15 in. (33 x 38 cm)
Courtesy of the artist and the
Cumberland Gallery, Nashville

Robert Durham's *Into the Wee Hours* combines wet on wet as well as wet on dry to create a lush canvas of rich colors reflecting from glass to metal to wood. The strong light from the right produces drama and emphasis.

king a Preparatory Sketch

.g your viewfinder and following the same procedure as you did in
 first painting, begin to draw the still life (see pp. 73–74). With this still
you will find the colors and values much more nuanced, but, as in the
 painting, look for value patterns on your pots and, especially, in the
 shadows. You should also pay close attention to the negative space
 es that are created between objects (see p. 76). This negative space
 help you to organize your composition.
 n this painting you will have to search a little harder to see the variety
 tterns. This requires a different emphasis and sensibility, and the
 finder will come in handy. In the first painting, we started off with
 nt color; now you will be taking bright color and toning it down. Some
 e bright colors you used in your painting of fruits and vegetables will
 appear within these pots, but now we are looking at how best to
 rate the more subdued colors that we will find in the tones of the pots.
 eep a light touch with the pastel pencil while maintaining flexibility
 ur drawing. In this painting, the circular and elliptical shapes must
 ays stay round, never coming to a point no matter how much they
 ar to do so. When drawing these shapes it will be helpful to remember
 act that a perfect circle will fit into a perfect square and, by the same
 n, an elliptical shape will fit into a rectangle. If you were to put a
 ght line through the horizontal length of an elliptical shape you would
 ver that the shape of the top and bottom halves was the same. The
 halves effectively reflect each other. Viewfinders and rulers help you
 e this phenomenon by showing you the contrast between their
 ght lines and the curvilinear shape of the pots.
 s in the first painting, if you are drawing the value patterns
 ughout, the sketch will take on a paint-by-numbers appearance.
 effect does not last long and can serve as a type of blueprint for the
 t to follow, disappearing once the paint is applied.

Mixing Your Palette

This wet on dry painting assumes an ongoing daily painting schedule that will allow time for a larger-scale painting. You should try to plan your palette mixing with a sense of how much time you can devote in a given day.

Lay out your choice of either oil or acrylic paints on your palette (see p. 40) and begin to mix them using your palette knife (see pp. 48–49). For this painting, you will need to mix your paints with the rule of "fat over lean" in mind (see box opposite). As you begin to mix specific colors, remember to refer to your chromatic chart, as you will find there many the colors that you will be using for this painting. Knowing that you have already learned to mix these colors will make you more confident as you continue. Pay special attention to the colors within the cast shadows and value patterns as you mix. You will see that the shadows are made up of several different color patterns and values. The color of the shadow bears some relationship to the color of the object it represents. This is another example of reflected color. Beginning students tend to see shadows as dark tones, or more often black, rather than their actual colors. If an object is solid green there is a reasonable expectation that some green tones will appear in its cast shadows. The farther away the light source, the lighter the shape will be. Cast shadows have at least five separate tones and colors created by how close or far away the light source is placed.

Detail of the larger photograph on p.100. The light is coming from two directions, and you can see the difference in reflected light in the marbles and on the pots themselves.

Keep the First Layers Thin

One important rule to keep to when using oil paint is the principle of fat over lean (or thick over thin), particularly on occasions where the drying time is crucial, as it is in the wet on dry technique. "Fat" paint is paint that contains more oil (such as paint straight out of the tube), while "lean" paint has a lower oil content (such as paint mixed with turpentine). If your last layer of paint dries more quickly than your first layer, this will lead to problems such as cracking in the finished painting. Fat over lean means that earlier layers of paint should be leaner, so that the first coats dry faster. When using a painting medium that speeds up the drying time, a good rule is to add a drop or two less for each layer. Each subsequent layer should be thicker and fatter than the one before it.

Fat over lean becomes especially important when using glazing, a technique in which you lay down very transparent colors over a dry underpainting. You can layer many glazes to create particular color effects, but each layer must be allowed to dry fully before the next application. In glazing, a very thin consistency of paint is used, as the painting is built up in layers. When using layers, the rule of thick over thin applies for acrylics as well as for oils: Owing to the quick drying time of acrylics, ignoring this principle may result in uneven areas across the painting surface.

Mix your colors as soon as you observe them. Each tone will be a ntly different shape based on how the light falls on the objects. Within same shadow, you may observe several variations of color; you will t to also include this observation. The shiny glass objects will have adow that is darker but with light tones caused by the light coming ugh. These pieces of glass will also reflect color onto the pots, which be subtle in tone but bright nonetheless.

Since this painting assumes a daily work habit, mixing new color from to day by its very nature results in variety. This tends to prevent you making exactly the same color combinations over and over again, n the reality is that there are many permutations of color. For example, u are mixing red and it seems to work in one part of a painting section, is no guarantee that it should be used again in that same section. Try observe how many varieties of red there are in that area first. Matching colors on dry is trickier than wet on wet, since wet colors pick up light differently than dry colors. With the variety of color within any still matching the colors exactly need not be a concern.

Applying the First Layer of Paint

All painting will, of course, start out wet on dry, as you are applying liqu
to a dry painting surface. As you apply your paint, you will need to bea
in mind the principle of fat over lean (see p.103), in which earlier layers
paint need to be leaner (contain less oil) than later ones. Unless you pai
incredibly fast or work in miniature, you will find that, as is common w:
most painters, you will usually continue your painting at a later time.

On your first day of working on this painting of pots, you should app
some color all over the painting surface, following the patterns you hav
set up in your sketch. Load up your brush and lay down color with a lef
to-right motion, making sure the paint is gently pushed onto the surfac
It is worth mentioning that it is much more difficult to mix and place sn
amounts of color on to the color wheel and chromatic charts that you
created than it will be to mix and place colors on this painting, where y
do not have to worry about staying strictly within the lines. Here, your
lines will be created where one color pattern meets a different one. Do r
draw with the brush, but make your strokes follow a pattern that blenc
the colors together.

You will find that a round brush with its tapered point will be most
helpful in blending two colors together where their wet edges meet. Th
filbert brush with its flat, rounded shape will cover much more ground
when painting larger areas, while the flats and brights will hold a large

Student Brittany Gabey begins
her pot painting by placing
color throughout the canvas.
She carefully starts to delineate
value patterns with color. Even
at the beginning stages, one
senses the strong organization
of space.

of paint to spread around. You should get used to all of your brushes so you can begin to understand how each one behaves. If I had to choose one brush, it would be a very large filbert, which I consider to be one e most versatile of my collection. (See pp. 86–87 for a discussion of the rent types of brush.)

he visual difference in this painting from your painting of fruits and etables, in terms of the value patterns, will be the more uniform shapes e by the pots themselves. In the fruit and vegetable painting, you d be more creative in the patterns and still have a believable painting. the pots, however, the application and the blending of paint must inually follow the round shape to accentuate the smooth surface. will discover while painting the pots that there will be no straight . When pots are leaning against each other there may be the illusion straight line. But, like the elliptical shape that the pots take on in pective, in a frontal view they continue to be round, never coming to int. Viewfinders are helpful in this regard because they have right es against which to compare the curvilinear shapes of the pots.

When you have covered most of the surface of the canvas with paint, ime to finish for the day. Clean up your brushes using the procedure ussed earlier (see pp. 56–57). The next day, you will continue to add e wet paint onto a dry surface, but this time you will try to blend in the t optically or physically with yesterday's rather than painting onto ink canvas.

Brittany continues to build up the surface of her painting, starting to use scumbling on dried paint from earlier painting sessions. As more of the white of the canvas begins to disappear, the colors become richer and change in appearance. Color is relative, and the white of the canvas makes any color appear darker than it actually is.

In this section you will:
— **continue your painting using
 the scumbling technique;**
— **decide when to stop;**
— **clean up;**
— **varnish your painting.**

Scumbling

Starting fresh the next day is an opportunity to create new colors that have a slightly different hue and tone. Do not worry if the new colors a[?] not exactly the same as those mixed the previous day—it is likely that color variety will exist within the still life anyway.

Scumbling comes into play when you are applying fresh paint and need to combine it with previous layers that have dried to the touch. Pa[?] color applied most recently will usually look richer and brighter becaus[?] it is still wet; with scumbling, however, the trace amounts applied are visually closer in appearance to the older layer.

Scumbling relies on the texture, or tooth, of the painting surface. Th[?] tooth creates a drag on the brush so that you do not saturate the area y[?] are glazing. The trace amounts of paint are still wet, but not as juicy as[?] paint you would use for wet on wet. As you scumble across the surface[?] paint that has dried from the previous painting session, you are laying[?] layers of paint with the idea that the original color will still show throug[?] With this technique, you can be as vigorous or as soft as you like with y[?] brush because you will not be disturbing the dry layer. Naturally, you want to make sure that the paint is indeed more than dry to the touch. Traditionally, scumbling has been used to create a lighter tone over a darker color, although it can also be used to add a darker tone. Unlike with other forms of glazing, you may use opaque or transparent colors. Remember, the rule of thick over thin still applies when scumbling.

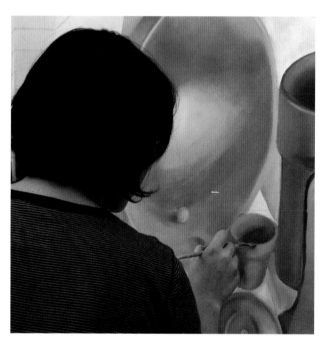

Above and **right**
Brittany Gabey scumbling her painting. She brushes fresh paint over the already dried colors, adding a slightly lighter tone to the rims of the pots.

Opposite
Brittany Gabey
Oil on canvas

The completed painting by Brittany shows exactly what the colors look like once the background color and shadows are put in. With the white of the canvas completely eliminated, the warmth of the colors and the strength of the composition are revealed.

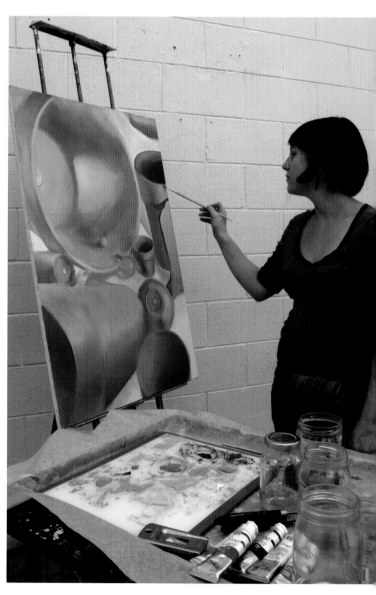

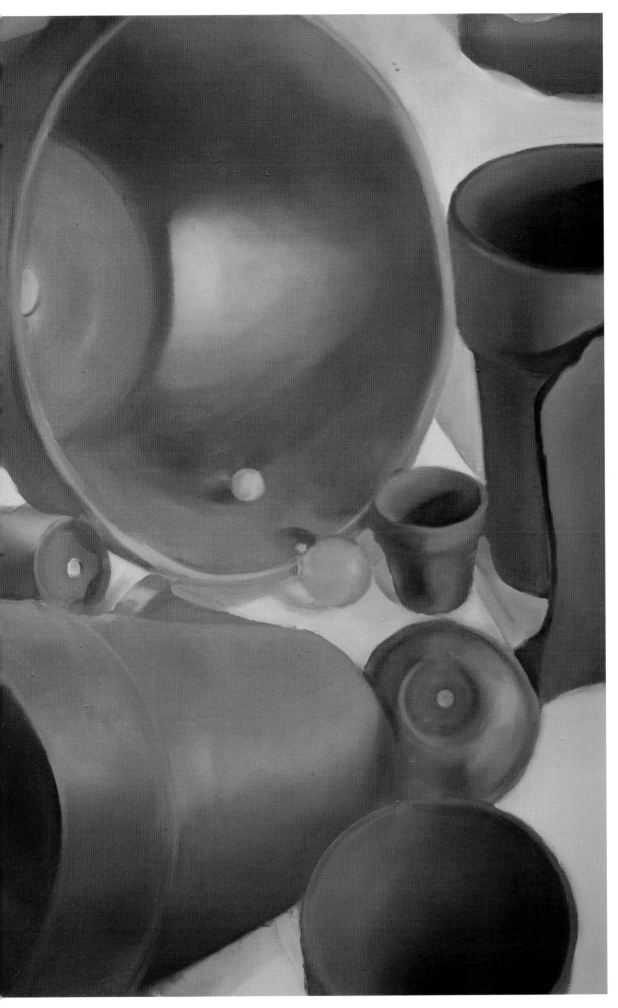

Scumbling Technique

Scumbling is a glazing technique, but rather than adding a juicy wet layer of paint, trace amounts of wet color are spread over the dried paint film, leaving a thin layer of color that changes the appearance of the older paint. Scumbling allows the artist to

add some finishing touches to a paint surface that is already dry without having to repaint whole areas.
This is especially useful in creating highlights, though you can also use scumbling to add darker tones. Many artists prefer to add a bit of painting

medium before they start to scumbl an area; I tend to keep the paint mor on the dry side and work it into and top of the older paint. What you deci to do will be determined by how we the old paint is—you do not want to disturb the original paint layers. Aft

1 Using a stiff bristle or old dried-out sable brush, load up a very small amount of acrylic paint on to the tip.

2 Place a thin coat of paint on the side of the head of the figure (or wherever it needs to be highlighted).

3 Apply just enough pressure to push th paint around the surface of the painti

1 If using oil paint, the technique is very similar, but you don't need to worry so much about drying time. Pick up small amounts of paint with a stiff brush.

2 Apply pressure to move the color across the surface of the painting.

3 Blend in the color.

mbling, you may want to varnish it
ive all the layers a uniform sheen.
te that the quicker drying time of
ylic paint allows you to scumble
r a surface many more times
n oil paint over the course of a
's painting.

Add more pressure on the brush as you continue scumbling.

5

Pull the brush with color along the surface of the painting.

6

Blend the scumbled area in so that the color is less harsh against the dried paint color.

Add color to a different area of the painting.

5

Blend in around the ear and neck.

Completing Your Painting

As you continue with your daily painting schedule, you will get the ha[ng] of how much paint you will need, how much you can paint over the co[urse] of the day, and especially how to save old paint. If you have leftover pa[int] that has been kept covered and in good shape (see p. 56), use that as w[ell] as mixing new paint for the next day's painting.

You can continue to add successive layers of paint over a period of t[ime] using this technique. Always follow the cleanup procedure at the end [of] each day. To know when to finish the painting, consider some of the questions raised at the end of the previous chapter as you completed y[our] painting in the wet on wet method (see p. 92).

Varnishing

Many artists may choose to varnish their finished paintings after lettin[g] them dry for six months to a year. Varnishing is a form of glazing that h[elps] liven up colors that have receded somewhat into the painting surface, something to which the darker colors can be especially prone. It also gives the painting surface a uniform overall shine. This is the key to the difference between a glaze and a varnish. A varnish can only sit on top [of] the surface and hold the paint underneath, and can be removed witho[ut] harming the painting. A glaze becomes part of the permanent painting film, and cannot be removed without disturbing the paint.

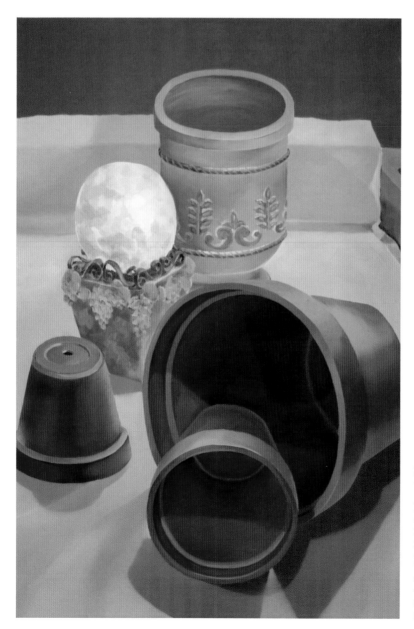

Elizabeth Baek
Oil on canvas

Elizabeth Baek's still life of pots illustrates the illusion of space in the insides of the pots in the foreground. This is instructive in its dramatic use of chiaroscuro: The cast shadows of the pots are examples of wet on wet painting to create this layered effect. Scumbling is later used to create volume.

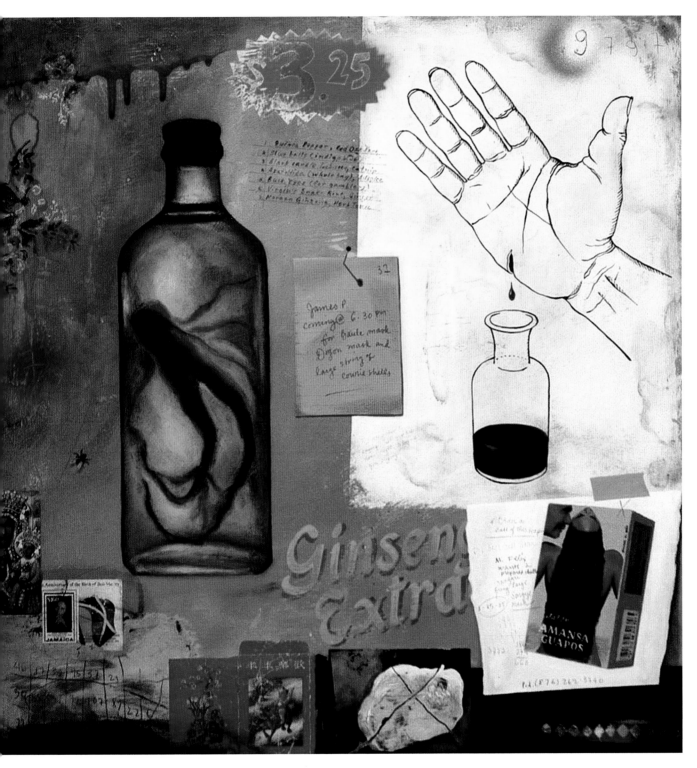

Renée Stout
Ginseng Extract
2005
Acrylic, oil, collage, and mixed
media on wood
24 x 24 in. (61 x 61 cm)
Courtesy of the artist

The imagery in Renée Stout's *Ginseng Extract* is
deeply influenced by African-American culture.
This picture represents Africa and the belief in the
intrinsic power of roots, herbs, and charms—a
belief also found in many other cultures. The motif
is based on the design of a poster, with a nod to
African-American dichotomies of self-image.

Chapter 5:
Third Painting:
Venetian Painting
Technique

The Venetian style of painting, which takes its name from its origins in Venice, became most prominent in the Renaissance between the fourteenth and sixteenth centuries. It uses a method of glazing that involves a number of fixed steps and depends on the color Venetian red both for toning the painting surface and the underpainting itself. First the painting surface is toned with a light covering of Venetian red, which serves as a middle tone. After making a preparatory sketch using a light pastel pencil, you will begin a monochromatic painting using Venetian red, flake white, and ivory black, and some transparent colors used in glazing.

The Venetian technique is closely associated with drawing. It relies solely on a monochromatic underpainting over which, when dry, transparent glazes are applied, allowing it to show through. Treat this underpainting as if it were a charcoal drawing going from dark to light using chiaroscuro shading—you want to put in as many dramatic lights and darks as possible. The colors that are then glazed over the top have the advantage of this value showing through each layer, just like colors over a black and white drawing. One way to achieve this is to apply Venetian red for darker tones and, with the paint still wet, use a clean cotton cloth to pull out some of the darker tones, thus exposing lighter areas. This is a reductive painting technique—it is important to allow the layers to dry before new colors are added in glazes. This style of painting is usually completed in several stages, with small amounts of color applied at a time. Of the three painting techniques covered here, the Venetian is the only one that should be used on its own, owing to drying time.

This is a different route to achieving full-range color, allowing you to build up your tones and colors gradually through multiple layers. In many ways, this style of painting is more akin to drawing, in the sense that you are dealing with values first rather than colors.

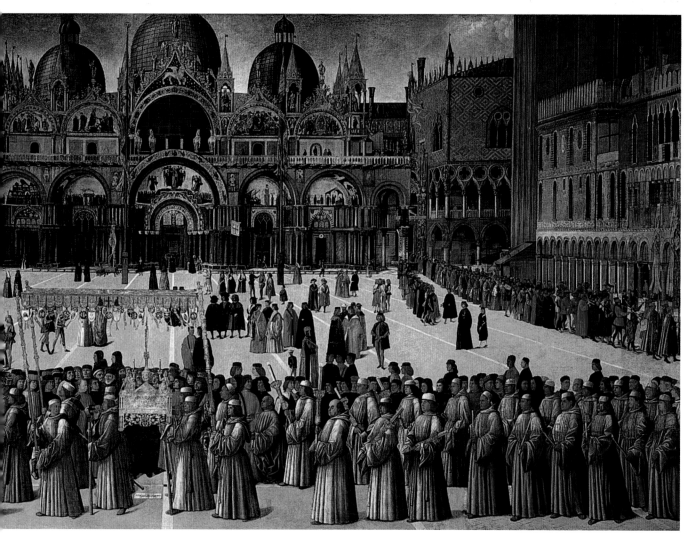

Gentile Bellini
*Procession in the Piazza
San Marco*
1496
Tempera on canvas
12 ft. x 24 ft. 5 ¼ in. (3.7 x 7.5 m)
Gallerie dell' Accademia, Venice

This painting gives both a flavor of the type of
Venetian paintings produced in the fifteenth
century and the beauty of Venice itself. Bellini paid
as much attention to portraying the buildings as
he did in painting the dignitaries themselves.

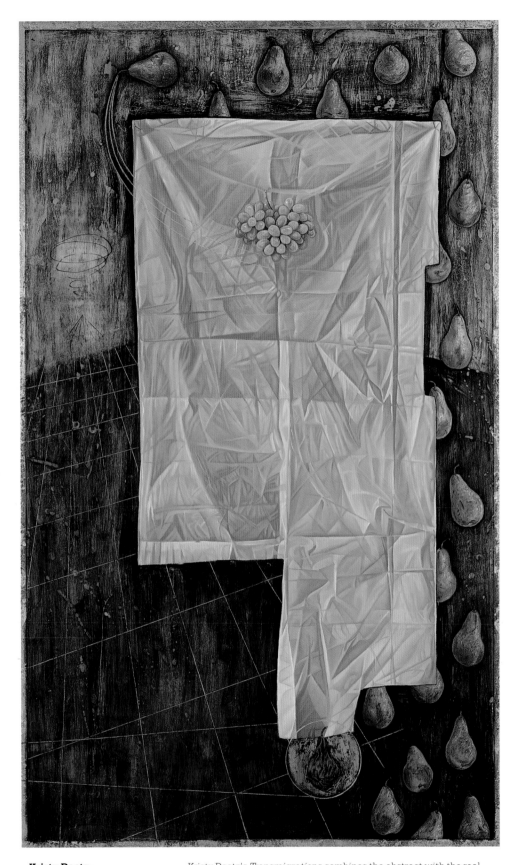

Kristy Deetz
Transmigrations
2000
Encaustic and oil paint on
wood panel
66 x 40 x 2 in.
(167.6 x 101.6 x 5 cm)
Courtesy of the artist

Kristy Deetz's *Transmigrations* combines the abstract with the real
using a variety of techniques. Deetz combines encaustic painting
(the mixing of heated beeswax and pigment) with oil paint on wood
to produce both an illusion and a tactile surface.

Robert Durham
The Well-groomed Male
2006
Oil on linen
32 x 24 in. (81 x 60.9 cm)
Courtesy of the artist and the
Cumberland Gallery, Nashville

The Well-groomed Male is part of a series of
tongue-in-cheek paintings poking fun at
conventional thinking. The vanity of a stuffed
animal and the reference to older popular culture,
in the nod to Burma-Shave, give a historical slant
as well. Though Durham has not used Venetian
red here, the luminosity of his glazing is certainly
reminiscent of the Venetian technique.

In this chapter you will:
— **arrange your still life;**
— **prepare your painting surface with gesso;**
— **tone your painting surface with a wash of Venetian red oil paint thinned with turpentine and trace amounts of the glazing medium;**
— **use a chalk pastel pencil to draw your subject matter;**
— **use Venetian red and your glazing medium to paint in all the dark tones;**
— **use flake white to paint your highlights;**
— **add the final transparent layers using colored paint.**

Selecting and Arranging Your Still Life

For this still life painting, I suggest you use a combination of marbles a drapery. Choose a variety of colored marbles and find a piece of materi with a striped pattern.

Using your viewfinder (see p. 72) arrange your still life so that the striped fabric is draped loosely, creating a pattern in its folds. Then ad some glass marbles, looking at how the striped fabric is reflected in the glass. A very strong and focused light source will produce multiple combinations of reflections for this painting, to dramatic effect.

Preparing with Gesso and Toning the Ground

Start either by using preprepared stretcher bars (see pp. 64–65), or construct your frame before stretching the canvas (see pp. 68–69). Then prepare your painting surface with gesso in the normal way (see pp. 66–67).

The next stage in the Venetian painting method is to apply a toned ground, or surface. Traditionally, Venetian red oil paint has been used this layer (but you can also use acrylic), thinned down with turpentine that it has a loose and watery consistency. Apply this with a brush to t gessoed ground, which should be thoroughly dried beforehand, and th wipe off the excess with a cotton cloth.

Allow a day for the ground to dry and then sand to a smooth surfac texture.

Photograph of the marble still life arrangement that is to be painted in stages throughout this chapter.

ing a Preparatory Sketch

e your preparatory sketch on the dry surface using a light-colored chalk
el pencil (using a pastel rather than a graphite pencil means that the
s of your drawing will dissolve when you apply wet paint). As you
in your sketch, you need to pay close attention to the patterns of the
erial and how they may distort when seen through the marbles.
will see that the shadows the marbles make on the material contain
ctions and may behave quite differently from the shadows of solid
cts, in many instances appearing lighter than the marbles themselves.
a number of arrangements: You can move the marbles around during
course of the painting to achieve the effect you want. Once you begin
nderstand how the marbles and the material behave visually, you can
ome more inventive. The marbles and material will appear slightly
erent from one day to another according to the light. Allowing your
t source to be aimed directly at some of the marbles will create shadows
t have a sheen as well as a darker tone.
Do not forget to use your viewfinder to help organize your composition,
remember that painting from observation in many ways involves as
ch creative license as actual observation.

First Layer: Monochromatic Underpainting: Creating Dark Values

Once the sketch is complete, you are ready to start the next process. Fo[r] this first layer, you will be using only Venetian red paint with a premix[ed] glazing medium (see box below), applied in thin, dark layers, to put in [the] dark values. Just as with a charcoal drawing, you are concerned with seeing the values and the shapes that they form in your still life.

Apply the Venetian red to all the dark tones you see in your still life. Your first layer of paint should be the thinnest (leanest)—about the consistency of creamy peanut butter, with only a drop or two of the medium used—and relatively quick-drying so that the top layers do n[ot] dry before the bottom ones and lead to cracking. Successive layers sho[uld] gradually become thicker (fatter) as you add more medium. Avoid excessive amounts of medium, however, as the paint surface will beco[me] too smooth for the next layer to adhere properly; layers of paint attach much more securely to a surface with some tooth. There will be variati[on] in the dark tones of your still life setup, with some being lighter than others, and you should keep this in mind so as to avoid a cutout feel. Yo[u] can always wipe some of the paint off with a cotton rag to create lighte[r] dark tones.

Continue this process as if you were doing a black-and-white draw[ing,] placing all the different values of the dark tones. In this underpainting [you] will be creating combinations of tone. Remember that small amounts [of] paint spread over an area accomplish much more than one thick layer. In many ways this is very similar to a drawing using chiaroscuro for yo[ur] lights and darks (see pp. 78–79).

Clean up for the next day's painting (see pp. 56–57) and let the canv[as] dry overnight.

Glazing Medium

You can control the thickness or viscosity of your paint by the use of your painting or glazing medium: the more medium, the thicker the paint. For the Venetian style of glazing, I recommend you use the following proportions to make your formula. Once this has been mixed, it should be kept in a separate container with a top.

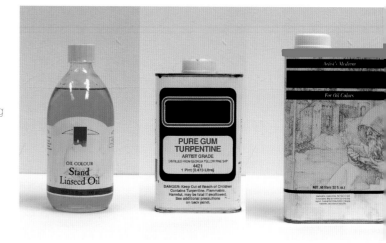

1 fl. oz. (30 ml) damar varnish
1 fl. oz. (30 ml) stand oil
5 fl. oz. (150 ml) pure gum turpentine
(or water if using acrylics)

In this detail of the second layer, you will notice that the dark tones are beginning to be emphasized, and white tones have been highlighted.

ond Layer: Adding Highlights

that you have your dark tones and shadows, you will begin to paint
iighlights in your still life. For this stage, use your flake white, noted
s transparency, which will still allow some of your original sketch to
v through. (Use gloves because of the lead content of this particular
t.) Paint in all the light areas you see. As with the darker tones, there
be a variety of light tones for you to observe. If need be, you can go
and work on the darks and the lights at the same time by mixing the
etian red with the flake white. If you are using the two colors in this
keep the thickness (fatness) of the paints as equal as possible.
will need to wait until these areas are dry before starting to paint the
day. Clean up at the end of underpainting, which is now ready for
inal stages.

Final Colored Transparent Layers

The final stages of the painting are worked with a series of transparent glazes, using your full range of colors instead of just the Venetian red a flake white. This is where you need to be disciplined. You have been he back from using all that bright and juicy color, but now you must try n to race to the finish; let the painting unfold slowly. The paint should be applied thinly and allowed to dry between each layer.

In this form of glazing, you will use particular paint colors that are noted for their transparency. A sense of luminosity is the goal for this painting. The colors that I recommended to you for your full-range colo palette (see p. 82) will also work with the Venetian technique. Some of the colors are more transparent than others. For those from the full-ran color palette that are transparent, see box below.

Mix your transparent colors on your palette with a palette knife (see pp. 48–49) and then add a drop of your glazing formula (see p. 120)

Once you have mixed your colors, start to apply them carefully to t lights and darks. You are not trying to cover up the underpainting; on t contrary, you want only to glaze color over the top. As you add layers, can wipe or dab paint away to create the effect that you want to achie As you gradually add colors, the image slowly evolves into richer tones Because the darks and lights were applied first, the color on top will be dependent on the shades underneath.

Transparent Colors from the Full-range Color Palette

If there is no clue on the packaging as to whether your colors are transparent, you can check by drawing a series of dark lines in indelible ink on a piece of paper, taking a dab of your color, and spreading it over these lines with a palette knife. Those paints that go over the dark lines and cover them well are obviously not transparent. Although you may think that some of these colors (right) seem rather dark, their transparent nature is in their hide, or covering power, and is thus not immediately apparent.

Lemon yellow

Alizarin crimson

Ultramarine blue dee

Viridian green

Sap green

Ivory black

Having placed early layers using Venetian red and flake white, the green layers of color are then added on top, allowing the darks and lights to come through. This is how transparency in layers is produced.

There are many ways to create and mix your colors. You can work on the entire painting in one day or concentrate on particular sections. Once the layer of glaze has dried, another layer of color may be applied. Each layer should be a little thicker (fatter) than the previous one. Remember to clean up between each layer.

This form of glazing does not necessarily result in a reddish tone unless the subject matter happens to contain some reds. This underpainting is a middle tone between the darkest and lightest values within a painting. Just as a grayscale value chart is usually drawn or painted in nine to eleven steps, with black at the bottom and then equal stages of tone proceeding to the white of the paper, so this underpainting is the middle gray. As you add colored layers on top, plan your mixing according to the effects you want to create: For example, if the material in your still life is green, placing yellow on top of the green in your painting will lighten it. You will still mix new colors on your palette, but you must allow for the mixing that occurs by way of glazing. As mentioned earlier, the shadows formed from the marbles are transparent in nature and, depending on the light source, will have highlights comparable to the lightest light of the marble itself. The lighter areas in your painting will have darker tones around them, as you have learned with chiaroscuro shading.

What makes this technique so interesting for the beginner is that you really have time for trial and error and you can observe the subtlety of changing color schemes. With this extra time, you can plan what areas to concentrate on as you move toward completion.

When you have finished (see p. 92 on tips on when to stop), clean up both your palette and your brushes.

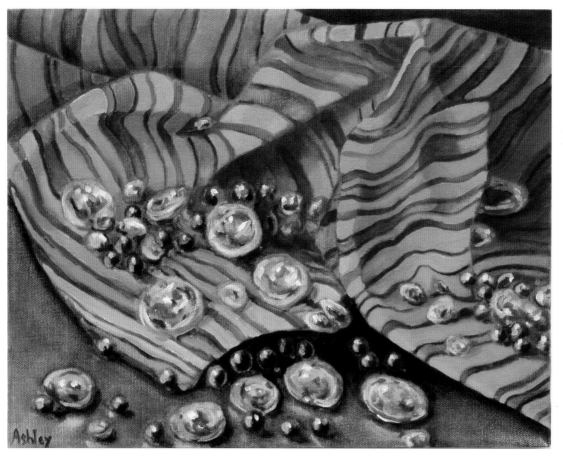

Ashley Long
Oil on canvas

Ashley Long's painting of glass beads on striped cloth is an example of reflective light on colorful material, also highlighting the transparency of the beads themselves.

is never too early to think philosophically of what you, as a new
er, hope to gain from this journey. Taste in art can be cyclical,
cated on changing mores and generational shifts in what is perceived
of value. I personally find a sense of freedom in the notion that what
ld is, or can be, new again. It is your stamp of individuality that
es newness. It is true, however, that you may not always find
hon ground with your audience, and I believe that it is more difficult
so if your main aim is to please. Have the confidence to put your
ound skills *and* your passion into your work; then, when *you* are
ied, present your work with the anticipation that others may
eciate and understand what you have done.
hinking about these issues may seem unduly weighty and premature,
would argue that it is an integral part of becoming a painter, along
honing your skills and gaining a knowledge of what has come before.

Andrew Lenaghan
Coney Self-portrait
2006
Oil on panel
12 x 24 in. (30.4 x 60.8 cm)
Courtesy of George Adams
Gallery, New York

Coney Self-portrait is an
impressive example of on-site
landscape painting from direct
observation. Lenaghan literally
puts the viewer in the driver's
seat. It is a lively romp in what
appears to be a fast-moving car,
with a nod to "I see you looking"
in the self-portrait in the
rearview mirror. Most artists
who work in this tradition take
creative liberties to interpret
what they see and feel, and
pull you in. This painting—part
still life, part portrait, and part
landscape—combines many of
the simple painting elements
that you have learned, taking
them to a very sophisticated level.

In this section you will:
— **prepare your painting surface with gesso in advance;**
— **choose your painting site and bring along a sketchbook and/or a camera;**
— **using a viewfinder, make a few preliminary drawings in your sketchbook;**
— **prepare your palette while observing your subject matter;**
— **use a chalk pastel color pencil to sketch out your subject matter, referring to your early sketches as well as working from observation;**
— **start your painting.**

Opposite
Ken McLeskey
The Narrows, S.W. Utah
2004
Oil on linen
40 x 58 in. (101.6 x 147 cm)
Courtesy of the artist

McLeskey's landscape presents the viewer with an open composition, which means his cropping decisions allude to a continuation of the imagery beyond the borders of the canvas. Strong visual drama is borne of careful use of scale and contrast. Additionally, the compositional ploys used here are the severe angles, close cropped spaces, and organization of the negative space. Nature has its own sense of design, and it is the artist who decides how to order the given elements within a painting. The simple design principle of overlapping, with objects appearing smaller as they move farther from view, is in some ways thrown on its head here. In this image, we are invited to walk in and sit at the bottom of the space looking up. By not having a traditional horizon, the viewer can look up and down and feel the size of the area.

Landscape

Landscape painting is best done from life and, therefore, outdoors. Working from life helps you to understand color, because you will see how light changes the colors in front of you over the course of the day. beginning students, the landscape may seem quite overwhelming at f but like all paintings, landscape is always your interpretation. The art Claude Monet was known to leave friends and dash away to paint if a certain time of day produced the desired match of color for him to com a landscape painting.

If you do not want to paint outdoors, there are alternatives. You cou arrange an indoor still life to include a mirror facing outside, which ser to bring the outdoors into the composition. You could start to paint outdoors and then continue indoors, using a photograph taken of your chosen view. However, you should be aware that a photograph does n always show all the possibilities that you would see in the landscape i you were actually sitting outside looking at it. The camera freeze-fram a moment via the lens and can flatten, darken, and exaggerate differe parts of the image without necessarily showing the subtlety of tonal changes. When shown a snapshot, most observers will look for specific information, not necessarily the intricate details about light and dark. photograph gives the appearance of complete accuracy, and most view do not challenge this point. Nonetheless, working from a photograph i combination with painting from life is often done and can be quite use The challenge is to learn how best to use the photograph, rather than merely making a copy. As you study a photograph, use it to give you id about the natural world. After all, you make the decisions about what include in your landscape.

Painting on site requires a traveling kit. You can purchase what is called a French easel, which is a combination of a seat and easel plus drawers for your art supplies. It folds into a suitcase for ease of travel. / alternative to such expensive equipment, you could use a fish-and-tac supply box to hold your paints and brushes, which also doubles as a surface against which to lean your painting. Your travel supplies are n much different than what you would use for the studio: paint medium, canvas, brushes, palette, and an umbrella to ward off the elements an protect your painting surface from dust and insects. Remember to brin your color wheel and chromatic color chart as well. Many artists choos make small, very detailed painted studies and photographs to reprodu later on a larger scale in the studio. Whatever you decide, remember th paint tends to dry faster outside, so plan with that in mind.

What you learned from the first three paintings regarding color relationships, patterns, reflections, lighting, chiaroscuro shading, and composition will serve you well in this landscape painting. Painting th landscape or cityscape is a study in making sense out of vastness usin combination of inclusion and exclusion. We generally notice only what need to as we move through our environments, giving attention only t what is relevant. For example, while climbing up stairs you might noti

Subject Matter and Content

James Valerio
Chicago
2002
Oil on canvas
60 x 72 in. (152.4 x 182.8 cm)
Private collection.
Image courtesy of George
Adams Gallery, New York

James Valerio places his back to
the viewer while he is engaged
in a private moment. The image
offers the viewer an invitation to
look over his shoulder and share
in his love of place, time, and
contemplation. The experience
of viewing the painting then
becomes a private moment for
the viewer as well. The observer
is witness to a naturally
occurring cityscape, which is an
individual interpretation of the
artist's viewpoint.

the step, but not the color or shade. Conversely, as you begin to observe
with an eye to detail, you can get caught up in the naming and
understanding of what is around you. You now see the step and the col
but not in the most natural way.

My theory is that you should paint things as you see them, as oppo
to trying to include every single detail. However, as you start to really
observe color, you will automatically see things in a new way. In the sa
way that you learned to understand how a piece of striped cloth behav
with a shiny object placed on top, you should learn to look at and
understand the outside environment as well.

After choosing and preparing your painting surface with gesso, ma
your preparatory sketch in the same fashion as all of the previously
mentioned painting methods. The major difference in painting outdoo
however, is the greater role that your viewfinder will play in organizing
your composition. You can make a variety of choices of what to include
as you begin this sketch, and you would still look for the kinds of value
patterns that appear in nature. For example, you may decide to rearran
the landscape in your sketch, ending up with a composite representati

of all, choose for your interpretation what interests you in the
cape. As you did in the early paintings, use your pastel pencil to
the many abstract shapes that are found in nature.

y to notice the basic shapes and colors as they interact with each
. You will see that the landscape can have a rather abstract
arance as you continue to look in this way. Use your viewfinder to see
nteraction of positive and negative space and start to create designs,
h can be incorporated into your painting. In many ways, there will
ore of a sense of inventiveness and risk-taking. Your point of view is
ens through which you visually interpret your world. No two artists
ee the same place in the same way, so even though you may be
enced by others, you will put your individual stamp on the image.

nce you have completed your sketch, palette preparation is next. Your
wheel and chromatic color chart should be available for reference.
 far you have learned wet on wet, wet on dry with scumbling, and
tian glazing painting techniques. Depending on the size of your
as and how much time you can give for a painting session, a variety
hniques could be used over the course of the painting. If you decide
rk with Venetian glazing, it would be best to keep the canvas small.

ace your painting mediums in containers near your palette (acrylic
aint will also require a plastic plant mister).

ith your choice of either oil or acrylic paints (see p. 40), lay out all of
ur yellows in a row along the edge of the palette. Follow the same
attern with all of your oranges, reds, blues, and greens. Lay out small
mounts of white for the yellow section, the blue section, the red
ection, and the green section. The amount of paint you need will be
etermined by the size of your canvas, so the amount you squeeze from
e tube can only be an estimate. As you observe your landscape, start
ff by mixing at least ten colors. See Chapter 2 if you need to refresh
ur memory about mixing and mediums.

hoose an area of your landscape to paint.

 every effort to trust the first few strokes of color that you make,
use the painting is going to go through many changes before you
le that it is complete. Remember the principle of fat over lean (see
3). If you are working over several hours, the color of the sky will
ge, and depicting this in your painting presents challenges. As a
ning painter, experiment and see what happens. Some artists choose
int outdoors at times when the conditions are as close as possible to
e when they started the painting. Some choose to average out the
ges in color that can be seen any time between sunrise and sunset.
ly, if you are after a sunset, you will want to time your outings
rdingly. If you are making a series of paintings, perhaps making
paintings daily will help you find the right pace.

These two preliminary sketch[es] are examples of open drawi[ng]. Open drawings allude to a continuation of the image beyond the boundaries of th[e] canvas. This sense of the op[en] drawing has to do with crop[ping] in ways that suggest that th[e] image continues beyond th[e] borders of the painting surf[ace]. When you aim a camera, th[e] rectangle of the viewfinder creates a window around a [part] of the view. Many times stu[dents] will start in the middle of th[e] canvas and have their subje[ct] matter floating. This would describe a somewhat close[d] composition.

Above top
John Lutz landscape in progress.

Above
John Lutz completed landscape painting.

e two finished examples of
nt landscape paintings
the same view from
ent angles and viewpoints.
lso another example on
y Laurin Ramsey.) What is
nt in each is the panoramic
of space defined by
spheric perspective.
spheric perspective is the
that you see in a faraway
cape on a day when the
y is affected by particles
air, which cause a subtle
ge in the colors and, to
extent, the shapes in the
These students chose to
de some buildings and
that were closer to them,
by also giving the viewer
se of scale, with the
tains in the background
ing a sense of distance.
use of softer and lighter
for the background adds
spatial qualities as well.
student has depicted his
own interpretation of
ilar scene from varying
points.

Top
Amanda Henke landscape
painting in progress.

Above
Amanda Henke completed
landscape painting.

Portraiture

In this section you will:
— **prepare your painting surface with gesso in advance;**
— **choose yourself, or a friend, and bring along a sketchbook and/or a camera;**
— **use a mirror and/or a viewfinder to make a few preliminary drawings in your sketchbook;**
— **draw the face, carefully observing the bone structure and the shape of the value patterns;**
— **prepare your palette while observing your subject matter;**
— **use a chalk pastel color pencil to sketch out your subject matter, referring to your early sketches as well as working from observation;**
— **start your painting.**

Portraiture and the self-portrait have rich historical and cultural traditi: that range from the straight depiction of likeness to other more psychological and allegorical premises. For the beginner, painting a pe often seems to awaken built-in fears. I find that students are more affe by success or failure in making a self-portrait than in other forms of painting. The beginner's assumption, I believe, is that we ought to kno what we or others look like. Instead, I encourage my students to think portraiture as a series of impressions. What you feel about your subject what he or she is willing to let you see are key components in making a likeness, which is much more personal than a quick snapshot. When I paint a portrait, it is usually someone I either know well or want to kno well. I engage in conversation and encourage the sitter to look at the w in progress, so that he or she starts to feel involved. In my studio I often the sitter whether the image feels familiar—not "Does it look like you?

The best way for the beginner to learn portraiture is to start with th self-portrait. Who else, after all, will be so committed for the long haul? A mirror and a series of photographs from multiple viewpoints is more than enough to begin. As an aid to really seeing color in skin tones it is recommended that you choose black-and-white photographs so that y color choices will come from what you see in the mirror rather than bei an attempt to imitate photographic color. New painters are often quite about the revelation a self-portrait may convey. Remember, this painti. is also an interpretation, and you should allow yourself to take creative liberties. I have made many self-portraits over the years and no two lo alike, but they all reveal aspects of who I am and how I was feeling at that point in time.

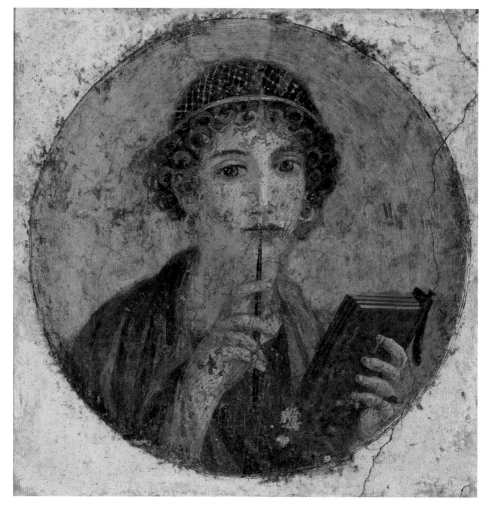

Anonymous
Portrait of a Young Woman Wearing a Hairnet
1st century AD
Wall painting
11 ⅜ in. (28 cm) diameter
Museo Nazionale Archeolog
Naples

This example of a fresco por of a young woman has a rath contemporary gaze that is somewhat inward in nature. That it was discovered in the of Pompeii covered in volcar ash makes it even more poig and timeless.

Leonardo da Vinci
Mona Lisa
c. 1503
Oil on panel
38 ½ x 21 in. (97.8 x 53.3 cm)
Musée du Louvre, Paris

Leonardo's *Mona Lisa* is famous for the subject's visual placement and enigmatic half-smile. For students of portrait painting, it is important to understand the crafting of this work. The atmospheric perspective of the background emphasizes the closeness of the figure on the picture plane.

Chuck Close
Big Self-portrait
1967–68
Acrylic on canvas
107 ½ x 83 ½ x 2 in.
(273 x 212 x 5 cm)
Collection Walker Art Center,
Minneapolis

In Close's *Big Self-portrait*, his portrayal is one of self-assurance: What you see is what you get. The shape and direction of the shadows across his face form a focal point, which keeps his gaze on the viewer. The use of grayscale rather than color allows no distraction from this engagement with his persona. Despite the cyclical nature of art conventions, Chuck Close presents the portrait as a dialogue that must be taken on the terms of the artist.

Chuck Close
Self-portrait
2004–5
Oil on canvas
8 ft. 6 in. x 7 ft. ½ in.
(259.1 x 214.6 cm)
Courtesy Pace Wildenstein,
New York

The thirty-seven years separating the *Big Self-portrait* (oppposite) from *Self-portrait* have not changed the visual impact and gaze. Close's more recent work in color has centered on a painting style using a series of abstracted shapes and marks, which, through the juxtaposition of individual color patterns, results in full chiaroscuro shading. If anything, the gaze has become more penetrating and poignant since his earlier self-portrait.

Diane Edison
Portrait of Lesley Dill
1996
Oil on panel
9 x 12 in. (22.8 x 30.4 cm)
Private collection

As a realist, I am concerned with accuracy in depicting the anatomical structure of a face; at the same time, in my portrait of Lesley, the power and gaze of the sitter is most important. In this portrait, I used a chromatic gray for the background to highlight and bring her face into the forefront. This choice was made after the principal part of the painting was completed. The painting was executed in wet on wet style over a long day, working from both photographs and life.

Diane Edison
Self-portrait, Side View
1996
Oil on panel
9 x 11 in. (22.8 x 27.9 cm)
Private collection

I created my self-portrait using three mirrors to capture the side view, together with a photograph. By moving completely away from the viewer's gaze, my image is private and inward. The style of this painting is wet on wet.

Before you begin any portrait, you first have to decide how much of
subject you want to include. There is no right way, only the way that yo
think works—you may choose a full-frontal, three-quarter, or side view
the whole body. Be prepared to break the rules the moment you underst
them: They are guideposts and parameters that you may break free fro
if you choose. Also, do not underestimate the creative possibilities of a
so-called mistake—your painting and which point of view you decide t
show will usually be well-planned, but there will almost always be som
accidental, unplanned element to it, which you can turn to creative
advantage. I would suggest that you start by working small and comple
a painting in a day, as this gives you more time to experiment.

It is useful to note that although the term "portrait painting" may, t
some, connote a commercial aspect, you are free to improvise as you w
Defining what constitutes a portrait should be left open to the artist an
the viewer. When I am working on a portrait, the emotion and power of
interaction between the sitter and myself is quite evident. I choose to v
in the traditional chiaroscuro technique to add to the complexity of the
subject. The portrait might loosely be defined as simple point of view, a
in a camera angle; you might just as well state that what you choose to
include is a portrait of a viewpoint. The real issue is not to let yourself b
hedged in by what you think your viewers might like to see. As new
painters, take care that you do not become so bogged down in the mas
of technique that you forget about why you want to do this. Painting is
and foremost about self-expression.

Robert Durham
What You Never Knew
About Daycare
2006
Oil on canvas, diptych
Each panel 12 x 16 in.
(30.4 x 40.6 cm)
Courtesy of the artist and the
Cumberland Gallery, Nashville

Robert Durham's painting of the secret lives of
babies is at once arresting and funny. He depi
the physicality of infant bodies with a sly nod
wink to eventual grown-up behavior. Through
observation, Durham has captured the wonde
richness in the individual color distinction in
each child, especially the way in which color a
light reflects onto and over the surface of brow
skin tones, while lighter skin tones are more
absorbent of light.

Claire Joyce
A Quarter-life Crisis in Three Parts
2005–6
Elmer's glue and glitter on panel
Each panel 8 x 4 ft.
(244 x 122 cm)
Courtesy of the artist

Claire Joyce's three-paneled self-portrait using colored glitter on wood panels exemplifies a playful trickster's point of view, with the nontraditional media serving as a counterpoint to the serious nature of the unfolding narrative, which is about journey, growth, doubt, and fulfilment.

Portrait in Progress

Step-by-step portrait of Rebekah by student David Zoellick.
David Zoellick began this step-by-step painting with good preparation,
combining a photograph with sitting with his subject Rebekah,
also a beginning painter.

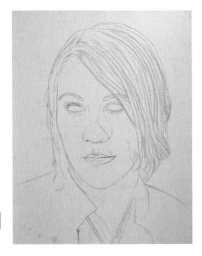

1 Preliminary sketch of the subject for this portrait using pastel pencil on the painting surface.

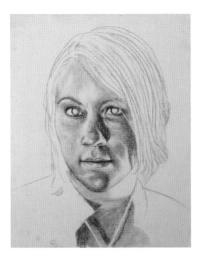

2 Using pastel to shade in some lights and darks.

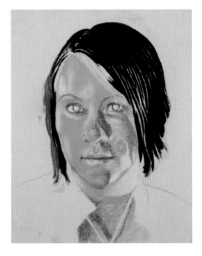

3 Starting to paint light and dark areas on the painting surface, bringing in dramatic lights and darks using chiaroscuro shading.

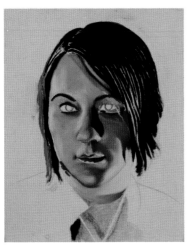

4 Continuing to paint in a variety of values and shapes throughout the painting.

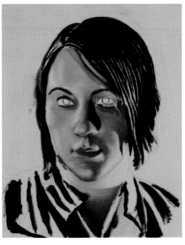

5 Painting light and dark shapes through the figure.

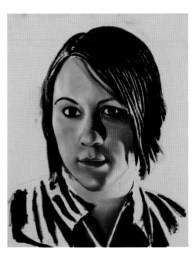

6 Fully blended dramatic lights and darks.

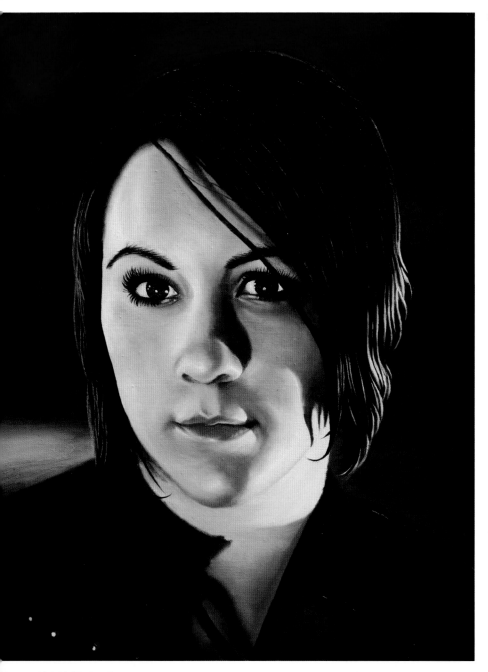

7 **David Zoellick**
Oil on canvas

David's completed portrait of
Rebekah clearly shows the effect
that the lighting has on the
contours of her face. The cast
shadows, reflected color, and
contrast of dark against light
create a dramatic composition
that exemplifies chiaroscuro
shading. Taking photographs of
each stage of the painting
enabled David to spend time
making good decisions based on
previous developments.

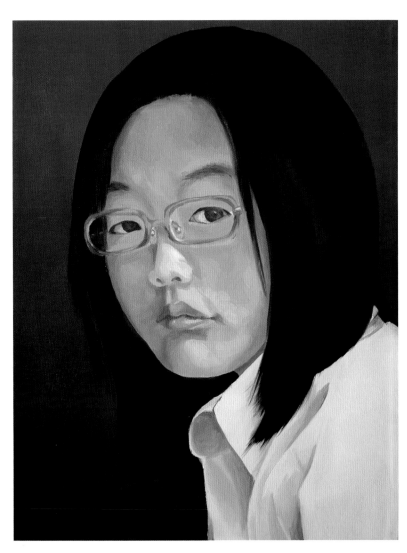

Left
Elizabeth Baek
Oil on canvas

The self-portrait of Elizabeth Baek is created in a three-quarter view. This angle has her face turning slightly away from the viewer. It has been painted with a combination of the wet on wet and wet on dry technique using a combination of a photograph and a mirror for reference.

Right
Tyler Brantley
Oil on canvas

This self-portrait of Tyler Brantley is direct in its gaze and full-frontal. The point of contact in this painting is his eyes, which are level with the viewer. The background colors and patterns direct you to his face in an almost halolike way.

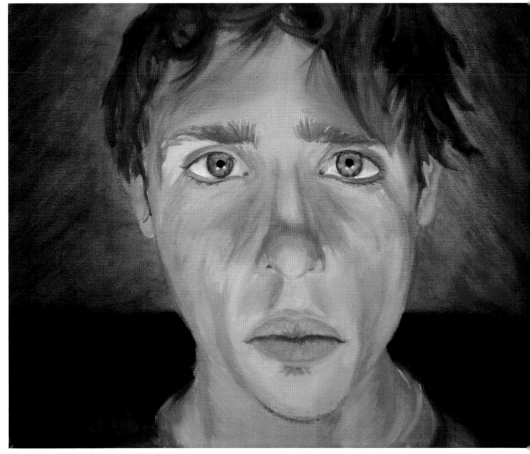

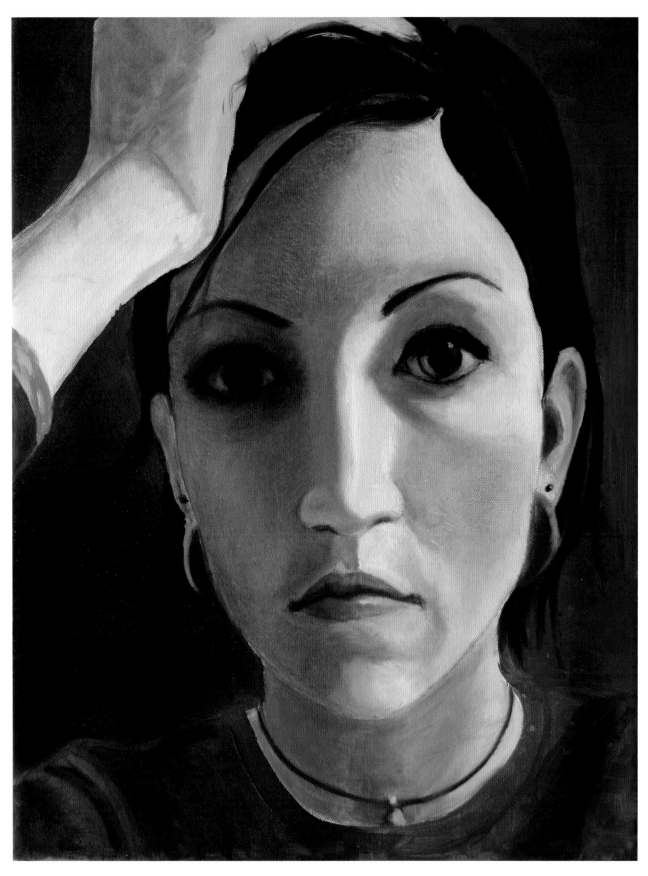

Holly Soros
Oil on canvas

This portrait of Holly Soros is a somewhat psychological interpretation, with her eyes just slightly averted from the viewer. The hand on her head suggests support and creates an interesting composition as well.

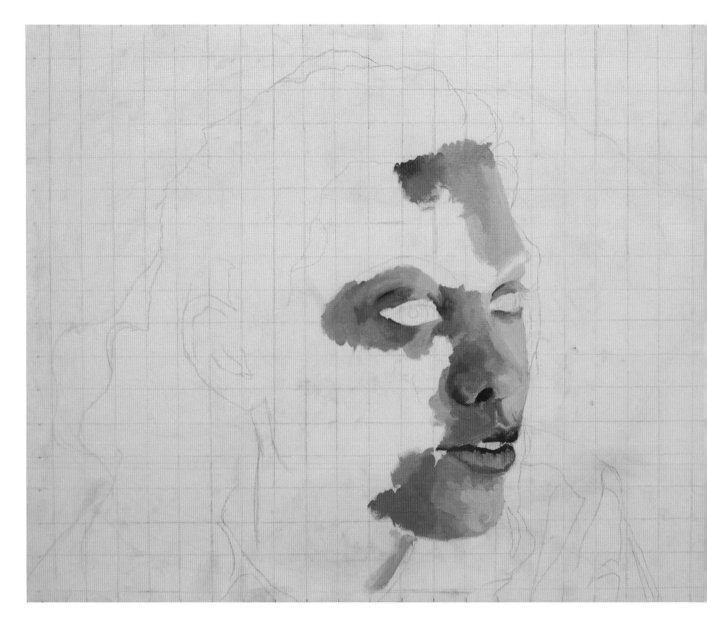

At this stage of a student se
portrait by Rebecca Claire
Stephens, a grid was used t
the proportions correct. The
is drawn on a photograph,
is then enlarged on the can
using each of the squares a
sort of mini viewfinder.

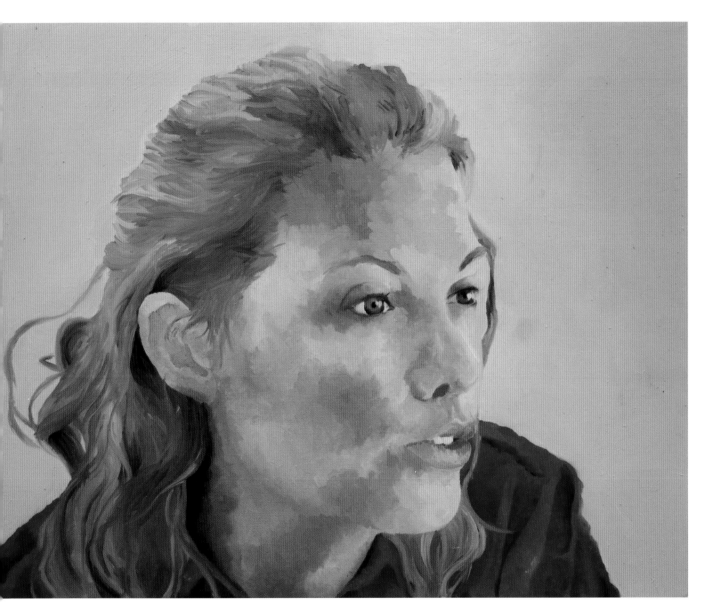

Rebecca Claire Stephens
Oil on canvas

Completed self-portrait by Rebecca Claire Stephens. Note how the same tones of color are used for every aspect of her canvas, and how the lower part of her face is set off by the reddish color of her shirt.

Radcliffe Bailey
One of Four Corners
2005
Photograph and mixed media
on panel
90 x 90 in. (228.6 x 228.6 cm)
Solomon Projects, Atlanta,
Georgia

This is one of four paintings with the same title,
each of which stands alone yet forms a part of
the whole. Bailey's painting combines paint,
photography, and other media to create a grand
sense of space. The very personal iconography
of the imagery focuses on family and time. The
photograph of the seated woman, along with a
blue-tinted color scheme, presents a mood of both
sadness and dignity at once. The cool colors retreat
visually, but the contrast keeps the image floating
up front. The tree imagery further adds to the
centrality of the stance of the woman.

Luis Cruz Azaceta
*Homage to Latin-American
Victims of Dictators, Oppression,
Torture, and Murder*
1987
Acrylic on canvas
77 ½ x 168 in. (196.8 x 426.7 cm)
Courtesy of George Adams
Gallery, New York

The intent of Azaceta's political title is more than
amplified through the painting's imagery, with the
symbolic sacrificial figure bound and controlled.
The use of a cool blue background color serves to
project the figure even closer into the foreground.

Stefanie Jackson
The Raft is not the Shore
2006
Oil on canvas
72 x 36 in. (182.8 x 91.4 cm)
Courtesy of the artist

In the tradition of heroic
painting, Stefanie Jackson
depicts images inspired by
recent flooding and storm
damage that occurred in Ne[w]
Orleans in 2005. The messa[ge]
is also about the many face[s of]
disaster and how those peo[ple]
affected keep their emotion[s and]
wits together. The closed-in[?]
feeling of the composition
heightens the sense of urge[ncy,]
though Jackson does not pr[ovide]
an easy way out—rather, sh[e]
forces the viewer to look on
helplessly, almost with a se[nse]
of collusion.

Antonios von Santorinios-Santorinakis
Four Seasons on Santorini—Spring
1980
Acrylic on glass
23 x 31 ½ in. (60 x 80 cm)
Private collection

Four Seasons on Santorini—Spring is an imaginative interpretation of a landscape with figures. Color usage is closer to local color, which is color that is unaffected by light and dark. In your painting assignments thus far, you have been exposed to full-range color that is very much dependent on the natural environment. Here, the background at times appears to be closer than it possibly could be, the result of bright contrast and heavy details, which is normally how we view items that are closer to us.

Abstraction

So far, you have been introduced to painting from a traditional and representational point of view. We will now explore pure abstraction by looking at some recent paintings by students. Studying closely the paintings of others, observing what you like and do not like, and making notes about the way in which certain effects are achieved will help you formulate your own ideas of how to approach your own abstract painti Remember that you have already been encouraged to use an abstract design quality when using the viewfinder—the cropping makes some imagery visually unclear and random. How and why artists choose abstraction is as varied and personal as any other choice, and it sometir requires a leap of faith to move from representative to nonobjective, or abstract, imagery. You should consider what you are aiming for in an abstract painting and how best to articulate that aim on the canvas.

Madeline Edwards
Oil on canvas

Student Madeline Edwards combines four separate canvases to create a whole, with imagery that mimics nature. Each panel could very well exist as a stand-alone painting as well.

Clarence Morgan
Subliminal Memory
2003
Acrylic, pencil, and ink on Mylar
59 x 59 in. (149.8 x 149.8 cm)
Courtesy of the artist

Clarence Morgan's painting is accentuated by both deep and shallow illusory space. His distillation of color and pervasive use of spheres and elliptical shapes further create a powerful space, which transcends the edges of the canvas, giving an illusory sense of weight and spaciousness.

Krista Franks
Oil paint, paper, transfers, and acrylic paint on canvas

Student Krista Franks uses the motif of the church to create a tableau of faith. She combines paint, news clippings, and transfers, repeating the shapes above the steeple for emphasis. She has also used text that visually and literally continues the narrative.

Miriam Rowe
Oil on canvas

This abstract oil painting by student Miriam Rowe is based on an interpretation of necklaces and other pieces of jewelry. The abstract quality comes from the way in which positive/negative overlaps create interesting visual tensions and patterns throughout the painting.

David Yeom
Oil on canvas with graphite

Student David Yeom creates a painting within a painting. His use of graphite to render the face is in direct visual opposition to the gestural painting techniques used throughout the painting. There is an almost textlike sensibility to the painting.

John Rudel
Kudzu Berries
2006
Acrylic paint, inkjet transfers,
and colored pencil on canvas
42 x 42 in. (106.6 x 106.6 cm)
Courtesy of the artist

Kudzu Berries appears to pay homage to the ubiquitous plant that threatens to take over the southern region of the United States. The abstraction of the landscape brings into focus abstract qualities in the natural world. In his use of new materials to weave a tapestry of overgrown vines, the artist treats his subject matter with unexpected respect.

Howardena Pindell
Autobiography: The Search:
Chrysalis/Meditation:
Positive/Negative
1988–99
Acrylic, tempera, oil stick, cattle
markers, paper, and polymer
photo transfer on canvas
72 x 112 in. (182.8 x 284.5 cm)
Courtesy of the artist

Howardena Pindell's *Autobiography* combines
straight abstraction with representation to create
a vast environment of overlapping identities, the
provocative and personal separation of color from
the bright yellow of the sunlight perhaps signifying
openness versus the right-hand side of doubt. This
is underscored by the repetition of her face, which
is more prominent on the left side of the painting.

Arlene Burke Morgan
#8
2005
Acrylic on paper
15 x 15 in. (38 x 38 cm)
Courtesy of the artist

Arlene Burke Morgan's acrylic painting on
watercolor paper is lush, with both the proper
of water and the opaque imagery of the acryli
ensuring that it is rich in color and design.
Morgan's illusory tactile texture creates an
intricate web of symmetry. The basic circle-
within-square motif creates a push-pull visua
competition between each section.

e considers nontraditional modes of expression, and you may, the
ty to be fearless and take risks is most often strengthened by the
s. Breaking the rules as you learn them is simply an extension of this
vledge. The accidental mark, the so-called mixing of the wrong paint,
ld not need to be seen in this light at all. The lines between old and
fade with each generation of artists and the variables of taste. When I
t with a painting class for the first time, a good part of my introduction
explanation of my teaching philosophy centers on the concept of how
s a class, and myself as the instructor will learn and acquire all sorts
nowledge from each other continuously as part of a type of compact.
transcends the instruction that a student should expect when signing
or a class. Consciously or not, every class is its own entity, and no
groups will be taught in the same matter. This lifelong learning is
ething to be strived for and treasured.

Abbie Morris
Oil on canvas

Abstract painting of a ball being thrown from a
hand and changing into a butterfly. Student Abbie
Morris shows how a picture of transformation can
create a feeling of movement.

*Ve work in the dark—we do what
e can—we give what we have.
ur doubt is our passion and our
assion is our task. The rest is the
adness of art."*

enry James, *The Middle Years*, 1893

Critiques
Health and Safety

Incorporating Critique and Self-critique

Over the years, I have always found it helpful to think of the current work that I am doing as my best. I say this because it usually is. You may improve tremendously over time, but the improvements will likely be incremental, so your current work will be your best at any given time. This sense of self-satisfaction is realistic, as you cannot know what kind of improvements lie ahead. To continue to grow as an artist and achieve this incremental improvement, the beginning painter will need to find ways to advance his or her skill level and at the same time have some criteria for measuring success. If one is attending a school, the opportunities for improvement and influence are built in.

One very important aspect of the class experience is critique. Critique can take the form of a solitary instructor's review or a group critique; the latter is the way in which I like to involve my students. In a group critique, artists attempt to analyze a painting through examination of the finished results. The two questions that sum up this search are *What is working?* and *What could use improvement?* For some, the term "critique" has negative connotations, which is why the very thought may induce a natural defensiveness. I rather prefer to treat group critique as an affirmative and collective self-help session. So aside from the positive responses from friends and family, based on the fact that you can make a painting of subject matter that is recognizable to the viewer, there is another layer of commentary that can help you grow. When first starting out, hearing these supportive comments is in itself a validation.

What is self-critique?

After leaving a class, or even if you are self-taught, the next step, if one is to consider painting in a more serious fashion, is the question of soliciting an informed critical voice to respond to your paintings. In some communities there are artists' circles (communities of visual artists who may choose to meet weekly and discuss each other's work in a supportive atmosphere. For those who either do not have access to such a group or are not ready for that type of critique, it would be helpful in the meantime to try to learn to assess your own work. Usually, students are much harder on themselves than anyone else is when it comes to critique. There is often a tendency to disparage their own work before anyone can say anything. Artists both new and old still have an involuntary need to protect their creations.

Critique is simply a way of understanding what you have accomplished in a painting. As in group critique, in self-critique it is still necessary first to understand the most successful aspects of your work and then to look at what needs improvement. Critique is simply a way of understanding what you have accomplished in a painting. Over the course of a painting assignment in a class, beginning painting students will usually have group critiques at every stage of the painting, from sketch to completion. In self-critique this is no less important. When you are making a preparatory sketch on the painting surface, this is the first opportunity to critically observe your start. Your critique can be based on whether you have a correct interpretation of your subject matter, if that is what you wish. But what exactly does "correct" mean in this situation? You are not taking a photograph, so it must be you who provides that the answer. Although critique is subjective, when you judge your own work, you should be aware of your own criteria and expectations.

at purpose should it serve?

most basic, critique, when done well, should help
ning painters to advance their painting skills and
urage them to take the risks needed to advance to
ext level. First and foremost, beginning painters
d judge themselves at their current level, rather
against any professional painters they may admire.
mber, these artists had their own beginnings and
own struggles, as will you. In that spirit, it is
rtant to like what you are doing even as you struggle
it. In each new painting you create, there will be
improvement from the last, and there will always
nething important about each experience that is
d forward.

How can critique encourage rather than discourage?

When describing the nature of critique to my beginning
painting students, I speak of affirmation, support, honesty,
clarity, and, most importantly, brevity. I believe it is
particularly helpful to speak about the most positive
aspects of a painting as a way of affirming the effort and
encouraging continuation. Being honest in critique is
sometimes hard, but should be seen as a gift. In a group
critique, giving critique freely will guarantee the favor
being returned. Brevity in critique forces the speaker to
be clear and to the point.

When you observe your own work, follow the same
advice and consider what you think is good and which areas
you need to work on. In many cases, the improvements
may not show until you have made several more paintings.
If you create ten paintings over a period of time, some will
be weak and some strong. Your successful efforts will be
built on earlier struggles. You must have the patience to
learn, and to work through the normal frustrations that
arise in every learning experience. Even as a professional
artist, I still believe I work in a state of hopeful doubt. My
past experiences are not an assurance of a great painting,
only a knowledge that the ability is there.

General Health and Safety Issues for Painting and Woodshop Studios

Whether you are painting at home in a spare room or in a dedicated studio, it is important to observe basic safety protocols.

Oil and acrylic paints

— Oil paints are for the most part toxic in nature, and the most hazardous of the paint colors are those containing cadmium. Although acrylic paint is much less toxic, you should at the very least assume that it is not completely safe.
— If at all possible, it is advisable to develop the habit of painting with gloves on, either cloth or surgical (latex). This will prevent absorption of chemicals through your pores.
— Avoid eating or drinking in your studio area. Eating a sandwich while painting makes it that much more likely that you will accidentally ingest some paint.
— Do not leave paints in direct sunlight.
— To prevent fumes from building up in your studio, save leftover paint in closed containers, or the whole palette can be covered in plastic wrap of some sort. Always replace the caps on your paint tubes.
— Wash your hands (including under your fingernails) after a painting session.

Turpentine and other toxic chemicals

— Before working with chemicals, always read the la for further information.
— Turpentine (gum or odorless) is highly, highly toxi whether through ingestion, skin contact, or inhala and when used requires good ventilation. Odorles turpentine only masks the danger. If working at h try to dedicate one area for your workshop and wo near an open window. If you intend to have a sepa studio space, try to choose one with high ceilings windows on both sides for cross-ventilation, or use electric fan while the window is open for a comple change of air.
— Basic poison precautions for turpentine and other chemical exposure are given below. It would also be advisable to call your local poison control cente in case of contact or ingestion.
— Painting mediums should be kept in airtight glass containers and securely covered when not in use. simple precaution will prevent fumes from buildin within your environment.
— Do not leave mediums or turpentine in direct sunl

Turpentine and other toxic chemical exposure precautions

— If swallowed, do not induce vomiting.
— Flush eyes with water for fifteen minutes.
— Wash hands thoroughly with soap and water.
— If inhaled heavily, get fresh air.
— In case of contact or ingestion, call your local pois control center.

ols and equipment

When using spotlights for still life painting, use the lowest wattage possible as a fire precaution.
When using extension cords, make sure they are heavy-duty, and take care in placing them around your working area.
When cleaning your palette, use your paint scrapers carefully. They are usually made with a razor held in place with a metal or plastic holder. The blades can break, so it is advisable to wear safety goggles. Always push the paint away from your body, keeping your hands out of the path of the blade.

neral health advice

If you are pregnant or have other health issues such as a compromised immunity, please contact a health care professional.
Take regular breaks to go outside for fresh air.
Supervise children in your studio.
Keep your pets away from your studio at all times.
Clean up completely after a painting session.

Woodshop safety

When you decide it is time to build your own stretchers, you will need to use electric power tools. This is perhaps the most dangerous part of painting preparation. You must respect the power of these tools to do harm, so do not get too comfortable with them.

— Goggles, dust mask, and earplugs are essential.
— Make sure that all woodshop areas are properly ventilated.
— Always keep the floors free of excess wood shavings to prevent slipping.
— If you are new to these tools, you *MUST* first get training, and afterward work with a partner. The buddy system protects you both if there is an accident.
— To prevent entanglements, do not wear loose clothing or have your hair hanging loosely while cutting.
— Before you cut, always check where your fingers are. All it takes is one moment of careless distraction for a serious accident.
— If the wood you are about to cut has rough knots in the grain, you may want to choose another piece, as the blades can at times kick back when they meet a knot.
— Clean up completely after painting and/or working in a woodshop.

Glossary
Further Reading

Glossary

A

absorbent ground *See* ground.

abstraction A work of art using nonobjective imagery, i.e., objects or images that may derive from the visible world but that do not imitate a recognizable subject.

acrylic A type of paint made with synthetic resin as the medium to bind the pigment (color) rather than natural oils. It is fast-drying and water-soluble.

advancing color An optical phenomenon by which deep, warm colors, such as yellow and orange, appear to move toward the foreground of the picture plane. *See also* retreating color.

alla prima painting *See* wet on wet.

atmospheric perspective The method used by an artist to show distance and/or atmospheric effects, such as dust or clouds, by soft-edged, hazy painting.

B

blending Mixing paint to create subtle gradations from light to dark, or from one color to another. This technique can be used wet on wet, or with glazing and scumbling. This is the basis for shading in most paintings.

body color *See* gouache.

bright brush *See* brush.

bristle A hair used for brush tips, traditionally from hogs, though now also made from nylon. Stiffer than sable hair (*see* sable), the rough quality of bristle hair makes it a good choice for scumbling and "drawing" with the brush.

brush You should always use different brushes for oil and acrylic. There are five main types of brush: The round brush has long hairs tapered to a point, with a round ferrule. The flat brush is flat with long hairs and makes the placement of paint more manageable, as it does not leave a raised edge on either side of the brush mark. The filbert brush is flat, oval-shaped, and fairly thick; one of the best all-around brushes for painting. The bright brush is flat with short hairs. The fan brush is, as its name suggests, fan-shaped. It can be both flat or thick and fluffy, is especially soft, and comes in a variety of hairs. It is generally used to blend areas where the color has been applied and softer edges are required. This is a finishing brush, usually reserved for the finishing touches. *See also* ferrule.

brush-cleaning jar Glass or metal container with a metal coil or netting at the bottom, which prevents the brush from touching the residue of old, dissolved paint.

brushwork The characteristic way an artist brushes paint onto the surface.

C

canvas Type of flexible material support for use in either oil or acrylic painting. The two main types are linen and cotton duck. Linen is high-quality, expensive, and has an irregular surface. Cotton duck is a cheaper option and has a more even, machine-woven surface.

cast shadows When a light source strikes an object, it casts a shadow similar to the shape of the object. The density and shape of a cast shadow depend on the brightness of the light source and its closeness to the object. The different positions of the light will affect the shape, tone, and size of the cast shadow.

charcoal A drawing instrument made by charring thin pieces of wood in a furnace. It can also be in the form of compressed charcoal, which is powdered charcoal mixed with a binding substance and compressed into sticks. It can be used both for finished drawings and for preliminary sketches. Charcoal comes in shades from white to black.

chiaroscuro A shading technique that uses the contrasts between lights and darks for dramatic effect. It is based on five principles of shading: the lightest light, the shaded area, the core (the darkest part of the shaded area), reflected light, and cast shadow. It comes from the Italian words for "clear" and "dark."

chroma The relative intensity or purity of a color when compared to grayness or lack of color.

chromatic chart A method of displaying the different types of chromatic gray.

chromatic gray, or chromatic neutral A gray created by mixing colors that are opposite each other on the color wheel, which will have a color bias or a distinct color to it.

collage The technique (and the name given to the finished work) in which the artist glues scraps of materials such as paper, card, foil, metal, plastic, found objects, etc., to a painting or drawing surface. Sometimes also combined with painting or drawing.

color bias In chromatic grays, or neutrals, the color emphasis is determined by more weight being given to one color than the other in the mixing process. For example, red mixed with its complement, green, will produce a gray that is more red or more green depending on the relative quantities of red and green paint that you add.

color temperature Reds, yellows, oranges, and red-violets are generally described as warm colors. Blues, greens, and violets are considered cool colors. Warm and cool are relative terms, and one color can have warm and cool shades: for example, a yellow with a hint of green is a cool yellow. *See also* advancing color, retreating color.

color wheel A system designed to show the properties of color. In this book, we use the Johannes Itten color wheel. Itten's standard color wheel illustrates the primary colors: red, yellow, and blue. The larger color wheel consists of three sections: primary colors, secondary colors (formed by mixing pairs of primary colors), and tertiary colors (formed by mixing adjacent primary and secondary colors). *See also* primary colors, secondary colors, tertiary colors.

E/F G H

lementary colors
Colors directly opposite
each other on the color
wheel. For example,
red's complementary color
is green. By mixing
complementary colors
together, chromatic neutrals
(grays) are produced.

position The proces of
arranging the forms of two-
or three-dimensional visual
art into a unified whole by
means of elements and
principles of design, such as
line, shape, color, balance,
contrast, space, etc., for the
purposes of formal clarity
and artistic expression.

ent The meaning with
which you imbue your
chosen subject matter.

colors *See* color
temperature.

n duck *See* canvas.

encaustic A method of painting
that uses pigments melted
with wax and fixed or fused
to the painting surface
with heat.

fan brush *See* brush.

fat over lean, or thick over thin
A rule important to remember
when painting in layers,
especially with oil paint. "Fat"
paint is paint that contains
more oil (such as paint
straight out of the tube),
while "lean" paint has a
lower oil content (such as
paint mixed with turpentine).
If your last layer of paint
dries more quickly than your
first layer, this will lead to
problems such as cracking
in the finished painting. Fat
over lean means that earlier
layers of paint should be
leaner, so that the first coats
dry faster. When using a
painting medium that speeds
up the drying time, a good
rule is to add a drop or two
less for each layer. Each
subsequent layer should be
thicker and fatter than the
one before it.

ferrule The section of the paint
brush between the handle
and the hairs that holds the
hairs in place. It is generally
made of metal.

figure/ground relationship
The relationship between
the shape in the picture,
whether object or person,
and the space between the
shapes and on which the
shapes rest in a painting.

filbert brush *See* brush.

film (paint film) A layer of
paint once it has been
applied to a canvas.

flat brush *See* brush.

fresco Traditional form of
painting using watercolor
on the wet plaster of a wall
or ceiling.

full-range color painting A way
of painting that uses a full
range of color from beginning
to end; painting with color
as one sees it naturally,
using the whole color wheel
and all tints, shades, and
chromatic grays in between.

gesso An undercoating medium
used on the painting surface
before painting to prime the
surface. Usually a white,
chalky, thick liquid.

gesso-prepared hardboard
Wood or masonite board
prepared with gesso for use
as a painting surface.

glazing A technique by
which transparent colors
are applied over a dry
underpainting. Many glazes
may be layered to create
particular color effects. Each
layer of dried paint, or glaze,
must be more flexible than
the previous one, so the
principle of fat over lean
must be used. *See* fat over
lean, or thick over thin.

gouache An opaque, water-
soluble paint.

ground The surface on which
you paint, often a coating
(gesso) rather than support,
unless the support is paper.
An absorbent ground pulls
in or absorbs paint rather
than letting it sit on the
surface.

harmony The art of bringing
together all the design
elements of a painting in
the right proportions so as
to create an image that is
easy to view.

hide The covering ability of
paint.

horizon line The point in a
perspective drawing or
painting where the
vanishing points converge.
See vanishing point.

hue The name of a color, such as
blue or red-orange. Another
word for color.

Glossary

L M N/O P

landscape A work of art showing the outdoors, comprising any one element of nature, landforms, weather conditions, or humanity. Also used to describe a rectangular page orientation where the longer axis is horizontal.

linear perspective The representation of an image as perceived by the eye, so that objects are painted smaller the further they are away from the viewer, and elements are foreshortened to cater to different angles of viewpoint. There are three main types of linear perspective:
One-point perspective—the artist is standing at the center of the scene, and there is a single point at which the lines and figures converge to a vanishing point.
Two-point perspective—the artist is standing at an angle to the scene, and the lines and figures will converge in two different points.
Three-point perspective—the artist is viewing the scene from above or below, adding yet another vanishing point at the top or bottom of the painting.

linen *See* canvas.

Liquin Brand name for an oil painting medium that helps create a smooth, glossy surface, thickens oil paint, and speeds up its drying time.

local color The actual color of an object or surface, unaffected by the quality of the light, reflected color, or other factors.

luminosity Describes a surface that shines, glows, and has a lustrous and glassy finish.

masking fluid Clear, latex-rubber fluid applied to any areas of a painting (acrylic or watercolor) that the artist wants to protect from paint. It can then be peeled off to reveal an untouched area.

monochromatic Describes the use of one color that is tinted by white and shaded with black. This is generally used for the underpainting, prior to glazing with full color.

muddy color In general, a color that is unclear or has a grayish or brownish tone—a form of chromatic gray. It may not be needed for your red apple overall, yet it may play a role in creating a cast shadow or a reflection on the apple.

negative space The area or space around an object or arrangement of objects in a painting or drawing that creates a visual shape or pattern. Negative space drawing involves concentrating on the background, leaving the object white.

oil A type of paint made with natural oils, such as linseed, walnut, or poppy, as the medium to bind the pigment. Oil paints dry slowly, allowing the artist time to blend the colors and rework the paint.

one-point perspective *See* linear perspective.

opacity A paint's resistance to light. A more opaque paint will not allow images or colors in the layers of paint underneath it to show through.

painting cups Small cups which to collect leftove paint to prevent it from drying out between painting sessions.

painting medium Agent mixed with oil or acrylic paint to affect its behav Mediums can change t gloss, drying time, leve transparency, and the f film of the painting.

palette A flat surface on w to mix paint colors, suc piece of glass or wood o ceramic tray.

palette cup A circular met cup used for saving left paint after a day's work designed to clamp on tc palette.

palette knife A metal knif with a wooden handle f mixing paint on a palett and for applying or rem paint.

pastel A colored chalk mac powdered pigment bou together with a water-b gum and molded into small sticks.

peephole viewfinder *See* viewfinder.

picture plane Any flat sur on which to start a pain e.g., paper or canvas.

pigment Substance that imparts color to other materials. In paint, the pigment is a powder tha when mixed in liquid, imparts color to a paint surface.

R S

tillism A technique used
y neo-Impressionist
ainters, where tiny dots
f pure color are blended in
he viewer's eye. See p. 9
or an example by Seurat.

raiture A work of art
epicting a person, usually
oncentrating on the face
nd its expression. Also
sed to describe a
ectangular page orientation
vhere the longer axis is
ertical.

ary colors Red, yellow,
nd blue. These colors
annot be formed by the
nixing of any other colors
nd are the foundation from
vhich other colors are
reated. *See also* color
vheel, secondary colors,
ertiary colors.

reflected color The color of
one object reflected in
another object.

rendering as you go A loose
description of the technique
of finishing whole areas of
the painting in a piecemeal
fashion.

retarder A medium added to
acrylic paint to slow down
the drying time.

retreating (or receding) color
An optical phenomenon by
which cooler colors, such
as blues and greens, appear
to retreat, or recede, on the
picture plane. *See also*
advancing colors.

round brush *See* brush.

sable A natural animal hair
traditionally used for brush
tips. It is soft and pliable,
leaving a smooth surface
finish.

scumbling A method of glazing
in which very thin layers of
wet color are applied to a
dried paint film by moving
trace amounts of paint
around the surface with a
stiff-bristled brush. Also
known as wet on dry.
See Chapter 4 for a full
discussion of this technique.

secondary colors The three
colors formed by mixing
together the primary colors:
orange (red plus yellow),
green (blue plus yellow),
and violet-purple (blue plus
red). *See also* color wheel,
primary colors, tertiary
colors.

shade The darker color of a
given hue resulting from the
addition of black or another
dark color. A shade is always
darker than the color that
comes straight from the
tube. *See also* tint.

sheen The way light can stream
and brighten up an area and
create a luster on the
surface.

simultaneous contrast
An optical phenomenon
that can occur when two
different colors are placed
next to each other,
producing a heightened
contrast, which intensifies
the difference between
them. Each color seems
brighter than when viewed
alone. A shimmering effect
is also sometimes produced.

still life A work of art depicting
inanimate objects.

stretcher A frame, usually
wooden although
sometimes made of metal,
on which a canvas is
stretched and attached.

subject matter The elements
that you choose to include
in your painting, chosen as
a result of preference, ease,
interest, and other personal
influences.

support (painting support)
The actual material or
surface on which a painting
is created, usually canvas,
paper, or wood.

Glossary

T

tempera Painting method in which finely ground pigment is mixed with a solidifying base such as egg yolk, sap, or glue. The name distemper is given to the method when a glue base is used.

tertiary colors The six colors formed by mixing together adjacent primary and secondary colors: red-orange, red-violet, yellow-green, yellow-orange, blue-green, and blue-violet. *See also* color wheel, primary colors, secondary colors.

three-point perspective *See* linear perspective.

tint The lighter color of a given hue resulting from the addition of white or another light color. A tint is always lighter than the color that comes straight from the tube. *See also* shade.

tone The lightness or darkness of a color in terms of black to white; for example, light or dark red, or light or dark gray.

tooth Grained but even texture of canvas. Tooth allows the attachment of succeeding layers of paint.

transparency The degree to which a layer of paint allows light to pass through, revealing the previous layers.

transparent colors Colors that have less hide, used for glazing or in conjunction with thicker paints.

turpentine For use in mixing the oil paint medium.

two-point perspective *See* linear perspective.

U/V

underpainting Traditional stage in Venetian painting using a monochrome as a base for composition.

value The relative lightness or darkness of a visual space. Value in color is defined as the relative gradations between the darkest and lightest tones. Adding white tints a color lighter, whereas adding black creates a darker shade. Examples: dark blue or pale red-orange.

value patterns The shape of patches of color on the surfaces of the subject matter. On a shiny silver ball, the shapes of the colors reflected in its surface will conform to its circular quality. Paying attention to these shapes will help in controlling the composition, and painting these shapes along with the outside lines of the object will help you to identify your color combinations.

vanishing point The point in a perspective drawing or painting to which the lines and figures seem to converge.

varnish A mixture used to bring a particular shine to a painting once it has dried. As well as its protective properties, it helps to brighten the painting surface and brings out the darks and lights in dramatic contrast.

Venetian painting technique A style of painting that originated in Venice and was prominent from the fourteenth to the sixteenth centuries. It is a method of glazing that uses a number of fixed steps, and relies on the color Venetian red both for toning the painting surface and for the underpainting itself. See Chapter 5 for a full description of this technique.

viewfinder A handheld frame that helps in editing a composition by putting a border around the chosen subject matter. This border represents the outside edges of the painting surface. A viewfinder can be constructed by cutting the center out of a piece of paper or cardboard. By cutting out the center of a piece of paper in roughly the same dimensions, you will have a handheld viewfinder. A peephole viewfinder, made of white card and with a smaller hole in the center, is designed to isolate individual colors, either on the painting palette or in the subject matter itself, by blocking out the other colors.

viscosity The thickness and body of paint.

W

wet on dry *See* scumbling

wet on wet, or alla prima painting A technique in which the painting is worked while the paint is still wet. Wet paint is blended into wet paint, and the painting is often completed in one sessio can be worked on in lay See Chapter 2 for a full discussion of this techn

urther Reading

Aims, *Color Theory Made Easy*, New York: Watson-Guptill, 1996

Albers, *Interaction of Color*, New Haven, CT: Yale University Press, 1975

Ardley, *The Science Book of Color*, San Diego, CA: Harcourt Brace Jovanovich, 1991

Armstrong, *Colour Perception*, Stradbroke, Norfolk: Tarquin Publications, 1991

n **Bell**, *What is Painting? Representation and Modern Art*, New York: Thames and Hudson, 1999

Birren, *Color and Perception in Art*, New York: Van Nostrand Reinhold, 1976

ld **Brommer**, *Emotional Content: How To Create Paintings That Communicate*, Verdi, NV: International Artist, 2003

io **Brusatin**, *A History of Colors*, Boston, MA: Shambhala, 1991

son W. **Carr** and Mark Leonard, *Looking at Paintings: A Guide to Technical Terms*, Malibu, CA: J. Paul Getty Museum, 1992

Chong (ed.), *Rembrandt Creates Rembrandt: Art and Ambition in Leiden 1629–1631* (exhibition catalog), Zwolle, The Netherlands: Waanders, 2000

n P. **Compton**, *Chagall* (exhibition catalog), New York : Harry N. Abrams, 1985

reevy, *The Oil Painting Book: Materials and Techniques for Today's Artist*, New York: Watson-Guptill, 1994

ph **D'Amelio**, *Perspective Drawing Handbook*, New York: Tudor, 1964; New York: Van Nostrand Rheinhold, 1984; New York: Dover Publications, 2003

na **De Grandis**, *Theory and Use of Color*, New York: Harry N. Abrams, 1986

çois **Delamare** and Bernard Guineau, *Colors: The Story of Dyes and Pigments*, New York: Harry N. Abrams, 2000

rice **de Sausmarez**, *Basic Design: The Dynamics of Visual Form*, New York: Reinhold, 1964; revised edition with a foreword by Gyorgy Kepes, New York: Van Nostrand Reinhold, 1983; second revised edition, London: A & C Black, 2002

ne W. **Eckstein**, *Color in the 21st Century*, New York: Watson-Guptill, 1991

James **Elkins**, *What Painting Is: How to Think about Oil Painting using the Language of Alchemy*, New York: Routledge, 1999

Edith Anderson **Feisner**, *Colour: How to Use Colour in Art and Design*, London: Laurence King Publishing; as *Color Studies*, New York: Fairchild Publications, 2000; revised edition, 2006

Victoria **Finlay**, *Color: A Natural History of the Palette*, New York: Ballantine Books, 2002

Mark David **Gottsegen**, *The Painter's Handbook*, revised and expanded edition, New York: Watson-Guptill, 2006

Barbara **Haskell**, *The American Century: Art & Culture 1900–1950*, New York: W.W. Norton, 1999

Cynthia Newman **Helms** (ed.), *Diego Rivera: A Retrospective* (exhibition catalog), New York: W.W. Norton, 1986

Hayden **Herrera**, *Frida: A Biography of Frida Kahlo*, New York: Harper & Row, 1983; London: Bloomsbury,1998

Linda **Holtzchue**, *Understanding Color*, New York: Van Nostrand Reinhold, 1995

David **Hornung**, *Colour: A Workshop for Artists and Designers*, London: Laurence King Publishing; and as *Color: A Workshop Approach*, New York: McGraw-Hill, 2004

Robert **Kaupelis**, *Experimental Drawing*, London: Pitman and New York: Watson-Guptill, 1980

Michael D. **Kinerk** and Dennis W. Wilhelm, *Popcorn Palaces: The Art Deco Movie Theatre Painting of Davis Cone*, New York: Harry N. Abrams, 2001

Margaret **Krug**, *An Artist's Handbook: Materials and Techniques*, New York: Harry N. Abrams, 2007

Trevor **Lamb** and Janine Bourriau, *Color: Art and Science*, New York: Cambridge University Press, 1995

Samella **Lewis**, *Art: African American*, New York: Harcourt Brace Jovanovich, 1978; revised edition as *African American Art and Artists*, Berkeley: University of California Press, 1990; third edition, 2003

John **Lidzey**, Jill Mirza, Nick Harris, and Jeremy Galton, *Color Mixing for Artists*, New York: Barrons, 2002

Judy **Martin**, *Dynamic Color Drawing*, Cincinnati, OH: North Light Books, 1989

Ellen **Marx**, *Optical Color and Simultaneity*, New York: Van Nostrand Reinhold, 1983

Guy C. **McElroy**, Richard J. Powell, and Sharon F. Patton, with an introduction by David C. Driskell, *African-American Artists 1880–1987: Selections from the Evans-Tibbs Collection* (exhibition catalog), Seattle: University of Washington Press, 1989

Otto G. **Ocvirk**, *et al. Art Fundamentals: Theory and Practice*, tenth edition, New York: McGraw-Hill, 2006

José María **Parramon**, *Color Theory*, New York: Watson-Guptill, 1988

Emma **Pearce**, *Artists' Materials: Which, Why, and How*, London: A & C Black, 1992

Stephen **Pentak** and Richard Roth, *Color Basics*, Belmont, CA: Wadsworth, 2004

Richard **Pumphrey**, *Elements of Art*, Upper Saddle River, NJ: Prentice Hall, 1996

Tom **Rockwell**, *The Best of Norman Rockwell, 1894–1978*, Philadelphia, PA: Running Press, 1988; revised edition, 2005

Ogden **Rood**, *Modern Chromatics*, New York: Van Nostrand Reinhold, 1973

Hans **Schwarz**, *Color for the Artist*, New York: Watson-Guptill, 1968

Pip **Seymour**, *The Artist's Handbook: A Complete Professional Guide to Materials and Techniques*, London: Arcturus, 2003

Ray **Smith**, *An Introduction to Oil Painting*, New York: Dorling Kindersley, 1993

Alvia J. **Wardlaw**, with essays by Edmund Barry Gaither, Alison de Lima Greene, and Robert Farris Thompson, *The Art of John Biggers: View from the Upper Room* (exhibition catalog), New York: Harry N. Abrams, 1995

Kurt **Wehlte**, *The Materials and Techniques of Painting*, translated by Ursula Dix, New York: Van Nostrand Reinhold, 1975

Michael **Wilcox**, *Color Theory for Oil Colors or Acrylics*, New York: Watson-Guptill, 1983

Philip **Yenawine**, *Colors*, New York: Museum of Modern Art, 1991

Paul **Zelanski** and Mary Pat Fisher, *Color*, fifth edition, Upper Saddle River, NJ: Prentice Hall, 2006

Index
Picture Credits

Index

Page numbers in **bold** refer to illustrations and subjects mentioned in illustration captions.

Index

S

cture Credits

nce King Publishing, the authors, and the
e researcher wish to thank the institutions
dividuals who have kindly provided
graphic material. Collections are given in
ptions alongside the illustrations. Sources
ustrations not supplied by museums or
tions, additional information, and copyright
s are given below. Numbers are figure
ers unless otherwise indicated.

every effort has been made to trace the
nt copyright holders, we apologize in advance
y unintentional omission or error and will
eased to insert the appropriate
wledgement in any subsequent edition.

otographs are by Robin Dana unless marked
wise.

ollowing abbreviations have been used:

t

:om

6 Courtesy Idelle Weber and Bill Massey;
7 © Laurin Ramsey;
9 © Photo Josse, Paris;
12 Courtesy of George Adams Gallery,
 New York;
13 © Photo Josse, Paris;
14 © Quattrone, Florence;
15 © Quattrone, Florence;
16 Courtesy of the artist;
17 © Kelly Smith;
18 Courtesy of George Adams Gallery,
 New York;
19 Image © 2007 Board of Trustees, National
 Gallery of Art, Washington (1937.1.44);
20 © Jessica Schramm;
21 © Vincenzo Pirozzi, Rome,
 fotopirozzi@inwind.it;
22 (3 drawings) Advanced Illustrations Ltd.;
23 © Photo Josse, Paris;
24 Courtesy Idelle Weber and Bill Massey;
25 Bridgeman Art Library, London;
26 Bridgeman Art Library, London;
27 Photo Curtis Publishing;
30 © James Morris, London;
31 © Photo Josse, Paris;
33 Private Collection;
34 Gallery Henoch, New York;
37 Courtesy of George Adams Gallery,
 New York;
41 Courtesy of George Adams Gallery,
 New York;
43 © 2004 Pacita Abad Art;
45 Roger Fawcett-Tang;
46T © David Zoellick;
46B © Kimberley Perry;
47 © Krista Franks;
50 © Zeke Paull;
52T Roger Fawcett-Tang;
52B © Laurin Ramsey;
53 © Alexander Shute;
55TR Rylan Steel
60 Courtesy of George Adams Gallery,
 New York;
61 Courtesy of the artist and the Woodward
 Gallery, New York;
62 © Kelly Smith;
66–67 steps 1 and 6 Rylan Steel;
70 Courtesy of the artist and the Woodward
 Gallery, New York;
73T © Brittany Gabey;
73B © Jasmin Kern;
74 © Miriam Rowe;
75 © Miriam Rowe/photo Rylan Steel
76 © Christin McMurray/photo Rylan Steel
77BR © Brittany Gabey;
79L © Photo Josse, Paris;
79R Courtesy of George Adams Gallery,
 New York;
80L&R Bridgeman Art Library, London;
81 © Craig McPherson, courtesy of Forum Gallery,
 New York;
82 Rylan Steel;
83T © Kari Ann Gertz;
83B © Jasmin Kern;

85 Courtesy of George Adams Gallery,
 New York
88 © Photo Josse, Paris;
89 © Elizabeth Baek;
91 © Brittany Gabey;
93 © Brittany Gabey;
96 © Studio Fotografico Quattrone, Florence;
97 © Patrimonio Nacional, Madrid;
98 © Photo Josse, Paris;
99 Museo National de San Carlos, Mexico City;
101 Courtesy of the artist and the Cumberland
 Gallery, Nashville;
104 © Brittany Gabey;
105 © Brittany Gabey;
106 (2 photographs) Rylan Steel
107 © Brittany Gabey;
110 © Elizabeth Baek;
111 Courtesy of the artist;
114–15 © Cameraphoto Arte, Venice;
116 Courtesy of the artist;
117 Courtesy of the artist and the Cumberland
 Gallery, Nashville;
119 © Brittany Gabey;
121 © Brittany Gabey;
122 (6 photographs) Rylan Steel;
123 © Brittany Gabey;
124 © Ashley Long;
125 © Brittany Gabey;
128 © Photo Josse, Paris;
129 © Vincenzo Pirozzi, Rome;
130 © Krista Franks;
131 Courtesy George Adams Gallery, New York;
134 Private Collection. Image courtesy of George
 Adams Gallery, New York;
136T&B © John Lutz;
137T&B © Amanda Henke;
138 © Fotografica Foglia, Naples;
139 © Studio Fotografico Quattrone, Florence;
140 Collection Walker Art Center, Minneapolis;
141 Photo Kerry Ryan McFate;
142 © Diane Edison;
143 © Diane Edison;
144 Courtesy of the artist and the Cumberland
 Gallery, Nashville;
146–47 © & photos David Zoellick;
148T © Elizabeth Baek;
148B © Tyler Brantley;
149 © Holly Soros;
150–51 © Rebecca Claire Stephens;
152 Solomon Projects, Atlanta, Georgia;
153 Courtesy of George Adams Gallery,
 New York;
154 Courtesy of the artist;
155 Bridgeman Art Library;
156 © Madeline Edwards;
157 Courtesy of the artist;
158L © Krista Franks;
158R © Miriam Rowe;
159 © David Yeom/photo Rylan Steel;
160 Courtesy of the artist;
161 Courtesy of the artist;
162 Courtesy of the artist;
163 © Abbie Morris.